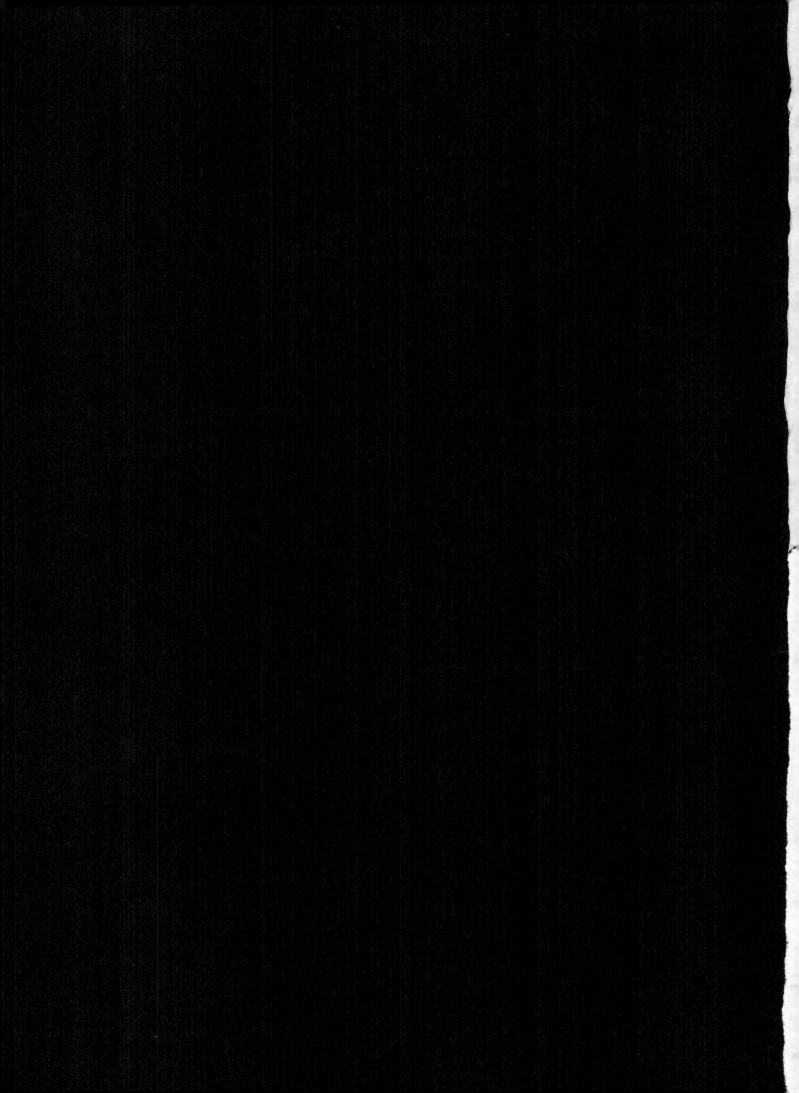

Graphis Inc. is committed to celebrating exceptional work in Design, Advertising, Photography, & Art/Illustration internationally.

Published by **Graphis** | Publisher & Creative Director: **B. Martin Pedersen**

Chief Visionary Officer: **Patti Judd** | Design Director: **Hee Ra Kim** | Senior Designer: **Hie Won Sohn**

Associate Editor: **Colleen Boyd** | Publisher Assistant/Designer: **Yuan Zhuang** | Account/Production: **Bianca Barnes**

Interns: **Maggie Herrera, Lauren Letarte, Ella York**

Graphis Advertising Annual 2025

Published by:
Graphis Inc.
389 Fifth Avenue, Suite 1105
New York, NY 10016
Phone: 212-532-9387
www.graphis.com
help@graphis.com

ISBN 13: 978-1-954632-35-6

We extend our heartfelt thanks to
the international contributors
who have made it possible to publish
a wide spectrum of the best work
in Design, Advertising, Photography,
and Art/Illustration.
Anyone is welcome to submit
work at www.graphis.com.

Copyright © 2025 Graphis, Inc.
All rights reserved.
Jacket and book design copyright
© 2025 by Graphis, Inc.
No part of this book may be
reproduced, utilized, or transmitted
in any form without written
permission of the publisher.

Any Photography, Advertising,
Design, and Art/Illustration work
must be completely original. No
content owned by another copyright
holder can be used or submitted
unless the entrant has been granted
specific usage rights. Graphis is
not liable or responsible for any
copyright infringement on the part
of an entrant, and will not become
involved in copyright disputes
or legal actions.

Printed in China

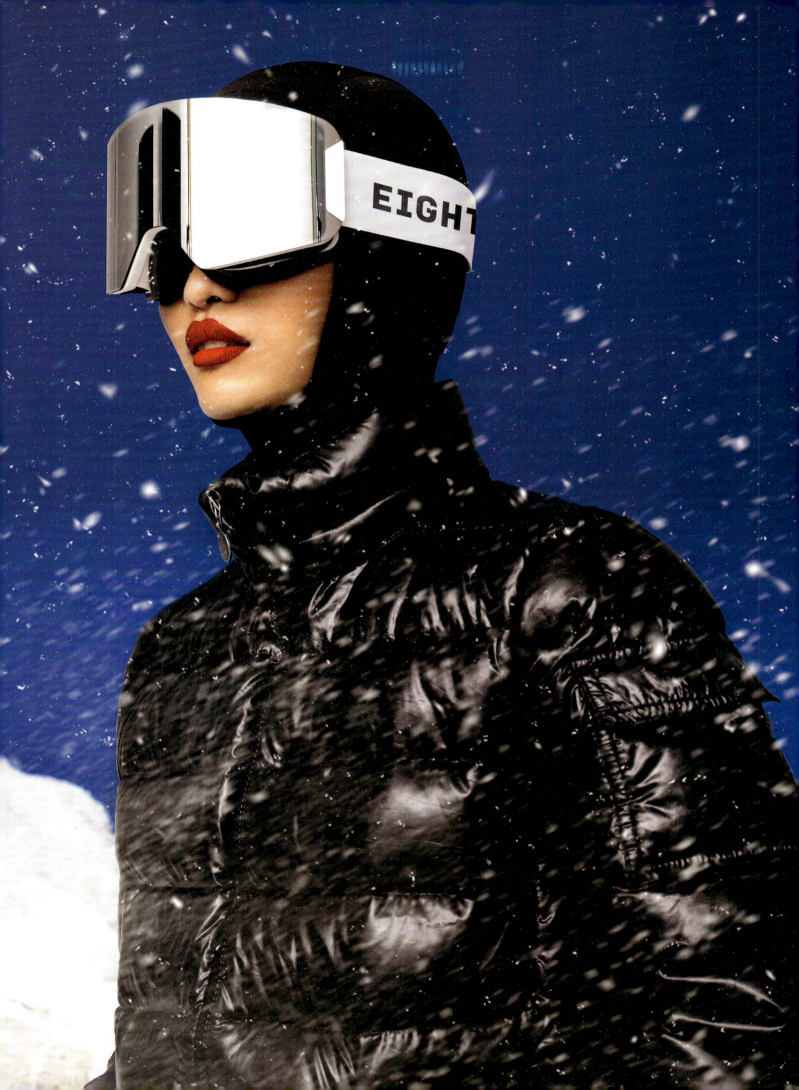

Contents

In Memoriam .. 6
A Decade in Advertising 8
Competition Judges 20
Platinum Awards **28**
Platinum Winners' Bios & Headshots
.. 29
Platinum Award-Winning Work 30
Gold Awards .. **58**
Automotive .. 59

Beverage .. 62
Billboard ... 64
Broadcast ... 66
Corporate ... 68
Entertainment.. 69
Environmental .. 80
Events ... 84
Games .. 86
Healthcare .. 92

Product .. 98
Promotion ... 101
Public Services 107
Restaurant .. 118
Retail ... 122
Travel .. 126
Utilities .. 132
Silver Awards .. **134**
Film/Video .. **155**

Honorable Mentions **174**
Credits & Commentary....................... **176**
Index ... 184
Winners Directory 187
Winners by Country 189
Graphis Titles 190

Page 3: *"Champions of Winter,"* by Eight Sleep
Page 4: *"Silent War,"* by Collective Turn

In Memoriam

The Americas

Howie Cohen
*Copywriter & Co-founder
of Cohen/Johnson
1942 – 2024*

Jack Connors
*Advertising Executive
& Philanthropist
1942 – 2024*

Salvatore DeVito
*Co-founder of DeVito/Verdi
1947 – 2024*

Neil Drossman
*Advertising Executive
& Copywriter
1940 – 2023*

Richard Field
*VP of Advertising
& Marketing of Kocolene
1930 – 2024*

Anita Gleimer
*Founder of Stuart,
Gleimer & Associates
1947 – 2024*

Kenneth Hanson
*Founder of Hanson
Marketing & Advertising
1942 - 2024*

Gary Koepke
*Creative Director
& Co-founder
of Modernista!
1955 – 2024*

Jeff P. Kreiner
*Creative Director
& Executive Producer
1957 – 2024*

Mary Wells Lawrence
*Advertising Executive
& Founding President of
Wells, Rich, Greene
1928 – 2024*

John Mattingly
*Creative Director,
Executive Creative Director,
& Copywriter
1950 – 2024*

Stanley F. Meyer
*President of
Wendt Advertising
1935 – 2024*

**Diego Cardoso
de Oliveira**
*Creative Director
1983 – 2024*

**Herman Stanley
Parish III**
*Creative Director,
Copywriter,
& Account Executive
1953 – 2024*

Monty Reese
*Senior VP of Marketing/
Advertisement of
Michaels Arts & Crafts
1950 – 2024*

Alan Rezza
*Advertising/Marketing
Professional & President
of Apex Communications
1946 – 2024*

Jim Riswold
*Creative Director for
Wieden+Kennedy
1957 – 2024*

**Charles David
Schollenberger**
*Marketing/Advertising
Professional at Christenson,
Barclay & Shaw
1952 – 2024*

Gloria Scoby
*Advertising Director
1945 – 2023*

Len Sirowitz
*Advertising Art Director
1932 – 2024*

Kenneth T. Ulsh
*Advertising Agency
Executive, President,
& Co-founder of Marketing
Communications Associates
1935 – 2024*

John Wolfe
*Advertising Executive
& Director of
Communications at the
Association of
National Advertisers
1951 – 2024*

Europe/Africa

Kevan Aspoas
*Co-founder & CEO of
The Jupiter Drawing Room
1958 – 2024*

Brian Stewart
*Creative Director
1950 – 2024*

Asia/Oceania

Ted Curl
*Advertising Creative Director
at Magnus, Nankervis & Curl
1940 – 2024*

Harold Mitchell
*Media Buyer, Entrepreneur,
& Philanthropist
1942 – 2024*

Brendan Pereira
*Advertising Creative Director
1928 – 2024*

Umesh Upadhyay
*Media Executive & Writer
1958 – 2024*

Fali Vakeel
*Vice Chairman
of Lowe Lintas
1952 – 2024*

Jack Vaughan
*Creative Director
& Copywriter
1945 – 2024*

Opposite page: "Tunica no. 01, 50" x 50", 2014," photographed by jpSch

A Decade in Advertising Platinum Winners from 2015

Butler, Shine, Stern & Partners 🇺🇸 Pg. 19

Doner Advertising 🇺🇸 Pg. 14, 15

Dunn&Co. 🇺🇸 Pg. 16

Lewis Communications 🇺🇸 Pg. 9

LLOYD&CO 🇺🇸 Pg. 10 , 11

The Richards Group 🇺🇸 Pg. 12, 13

WONGDOODY 🇺🇸 Pg. 18

Zulu Alpha Kilo 🇨🇦 Pg. 17

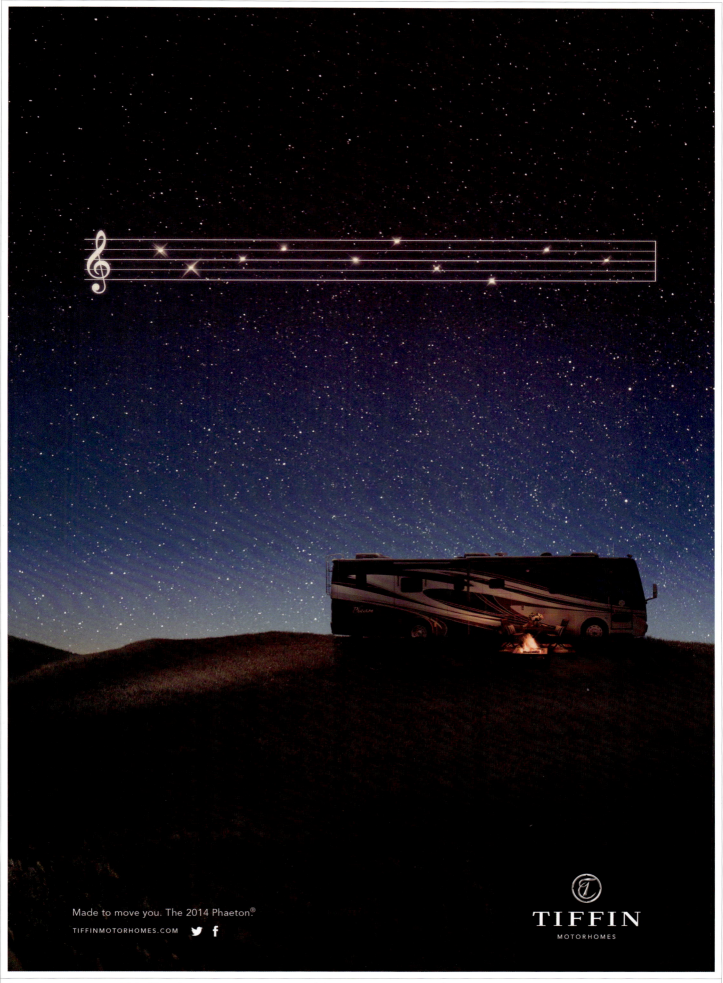

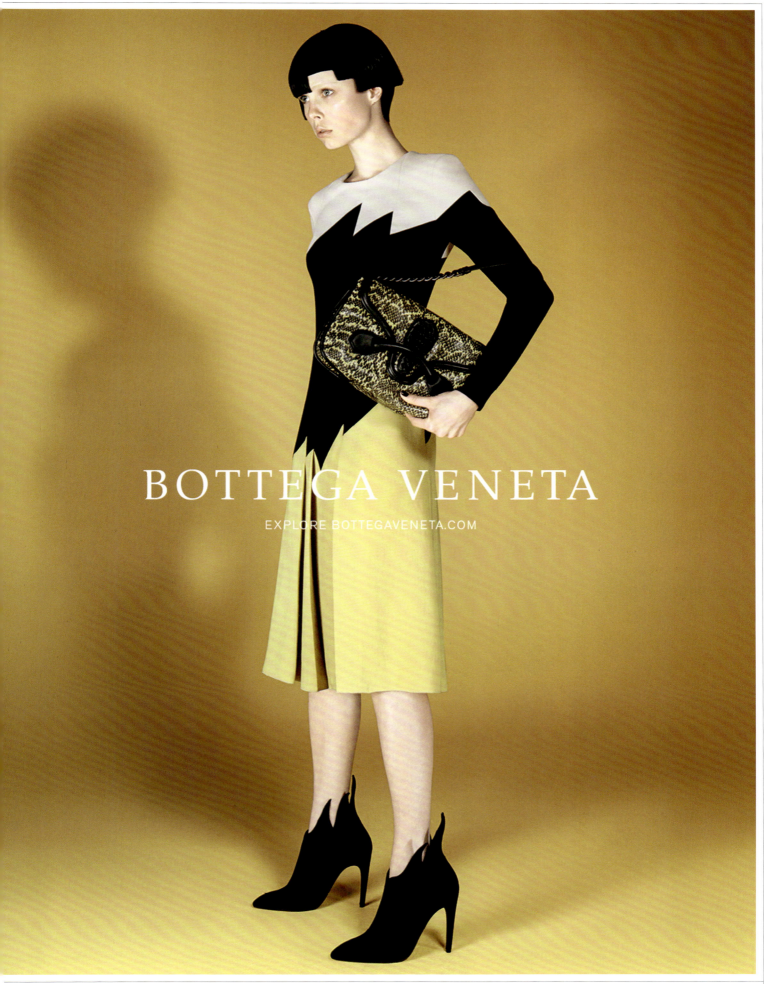

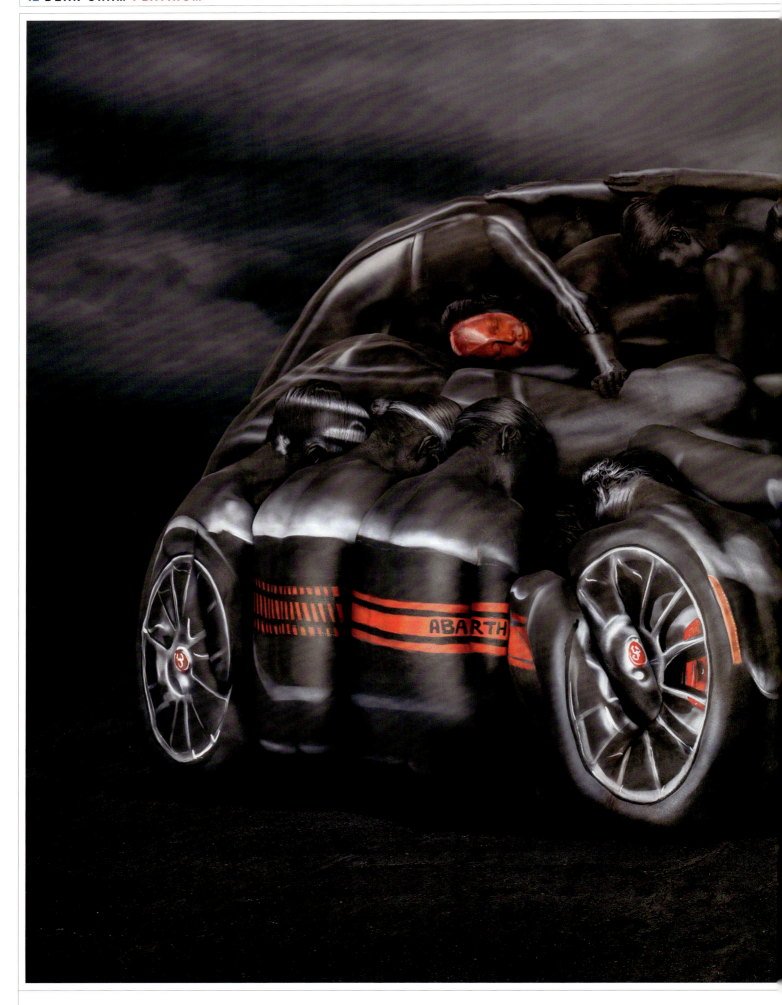

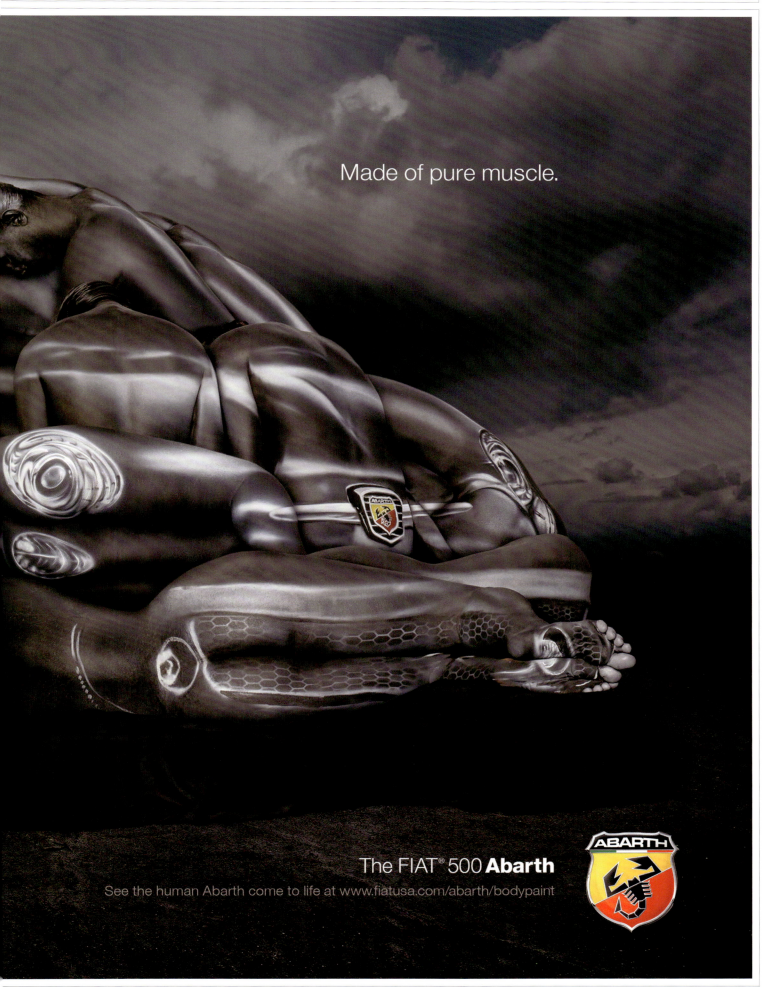

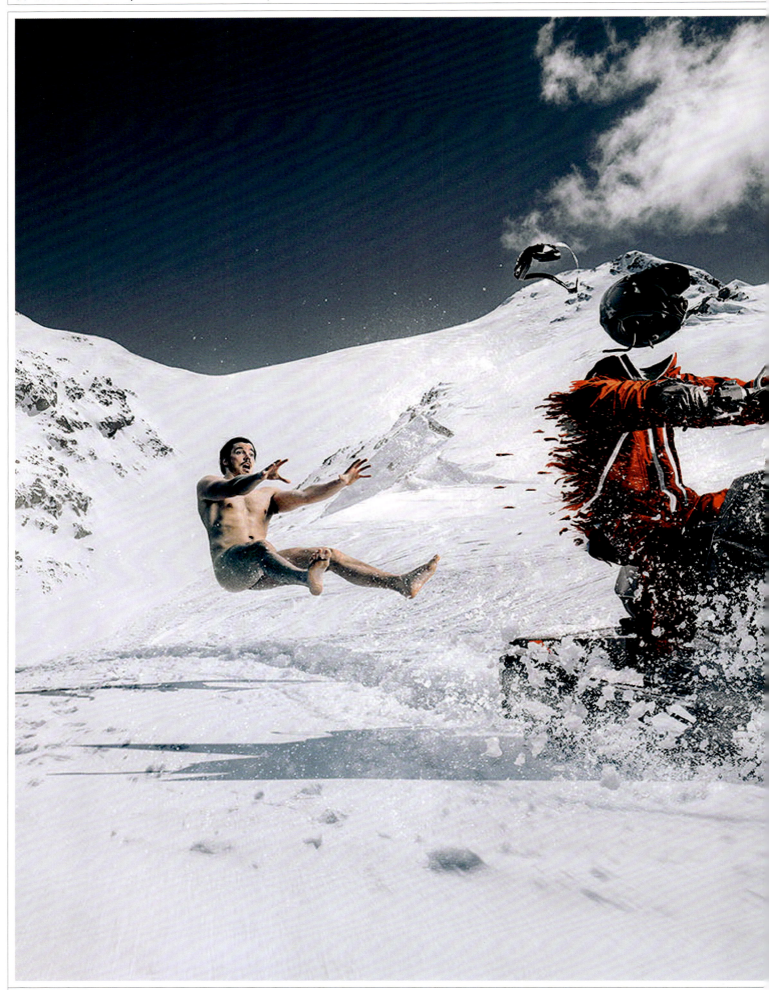

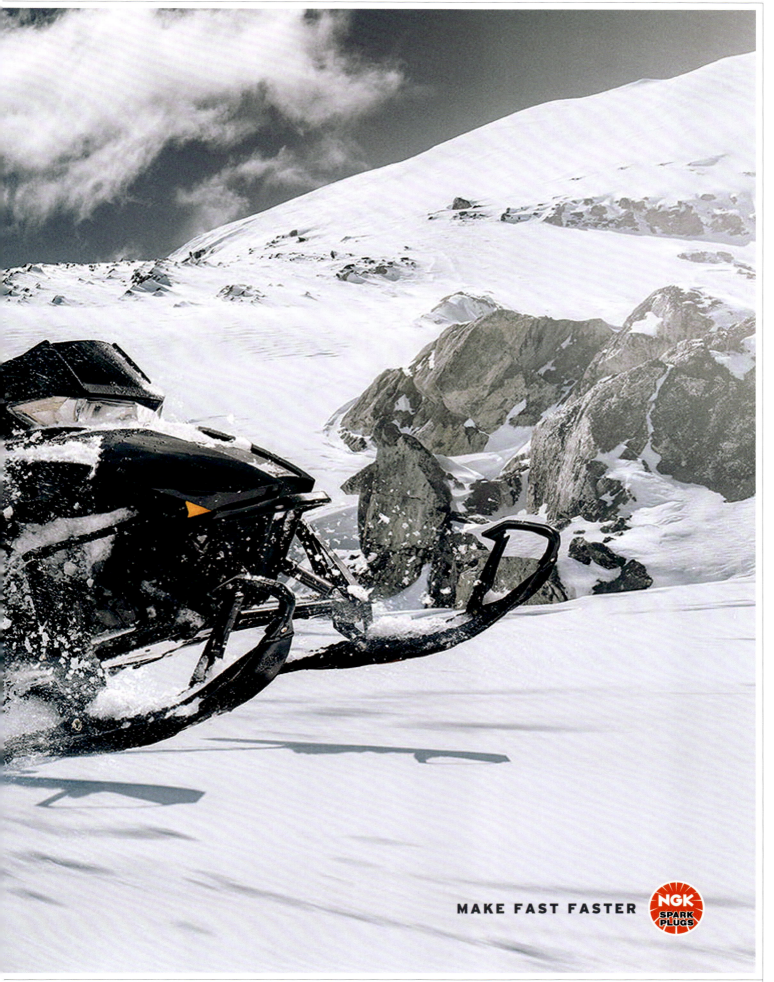

Title: Make Fast Faster | **Client:** NGK Spark Plugs | **Agency:** Doner Advertising

16 TROY DUNN, GLEN HOSKING **PLATINUM**

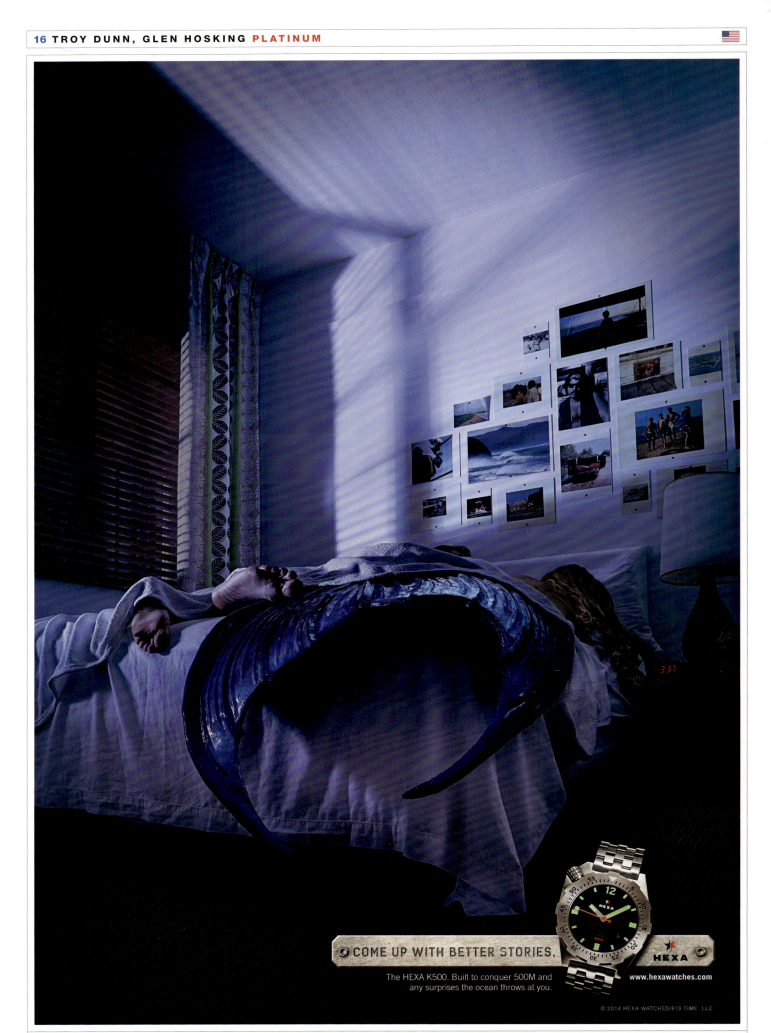

Title: Come Up with Better Stories | Client: Hexa Watches | Agency: Dunn&Co.

18 TRACY WONG, MARK "MONKEY" WATSON PLATINUM

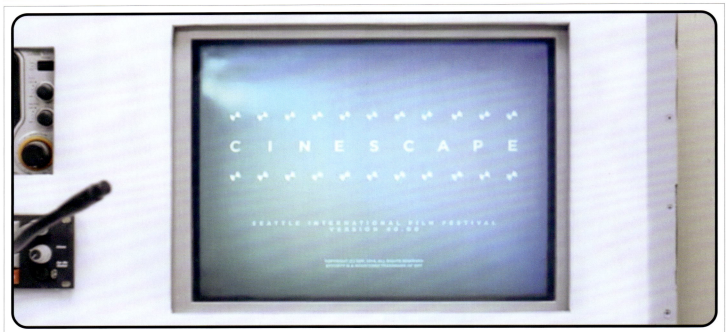

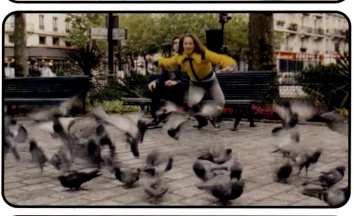
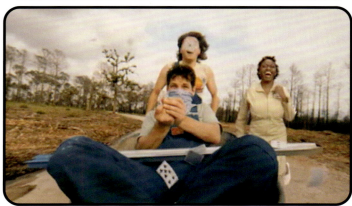

Title: Cinescape
Client: Seattle International Film Festival
Agency: WONGDOODY

19 STEVE MAPP, LYLE YETMAN **PLATINUM**

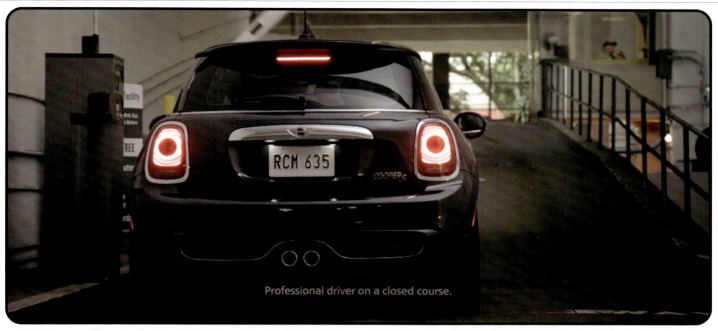
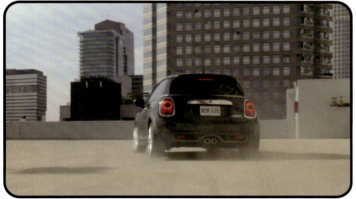

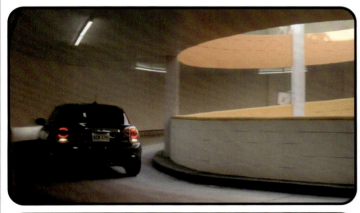

Title: Vertigo
Client: MINI
Agency: Butler, Shine, Stern & Partners

Graphis Judges

21 ADVERTISING AWARDS 2025 COMPETITION JUDGES

Scott Bucher | Traction Factory | President
Biography: Scott Bucher is the president of Traction Factory, an award-winning advertising, design, and marketing communications firm. They create strategic, dynamic work that thrives at the intersection of art and commerce. Their teams have earned over 100 Platinum, Gold, and Silver Graphis Awards and Graphis Master recognition.
Commentary: I really enjoyed being part of the talented judging panel for this year's Graphis Advertising Annual. In the decade Traction Factory teams have submitted work, we've gained valuable insights through the judging process. As an organization, our work has benefitted from a dispassionate, expert, third-party perspective. I hope that through my participation this year, I was able to pay that forward. I applaud the teams responsible for the work I saw this year. I found the strategic thinking that was the foundation of the best work to be especially impressive. Creativity is alive and well. That thought should encourage those of us who make our living as part of this community.

Steve Chavez | The Buntin Group | Executive Vice President, Managing Partner, & Chief Creative Officer
Biography: Steve Chavez is currently the executive vice president, managing partner, and chief creative officer of The Buntin Group, an independent advertising agency headquartered in Nashville, Tennessee. With over 30 years of experience, Steve's career is marked by influential leadership roles at some of the most iconic agencies in the industry, including the "Big 4" and, most recently, WPP's Garage Team Mazda. He has spearheaded campaigns for major brands like Mazda, GM, Amazon Kindle, and Pennzoil. Steve's ability to consistently deliver impactful, award-winning campaigns has made him a powerhouse in advertising, leaving a lasting mark on the global stage.
Commentary: Though there were inspiring examples of smart creative, insightful design, and slick visual storytelling, there weren't as many as I had hoped for when I began my two-day online journey as a judge for this year's Graphis Advertising Annual Competition, scrutinizing the advertising category. I've thought about this, trying to put my finger on the source of the problem. I think the culprit is time. We're all in a rush, me included. So let's make a pact and shake on it. Let's find the time to hone our craft, sweat the details, and expose the collective humanity we share from time to time, first for our clients and then for ourselves.

Quinnton Harris | Retrospect | Co-founder & CEO
Biography: Retrospect co-founder and chief executive officer Quinnton J. Harris is a creative leader and entrepreneur living in Brooklyn, New York. His new venture focuses on building products and digital experiences that are radical, culturally nuanced, and more accessible for untapped or overlooked market opportunities. Previously, he served as Publicis Sapient Group's creative director within experience design and co-leader of global computational design, which focused on evolving the organization's design systems practice. He played a critical role in accelerating CXO John Maeda's vision for fostering a more inclusive, multidimensional, and cohesive experience design capability. He also served as head of experience for San Francisco. In early 2020, he completed a short tenure as John Maeda's chief of staff, successfully pushing critical CXO initiatives, implementing systems for global collaboration, and enhancing internal communication strategies. Quinnton also led the #hellajuneteenth movement and got over 600 companies committed to observing Juneteenth as a paid holiday for its employees. Before joining Publicis Sapient, he served as inaugural creative director at Blavity, Inc., and before that, led design at Walker & Company Brands, a start-up consumer products and tech company notably acquired by Procter & Gamble. He is an MIT alum with an SB in mechanical engineering and dual minors in architecture and visual arts.
Commentary: The category submissions this year feature a wide range of topics and applications, mostly static and posters. The pieces that stood out were not only conceptually rich but executed in delightful and unexpected ways. My rankings for the work hinged on the novelty and the strength of message clarity. Is the copywriting good? Does it take me too long to feel something? Even if a campaign featured incredible visual design, excellent verbal design and semantics rose to the top. Some of the most standout pieces dealt with the uncomfortable truths of animal extinction and climate change.

Mike Kriefski | Shine United | President & Chief Creative Officer
Biography: Mike Kriefski's career of over 30 years is marked by equal parts diligent craftsmanship and inspired entrepreneurialism. After beginning his career as an assistant photographer, he transitioned to agency life at big and small companies, including time as an art director with Young & Rubicam. Mike co-founded Shine United in 2001. Under his leadership, what started as a boutique advertising and design shop has grown to a full-service creative, media, and production house. Mike has created transformative communications for brands like Harley-Davidson, Kohler, UW Health, Audi, and Mizuno. In addition to managing the agency and its creative output, Mike writes and directs TV and video content across a wide range of clients and categories.
Commentary: Big thanks to all who entered Graphis Advertising 2025. What an amazing privilege it was to review some of the most innovative and thought-provoking work in the industry. Each campaign felt like a true masterclass in storytelling and strategy—leaving me truly inspired. The level of thought, execution, and sheer passion was overwhelming—reminding me why creativity remains at the heart of this industry. Well done all.

Dan Magdich | Brunner | Vice President & Executive Creative Director
Biography: Dan Magdich is a rare creative—an artist turned advertiser who is intuitively strategic, creatively curious, and friendly as hell. While Dan serves as Brunner's VP and executive creative director, his past creative titles have included designer, art director, copywriter, filmmaker, illustrator, and author. As a "creative's creative," he believes every word, color, and visual builds more substantial brands. That belief is felt in his work for Church's Texas Chicken, YellaWood, Dairyland, Dick's Sporting Goods, Dropbox, Google, GNC, and more. Dan's favorite project is his not-safe-for-kids parenting memoir, *Hot Dog People and Other Bite-Size Sacrifices*.
Commentary: Graphis has been one of the go-to shows for inspiration throughout my career. After judging the 2025 Advertising show, I have a newfound level of admiration for the craft we love as creatives. The body of work across categories and mediums was inspiring as hell. I found myself watching, reading, reviewing, then rewatching, re-reading, and re-reviewing every single entry dozens of times. Regardless of the individual outcomes, the finalists should look back at their submissions with pride. You all killed it and made judging this annual incredibly difficult. Thank you for submitting your work. The heart you put into it shows.

Courtney Richardson | Droga5 | Creative Director
Biography: An award-winning and highly sought-after creative force, Courtney Richardson is a lauded creative director at Droga5, leading campaigns for influential brands, including Amazon Music, Chase Sapphire, Ad Council, The Africa Center, and others. She is also the founder of the Museum of Nail Art (MoNA), whose goal is to be an immersive destination highlighting trendsetting cultural influences regarding nail art as radical Black beauty. Opening its doors in spring 2025, she dedicates the concept of the MoNA to the diverse women of color she grew up around, who taught her: "Treat yourself. Never cheat yourself."
Commentary: For me, there were many high-ranking entries in the competition. "Better Angels: The Gospel According to Tammy Faye" had a truly beautiful and brilliant concept with an intentional design and art direction down to the very last detail. "RAY" was meticulously designed with stellar craft and a strong creative strategy and approach. "Voltari" had a sleek, bold, and confident tone and stunning photography, design, copywriting, and art direction, while "Man Eating Shark" was direct and compelling with provocative copy in the name of social impact.

Special care was taken to insure that they did not judge their own work.

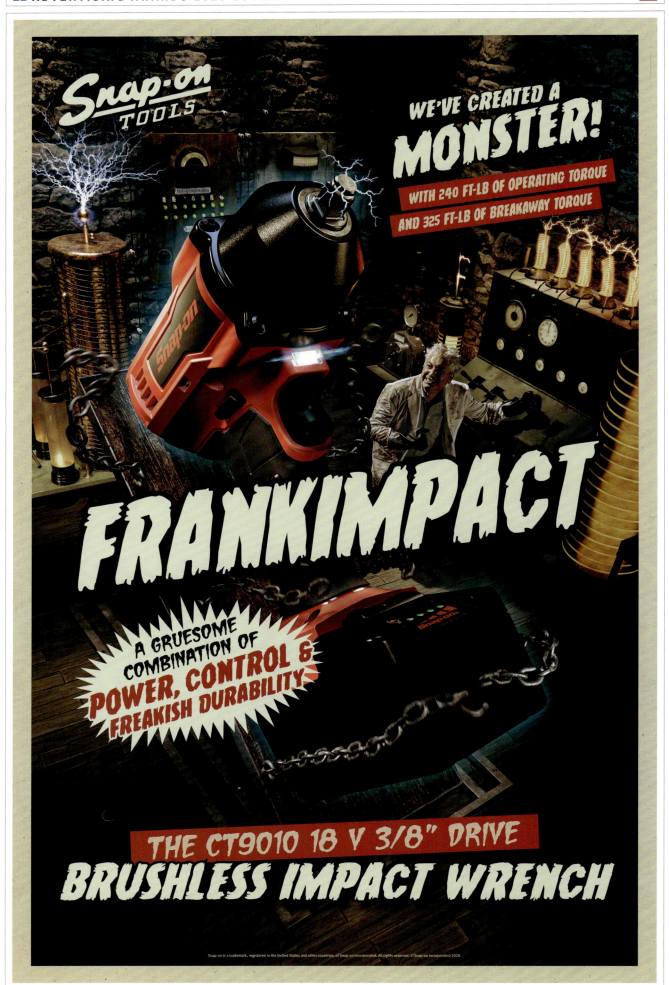

Title: Frankimpact | Client: Snap-on Tools | Agency: Traction Factory

24 ADVERTISING AWARDS 2025 JUDGE QUINNTON HARRIS

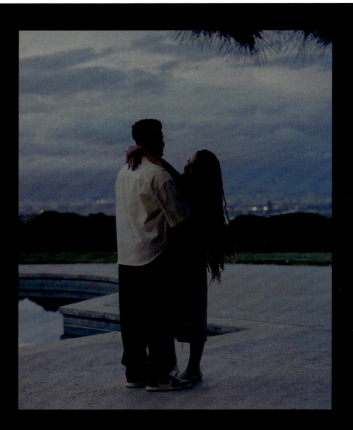

Title: SheaMoisture Black Men Love | **Clients:** SheaMoisture, Unilever | **Agencies:** Retrospect, Durable Goods, Thorpe Communications

25 ADVERTISING AWARDS 2025 JUDGE **MIKE KRIEFSKI**

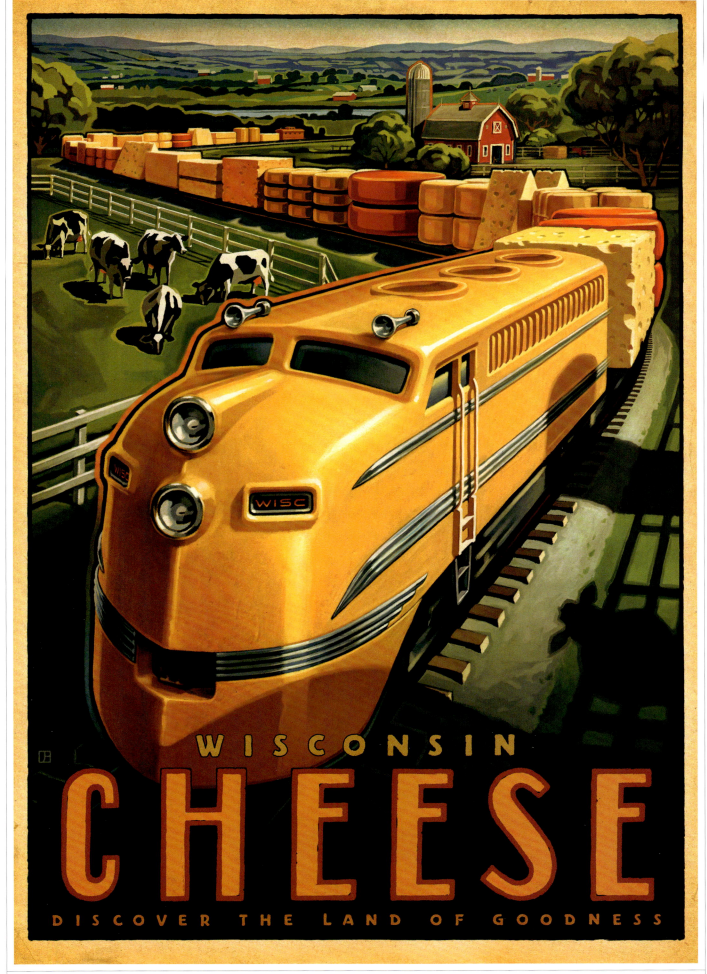

Title: Land of Goodness Campaign | **Client:** Wisconsin Cheese | **Agency:** Shine United

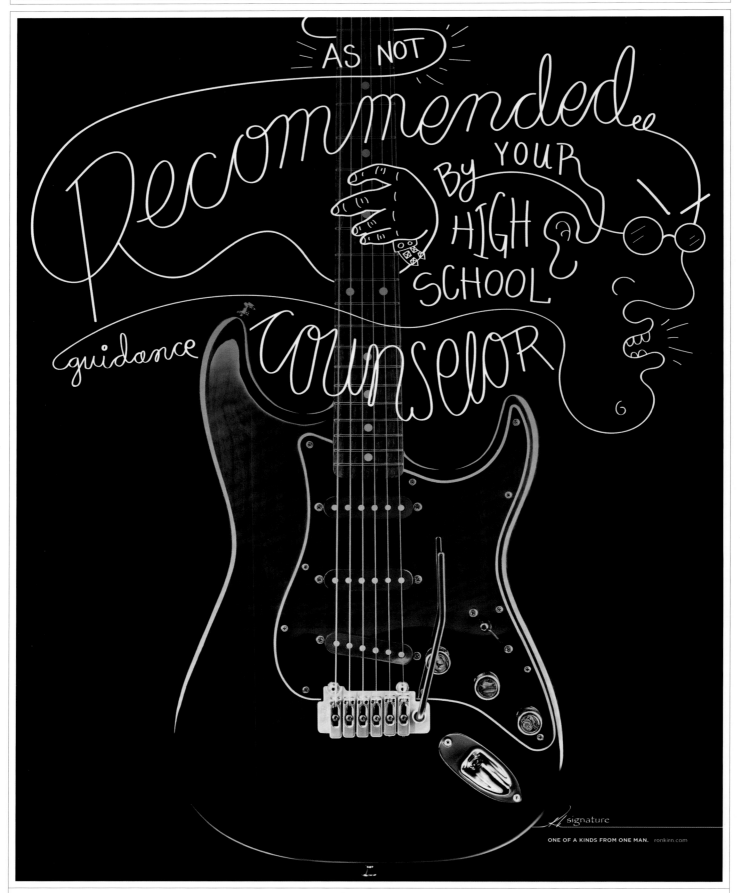

27 ADVERTISING AWARDS 2025 JUDGE COURTNEY RICHARDSON

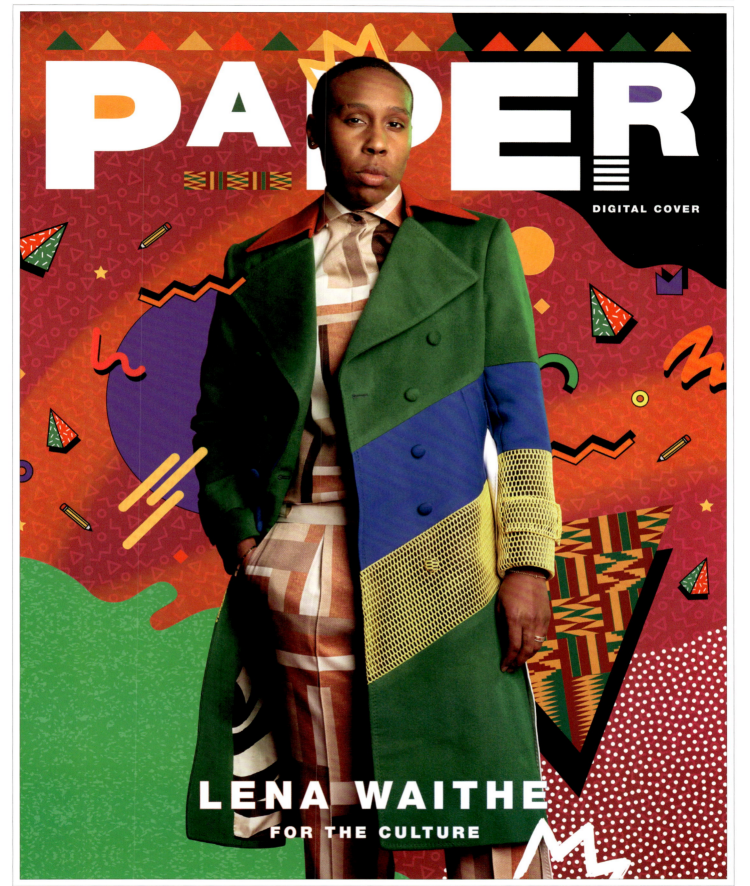

Title: For The Culture | Clients: Bet Networks, Viacom | Agency: PAPER

Graphis Platinum Awards

29 PLATINUM WINNERS

ARSONAL | Page: 30 | www.arsonal.com
Biography: ARSONAL is an advertising and design agency specializing in print and digital creative for the entertainment industry. Over 15+ years of service, they've launched hundreds of theatrical, television, and streaming content varying in size and scope. Their production and development teams are highly skilled and detailed within this fast-paced industry. Advertising and design are ARSONAL's passions, and they take pride in doing so with the highest level of service and creativity.

barlow.agency | Page: 31 | www.barlow.agency
Biography: Barlow.Agency was founded in Sydney, Australia, and is a creative design studio specializing in directing and designing key art for film studios, TV networks, streaming services, and more. Driven by a deep curiosity about pop culture and its evolving design trends, their vision is to deliver high-quality projects for major studio productions, independent films, and everything in between. Since its launch, Barlow.Agency has crafted key art campaigns for Netflix, Amazon Prime Video, Paramount+, Apple TV+, SBS, and others, earning multiple prestigious awards along the way, including the MUSE Creative Award and the Global Entertainment Award.

Canyon | Pages: 32-37 | www.canyondesigngroup.com
Biography: Canyon Design Group is an award-winning creative agency that has been in business for over 20 years. Collectively, their passionate and talented team of art directors, illustrators, storytellers, builders, conceptors, strategists, 3D and motion artists, photographers, and writers bring their unique points of view and skills to their clients' individual projects to design dynamic creative campaigns powered by captivating narratives.

PETROL Advertising | Pages: 38-41 | www.petrolad.com
Biography: PETROL Advertising offers industry-leading integrated marketing capabilities that connect exceptional brands to the communities they inspire. For more than 21 years, PETROL has been creating rocket fuel for brands on a global scale and has pioneered iconic creative and marketing strategies that make the target market want more. Whether it be growing a brand, promoting a new title, or launching a new property, PETROL consistently converts interest in their campaigns into success for their client partners.

Eight Sleep | Pages: 42-45 | www.eightsleep.com
Biography: Eight Sleep is the world's first sleep fitness company developing hardware, software, and AI technologies to improve sleep. Its signature product, the Pod, powers pro athletes and everyday high performers around the globe, including the top American tennis player Taylor Fritz, the EF pro cycling team, Lewis Hamilton, George Russell, Patrick Peterson, Brock Purdy, and Chelsea Gray. Eight Sleep was named one of *Fast Company*'s "Most Innovative Companies" in 2019, 2022, and 2023 and recognized two years in a row by *TIME*'s "Best Inventions of the Year."

Chang Liu | Freelance Designer | Pages: 46, 47
Biography: Chang Liu, born in Suzhou, China, draws inspiration from the serene beauty and Eastern aesthetics of his hometown. He is passionate about integrating these elements into his designs. A graduate of the School of Visual Arts in New York with a focus on design, Chang has also pursued diverse artistic studies in San Francisco and Milan, exploring fields such as interaction and fashion design. His design experience includes branding and packaging for Half Tea, where he merges traditional aesthetics with contemporary practices. Additionally, his work "Garbage Aesthetics" has been exhibited at the Suzhou Museum.

PPK | Pages: 48, 49 | www.uniteppk.com
Biography: Established in 2004 in Tampa, Florida, PPK is celebrating its 20th anniversary in business and is one of the Southeast's most decorated independent advertising agencies. It was founded on the belief that sound and creative strategy and communications plans coupled with true partnership and client collaboration will always deliver results. Regardless of the category or brand, PPK helps businesses overcome any challenge and takes them to the next level.

Michael Vanderbyl | **Vanderbyl Design** | Designer & Educator | Pages: 50, 51 | www.vanderbyl.com
Biography: Michael has achieved international prominence as a design practitioner, educator, and advocate. In 1973, he established Vanderbyl Design, working across the spectrum of print, digital, interior, and product design. In 1987, he was elected to the Alliance Graphique Internationale (AGI). In 2000, he received the AIGA Medal and, in 2012, was inducted into *Interior Design* magazine's Hall of Fame. Michael received the Lifetime Achievement Titan Award from the International Interior Design Association (IIDA) in 2014. As an educator, Michael acted as dean of the School of Design at California College of the Arts (CCA) and has taught for over 30 years.

Darkhorse Design | Pages: 52-55 | www.darkhorsedesign-usa.com
Biography: Darkhorse Design was founded in 2007 in spiritual Santa Fe, New Mexico, and is now based in the heartland of Lancaster County in Pennsylvania. This smart graphic design office is a globally experienced, multidisciplinary, award-winning graphic design studio that specializes in graphic design, logo design, brand identity, website development, digital media, advertising, consulting, strategic thinking, conceptual ideas, problem-solving, and e-commerce. Here, one will find creativity fueled by the surrounding beauty and passion for concept, design, and content that have become its trademarks, specializing in working with museums, charities, and clients with social responsibility. Its founder, Robert Talarczyk, has received over 200 career awards in design and photography.

Lewis Communications | Pages: 56, 57 | www.lewiscommunications.com
Biography: Lewis is a fiercely independent, internationally acclaimed, full-service creative ideas agency with over 100 team members in three offices across two states. Since 1951, every facet of who they are—the teams they've created, the services they've developed, and the way they work—has been built to equip their clients with the tools to take bold, decisive marketing actions to grow and promote their business.

Ogilvy Brazil | Pages: 156, 157 | www.ogilvy.com
Biography: Ogilvy Brazil is a leading and award-winning agency with global renown, having amassed recognition for its work from advertising festivals like Cannes Lions, London International Awards, the Clios, Effies, One Show, and many more. Guided by David Ogilvy's tenets of insatiable curiosity, creativity, and courage, the agency is now at the forefront of innovative ideas in the digital world, including social media, CRM, and content. It believes creativity is not only great for clients but essential as a competitive advantage, that awards matter because they strengthen our industry, and, like David himself said, "It keeps the cash register ringing."

Visit our Credits & Commentary section in the back of the book to read the full assignments, approaches, and results from this year's Platinum winners.

30 ARSONAL PLATINUM ENTERTAINMENT

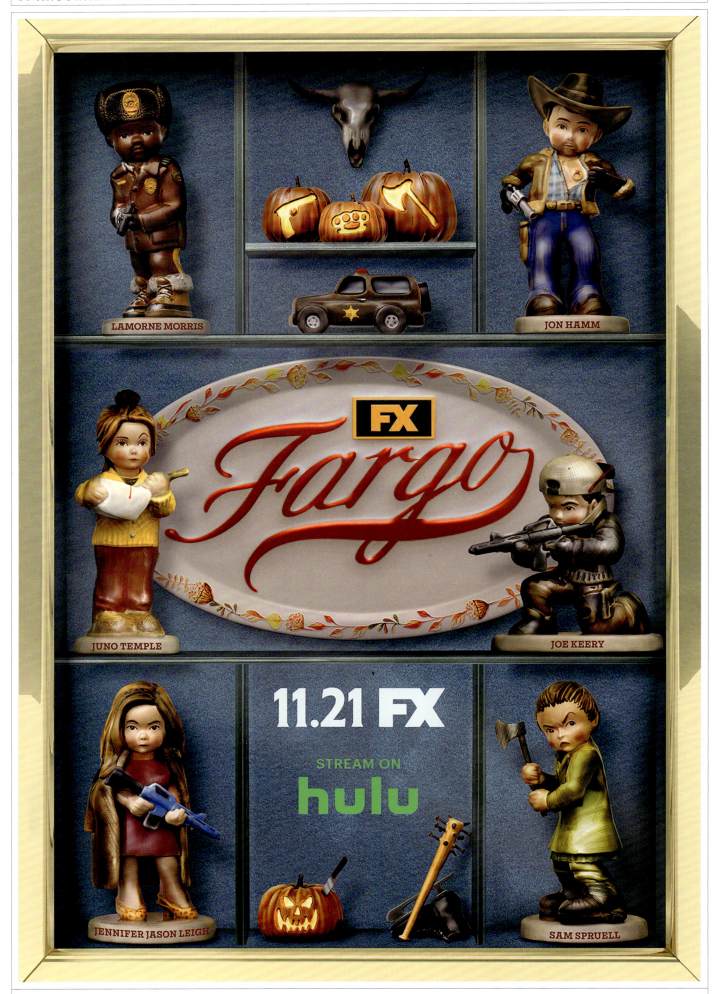

P177: Credit & Commentary | Title: Fargo | Client: FX Network | Agency: ARSONAL

32 CANYON PLATINUM FILM

P177: Credit & Commentary | Title: Life On Our Planet | Client: Netflix | Agency: Canyon | Image 1 of 4

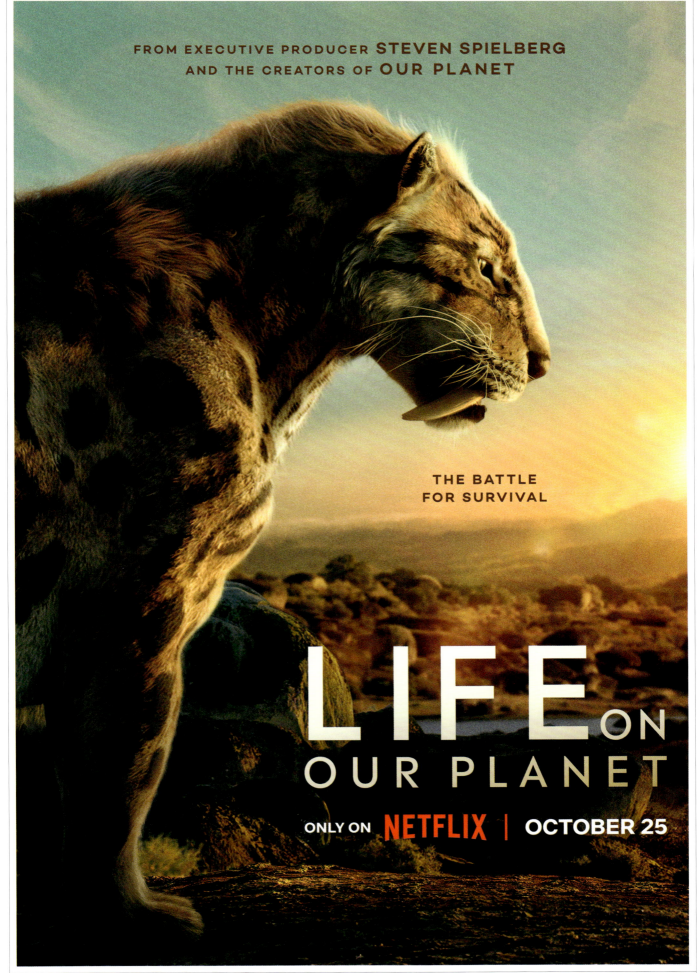

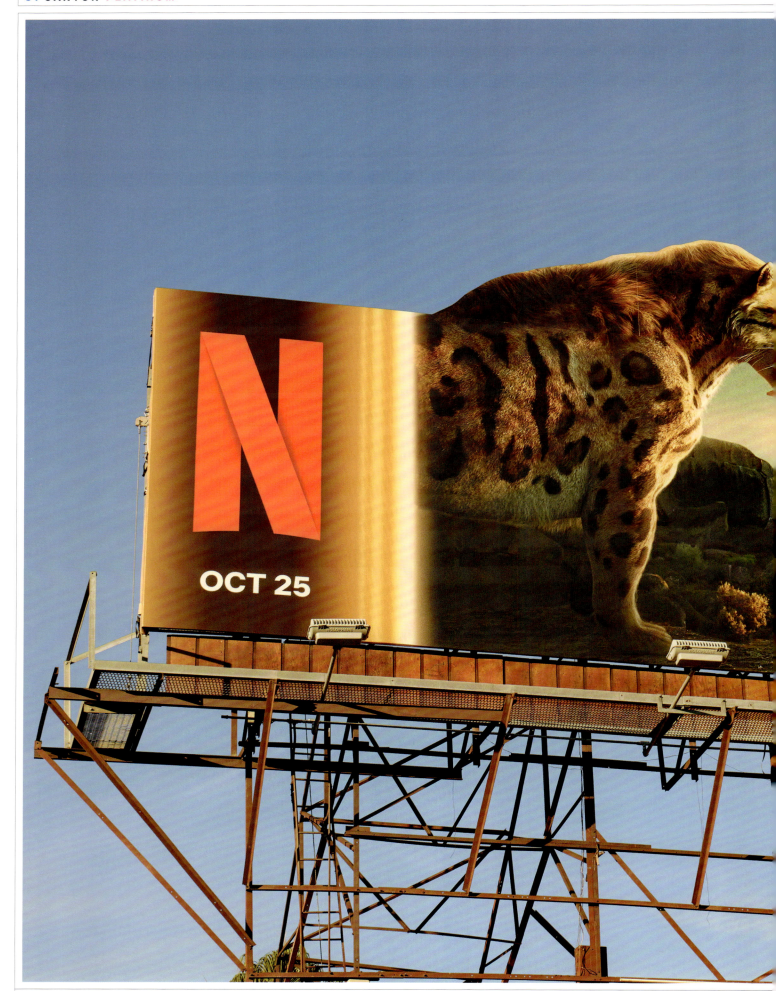

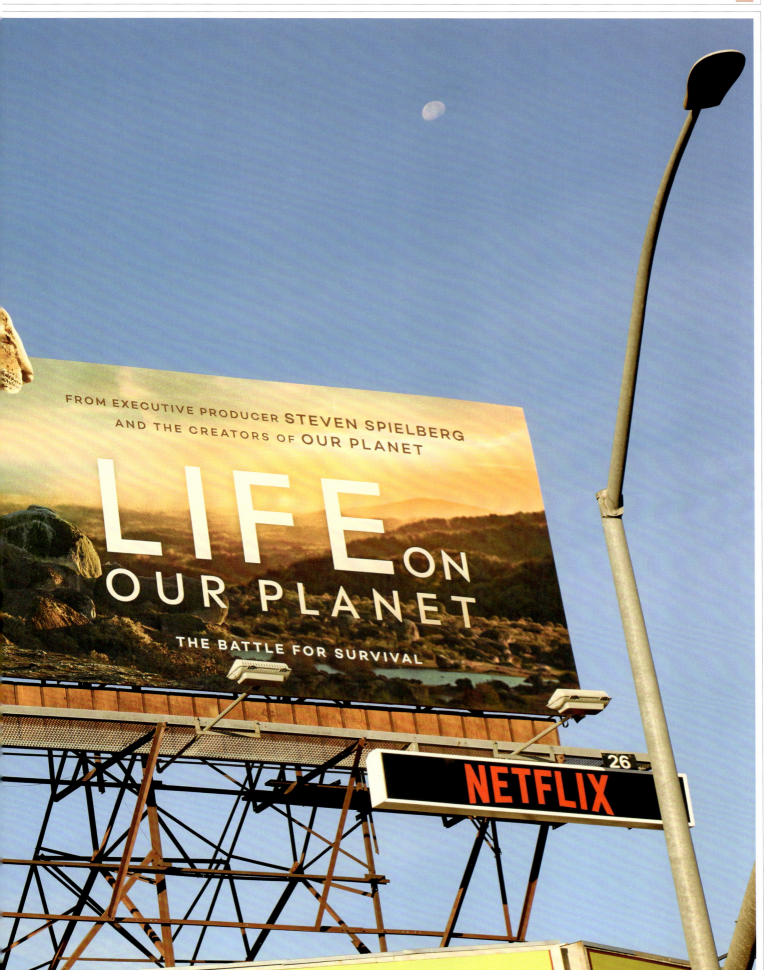

Title: Life On Our Planet | **Client:** Netflix | **Agency:** Canyon

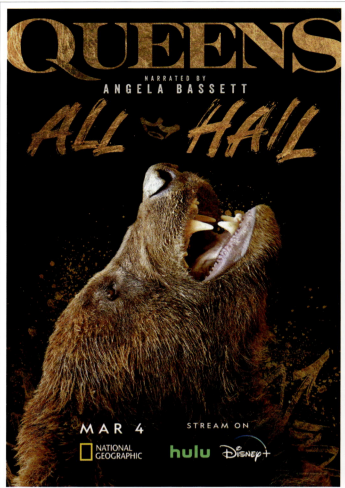
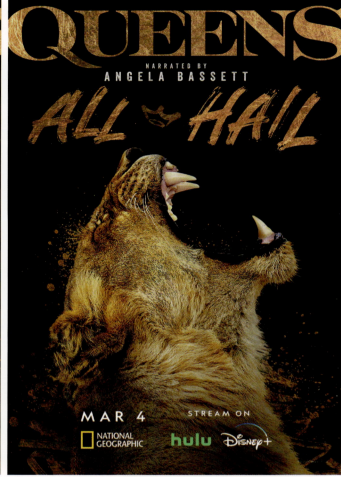
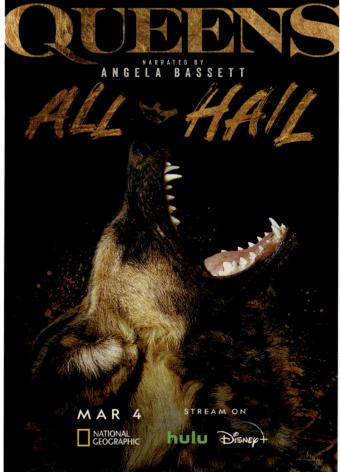
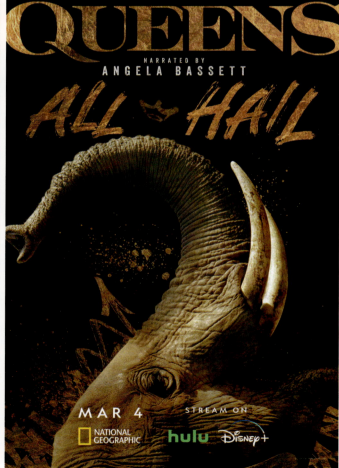

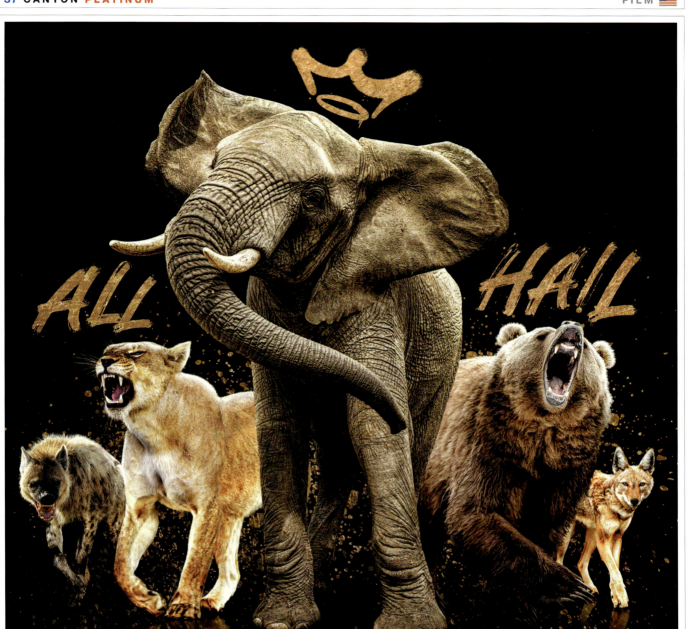

38 EMPTYVESSEL, PETROL ADVERTISING **PLATINUM**

GAMES

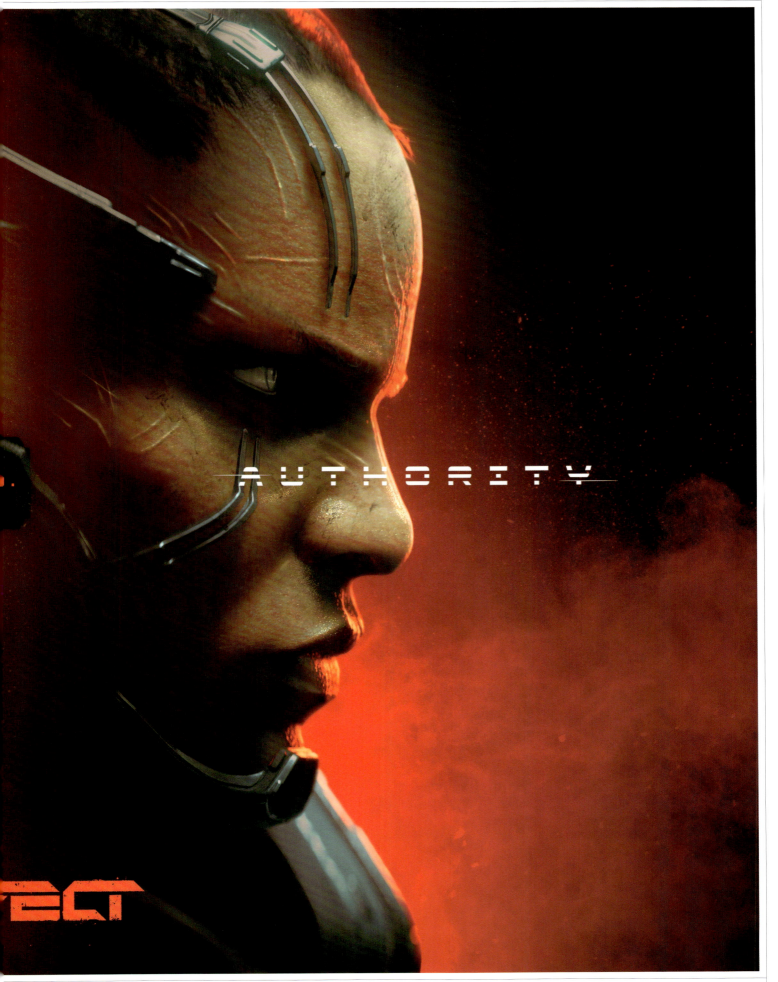

Title: **DEFECT - Announce Key Art Series** | Client: **EmptyVessel** | Agency: **PETROL Advertising**

40 **EMPTYVESSEL, PETROL ADVERTISING** PLATINUM

P177: Credit & Commentary | Image 2 of 4

GAMES

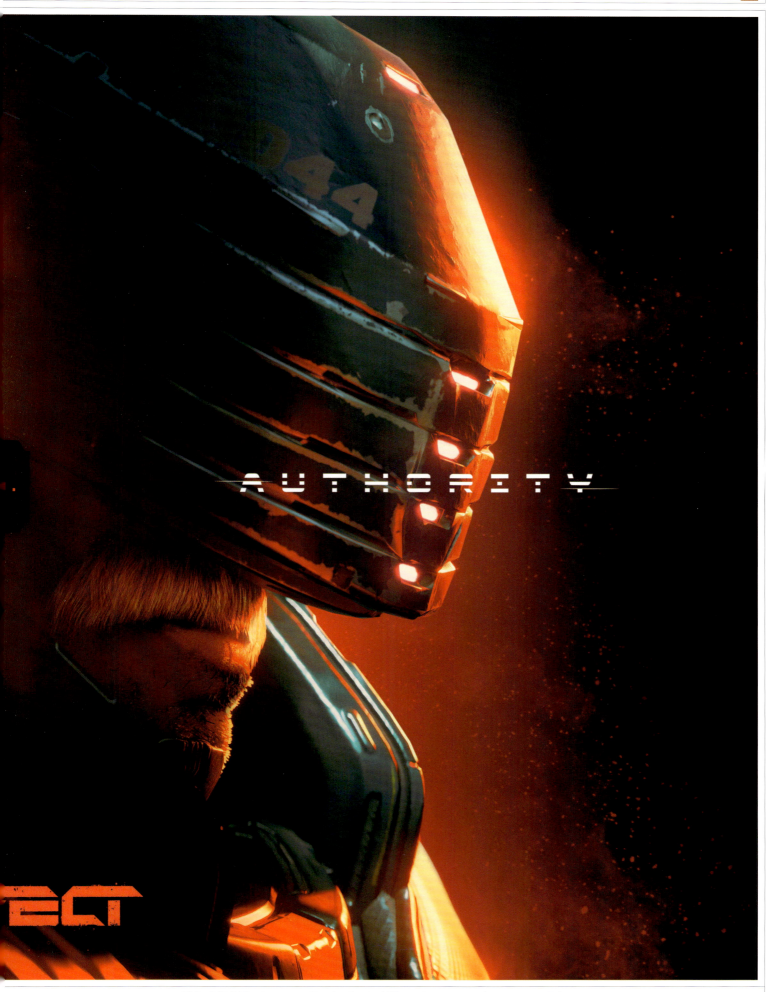

Title: DEFECT - Announce Key Art Series | **Client:** EmptyVessel | **Agency:** PETROL Advertising

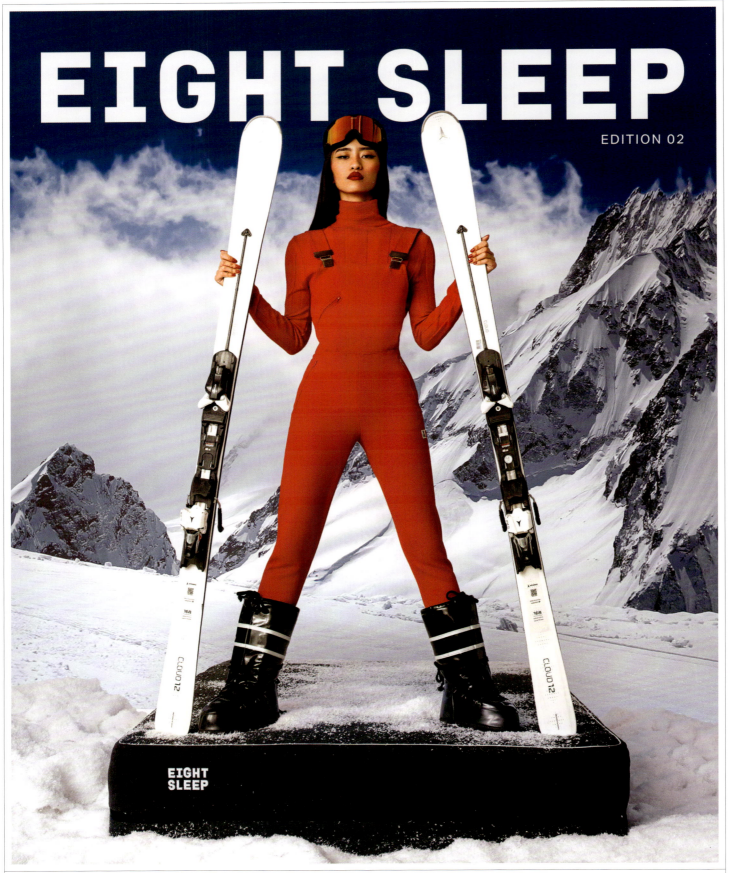

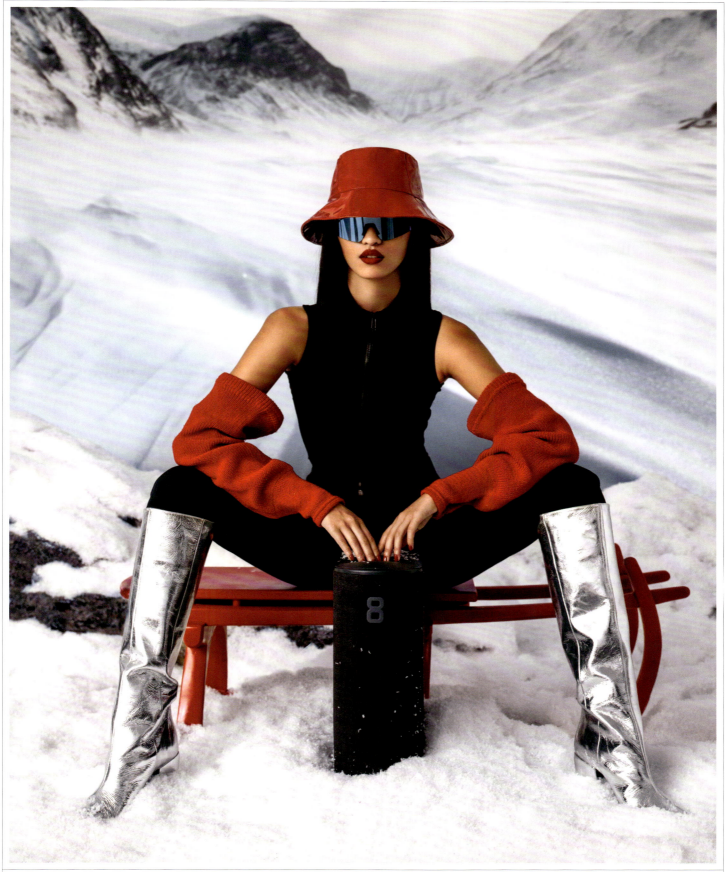

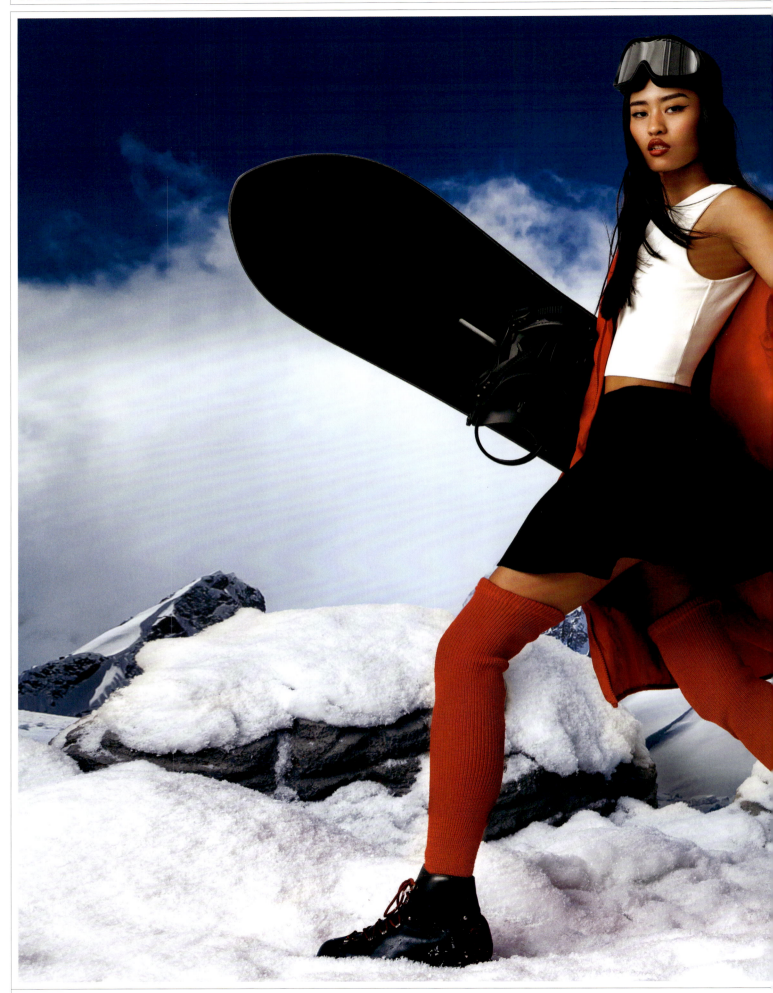

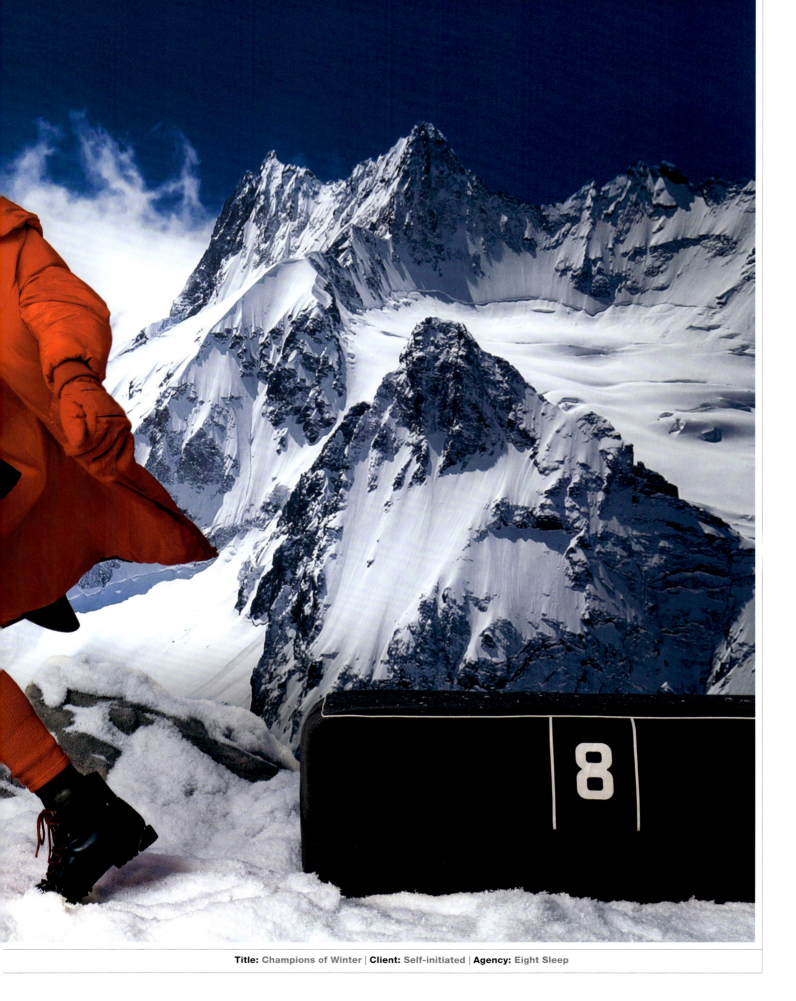

PRODUCT

Title: Champions of Winter | Client: Self-initiated | Agency: Eight Sleep

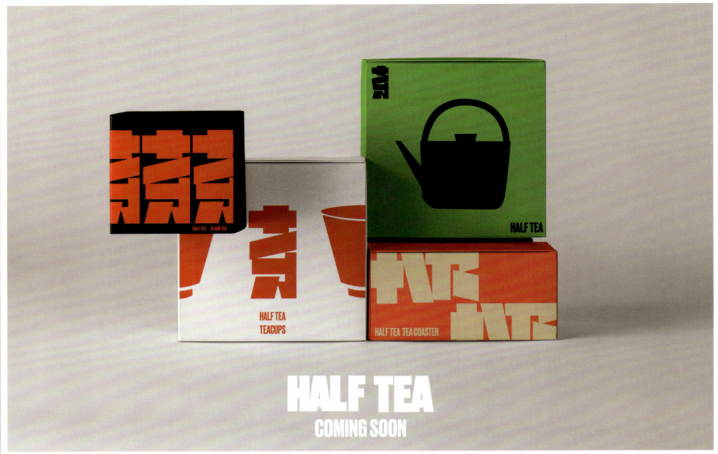
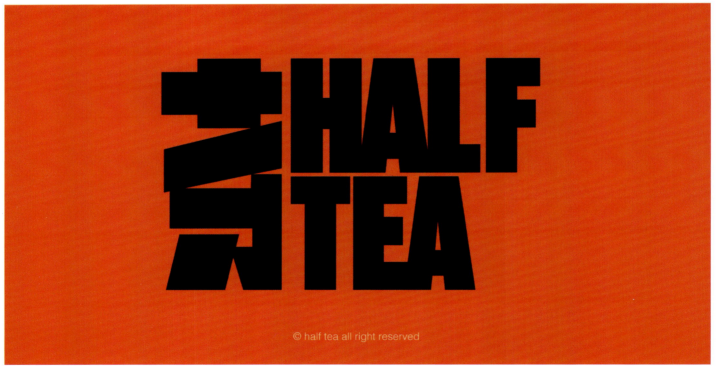

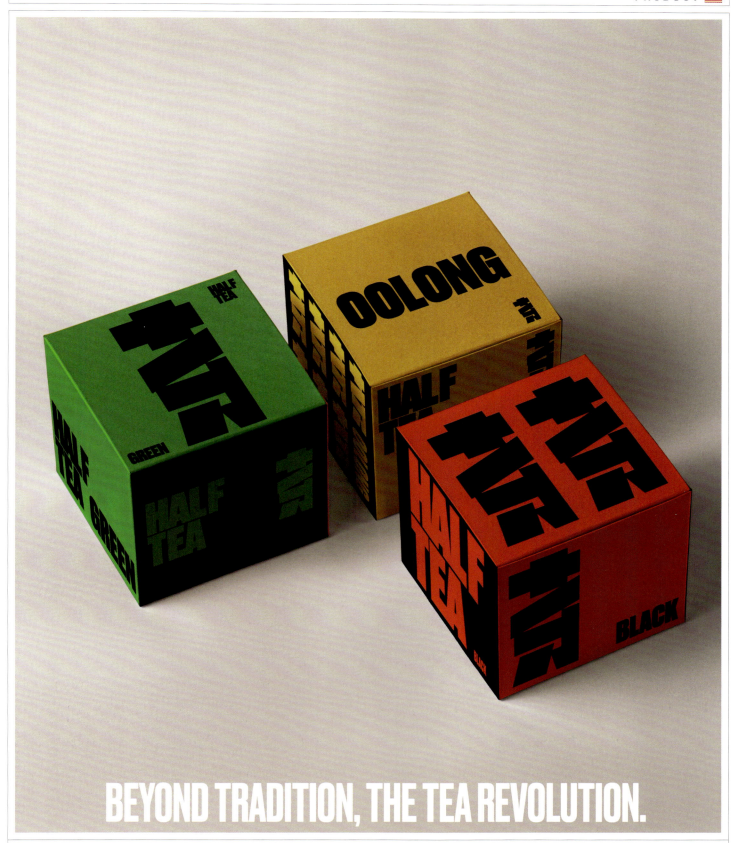

After
20
Incredible Years

of performing in the circus, they were going to give Leon something special for his retirement.

Stop the abuse of big cats.
Learn more at BigCatRescue.org

PUBLIC SERVICES

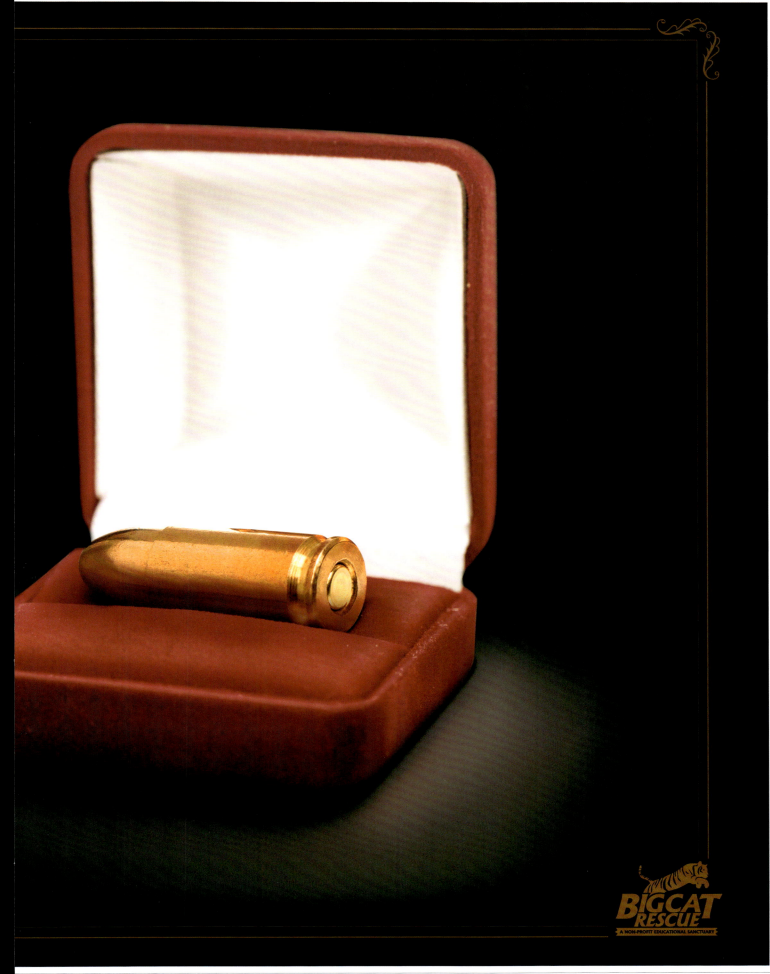

Title: Special Retirement Gift | **Client:** Big Cat Rescue | **Agency:** PPK

50 MICHAEL VANDERBYL PLATINUM

RETAIL

ARTERIORS**OUTDOOR**

ARTERIORS

THE FINE ART OF OUTDOOR LIVING | ARTERIORSHOME.COM/OUTDOOR

P177: Credit & Commentary **Title:** Arteriors Outdoor Advertising | **Client:** Arteriors | **Agency:** Vanderbyl Design

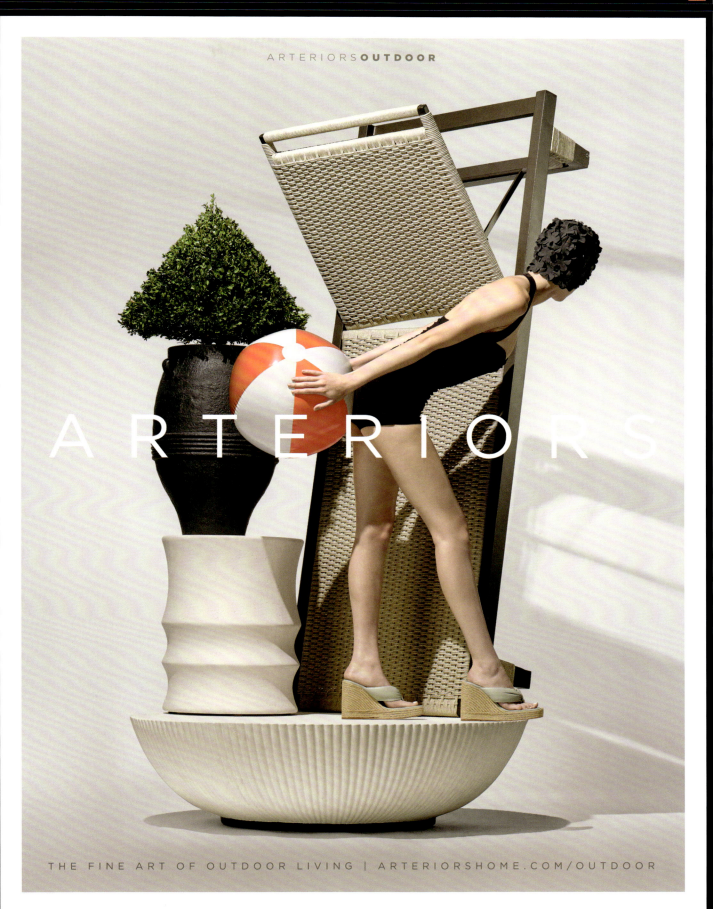

52 ROBERT TALARCZYK PLATINUM

WARBIRD

Readi

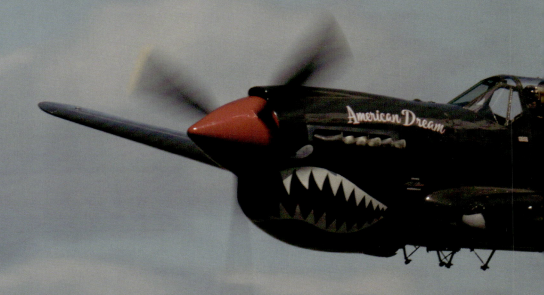

THE GRAPHIC DESIGN & PHOTO

Photographed By: Robert Talarczyk, HighAndMightyPhoto.Com Poster Design
"American Dream", TP-40N

SELF PROMOTION

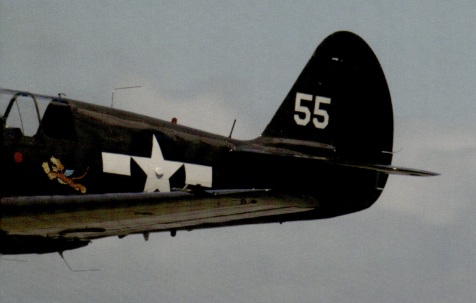

ATHERING

g, PA

RAPHY OF ROBERT TALARCZYK

bert Talarczyk, Darkhorse Design, Lancaster, PA., U.S.A. ©All Rights Reserved **DARKHORSEDESIGN**

rhawk, Pilot Thom Richard

Title: "Gathering of Warbirds & Vapor Plumes" | **Clients:** High And Mighty Photo.Com, Self-initiated | **Agency:** Darkhorse Design

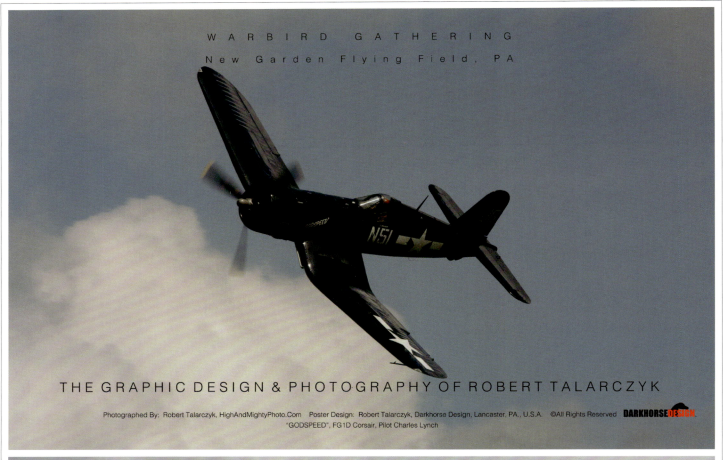
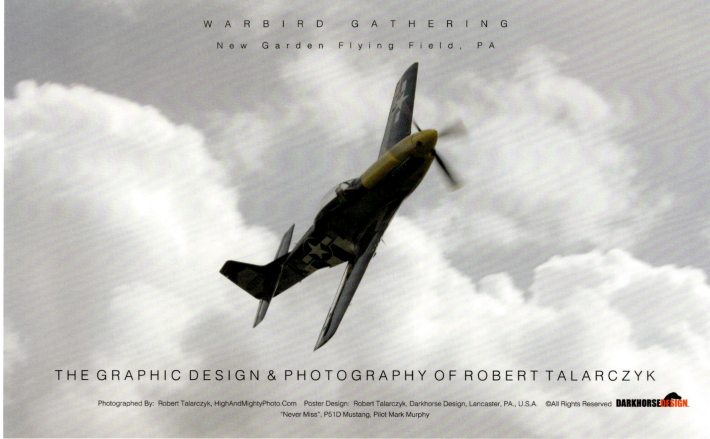

Title: "Gathering of Warbirds & Vapor Plumes" | **Clients:** High And Mighty Photo.Com, Self-initiated
Agency: Darkhorse Design | **P177:** Credit & Commentary | Images 2, 3 of 7

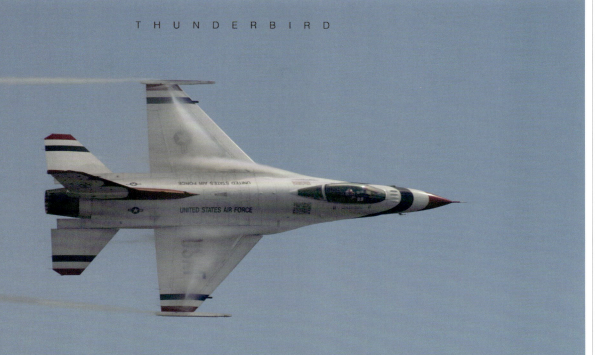
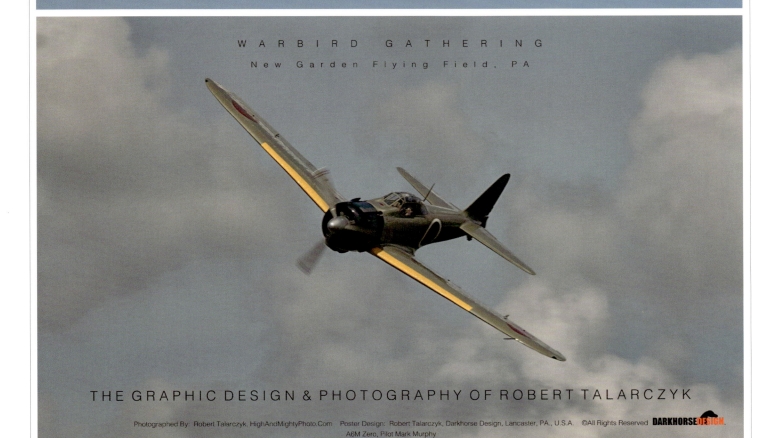

Title: "Gathering of Warbirds & Vapor Plumes" | Clients: High And Mighty Photo.Com, Self-initiated
Agency: Darkhorse Design | P177: Credit & Commentary | Images 4, 5 of 7

57 ROY BURNS III PLATINUM

TRAVEL 🇺🇸

No. of people who *enter Kentucky* in search of better bourbon:

2,137,034

No. of people who *leave Kentucky* in search of better bourbon:

Zero

KENTUCKY BOURBON TRAIL®

The world's most *beloved* Bourbon experience.
KYBOURBONTRAIL.COM

SCAN HERE TO
Build Your Own
Bourbon Trail™

©2024 Kentucky Distillers' Association. All rights reserved. Enjoy Bourbon like a true Kentuckian — Responsibly.

Title: Kentucky Bourbon Trail — Posters | **Client:** Kentucky Distillers' Association
Agency: Lewis Communications | **P177:** Credit & Commentary

Graphis Gold Awards

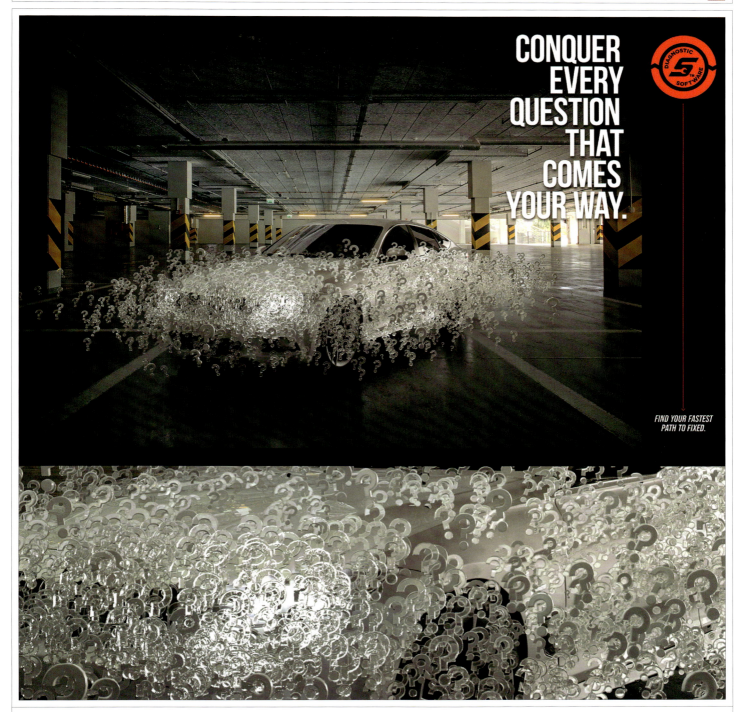

P177: Credit & Commentary | Title: Questions Conquered | Client: Snap-on Diagnostics | Agency: Traction Factory

TESLA

DESIGN STUDIO
15 Years Anniversary

AUTOMOTIVE

Title: Tesla Design Studio 15 Years Anniversary | **Client:** Tesla Design Studio | **Agency:** Qianzi Chao

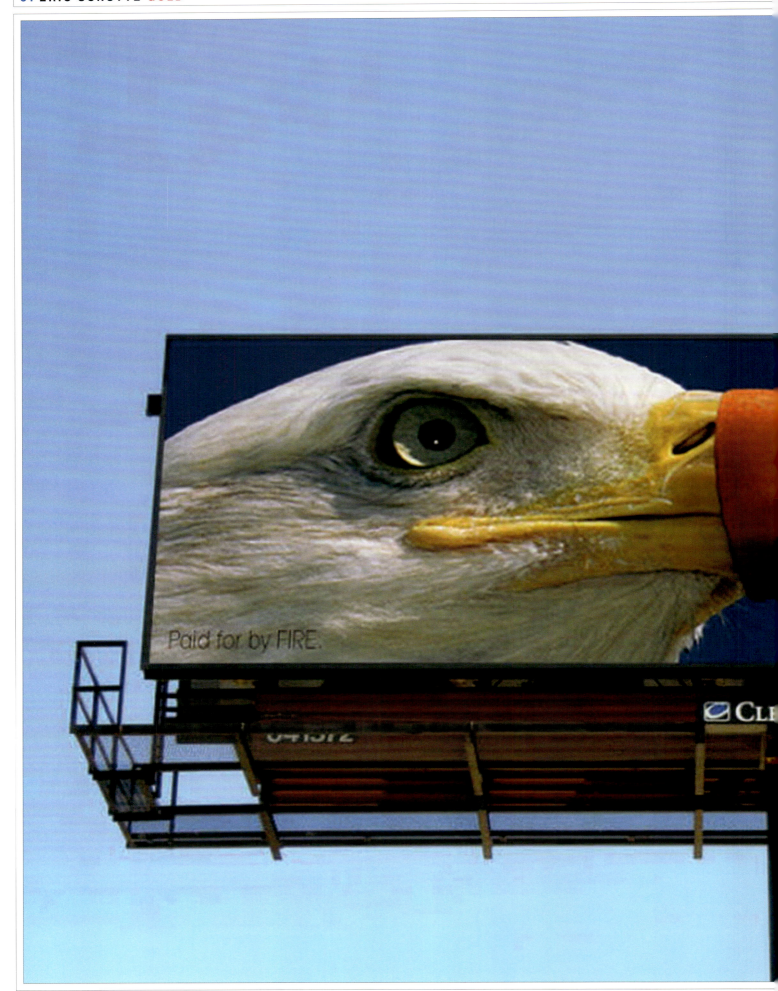

Title: FIRE Out of Home | **Client:** Foundation for Individual Rights in Education | **Agency:** DeVito/Verdi

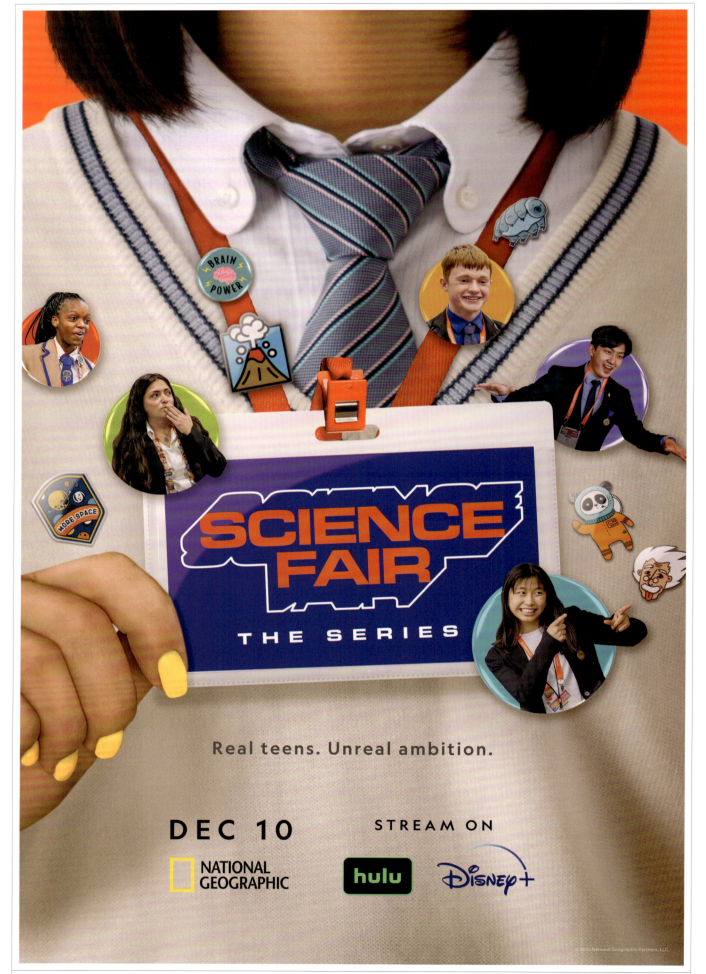

67 SJI ASSOCIATES GOLD BROADCAST

Title: Secrets of the Octopus | **Clients:** National Geographic, Chris Spencer, Brian Everett, Mariano Barreiro, Leah Wojda
Agency: SJI Associates | **P177:** Credit & Commentary

68 GASTDESIGN GOLD

CORPORATE

Es geht nicht immer geradeaus

Wenn sich Ihre finanzielle Situation anders entwickelt als erwartet. Wir schaffen Perspektiven – unternehmerisch und persönlich.

www.nst-inso.com

NST NIERING STOCK TÖMP RECHTSANWÄLTE

Title: Life Doesn't Always Go Straight Ahead | **Client:** NST Lawyers
Agency: Gastdesign | **P177:** Credit & Commentary

69 ARSONAL, FX NETWORK **GOLD**

ENTERTAINMENT

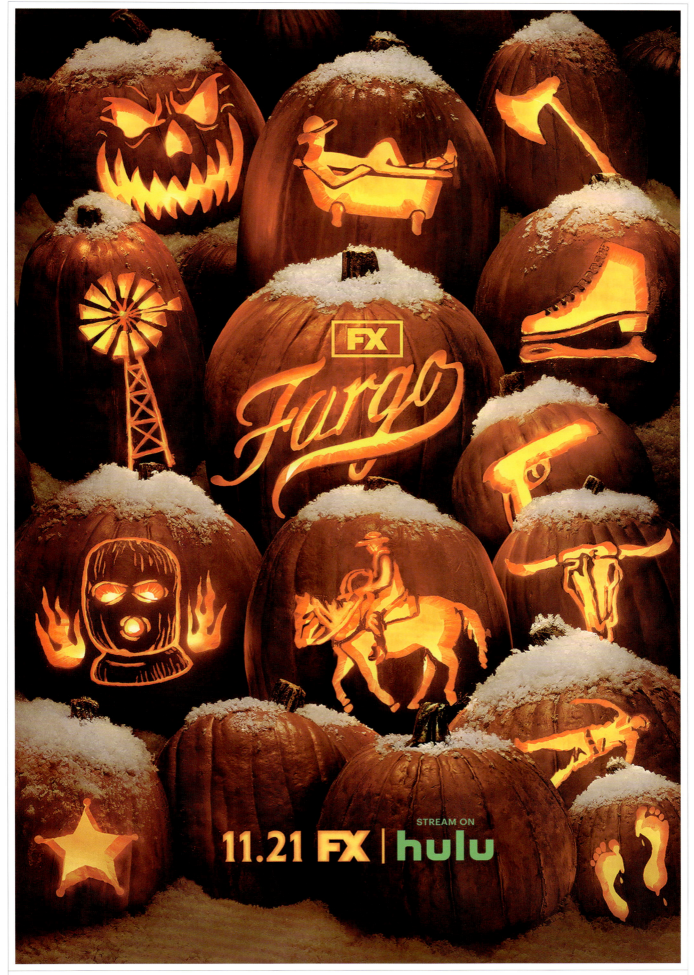

Title: Fargo | Client: FX Network
Agency: ARSONAL | P178: Credit & Commentary

70 RON TAFT GOLD

ENTERTAINMENT

Before

Wilt The Stilt

Earl The Pearl

Clyde The Glide

The Big O

Magic

Air

The Splash Brothers

And The King

There was just a Basket

A Ball

A Dream

And A Team

TRAILBLAZERS
THE SERIES

media
venture
television

Title: **TRAILBLAZERS** | Client: Creative Projects Group
Agency: Ron Taft Brand Innovation & Media Arts | P178: Credit & Commentary

71 CÉLIE CADIEUX GOLD ENTERTAINMENT

Title: Better Angels: The Gospel According to Tammy Faye | Client: Vice Studios
Agency: Célie Cadieux | P178: Credit & Commentary

72 ARSONAL, HBO GOLD

P178: Credit & Commentary

The pieces that stood out to me were not only conceptually rich but they were also executed in delightful and unexpected ways.

Quinnton Harris, *Co-founder & CEO, Retrospect*

ENTERTAINMENT

Title: **HOUSE OF THE DRAGON** | Client: **HBO** | Agency: **ARSONAL**

The level of thought, execution, and sheer passion was overwhelming. It reminds me of why creativity remains at the heart of this industry.

Mike Kriefski, *President & Chief Creative Officer, Shine United*

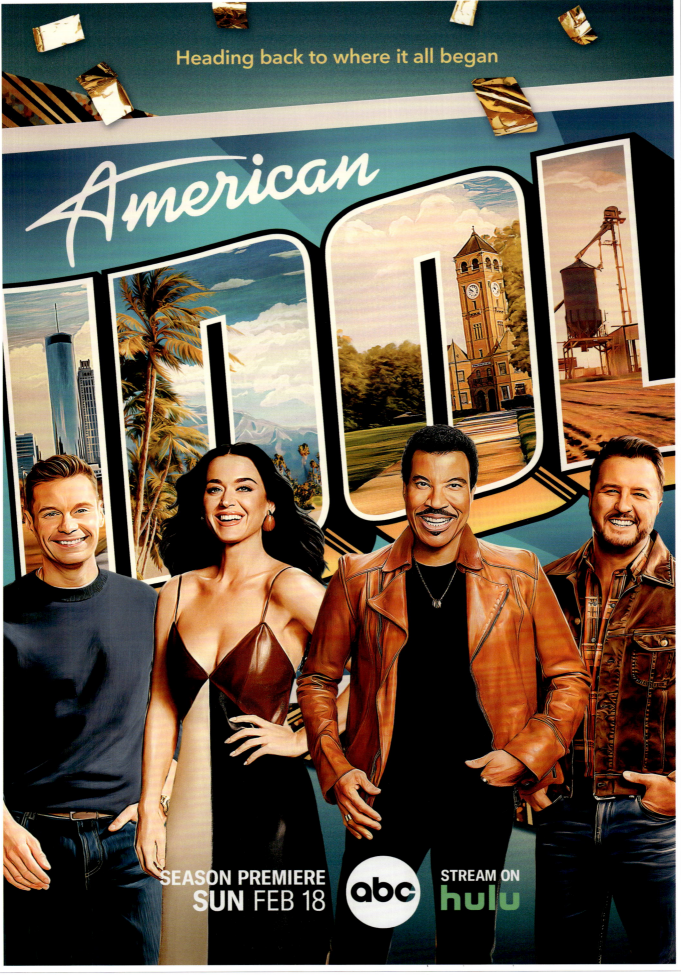

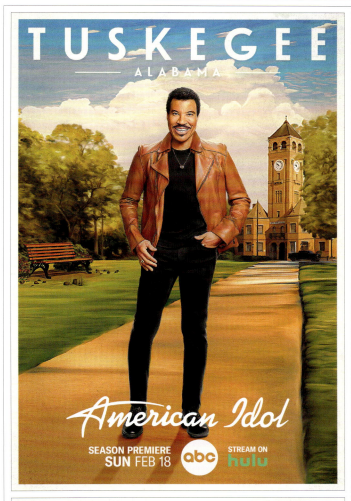
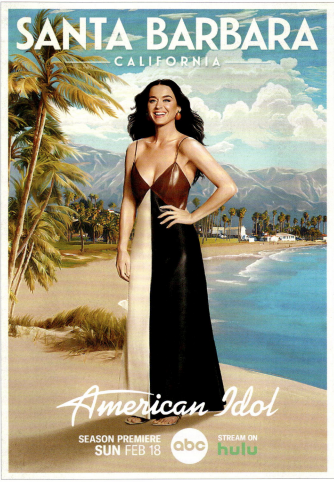
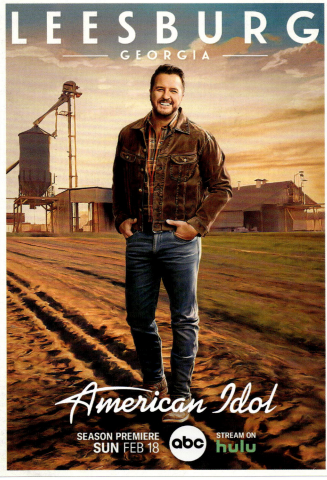
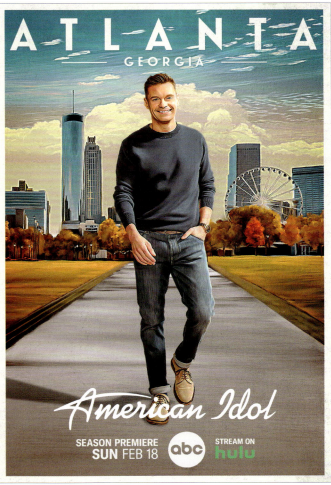

76 TODD WATTS, NICK FOX **GOLD** ENTERTAINMENT

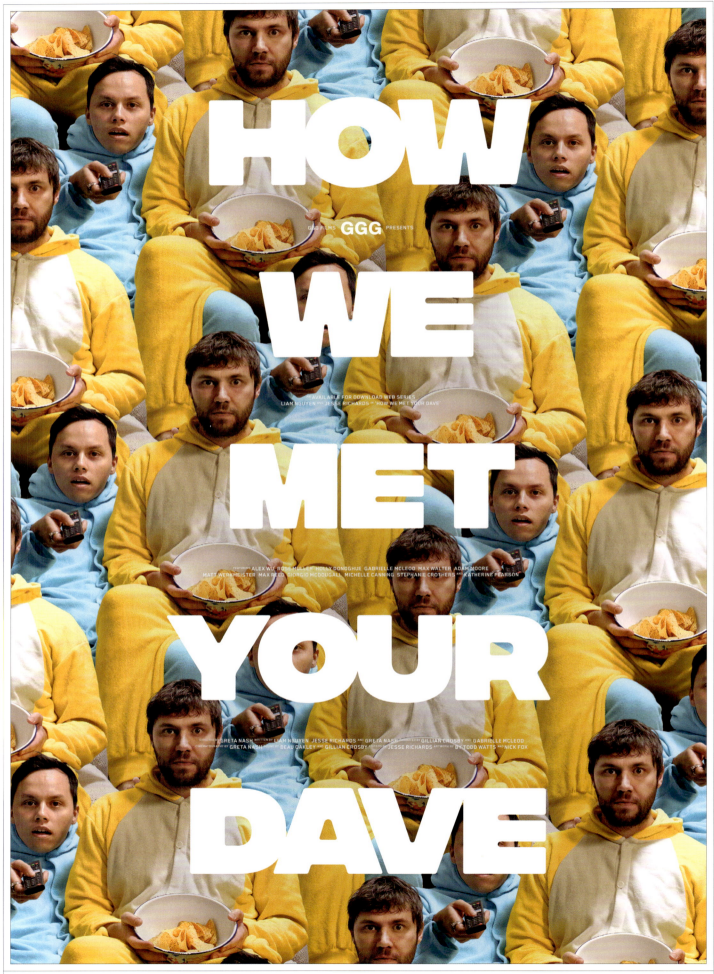

Title: How We Met Your Dave | **Client:** Available For Download
Agency: Todd Watts & Nick Fox | **P178:** Credit & Commentary

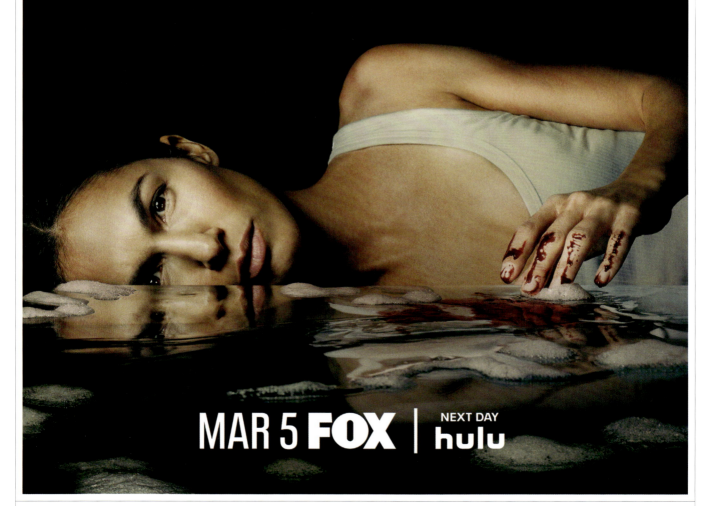

78 ARSONAL, HBO MAX **GOLD** ENTERTAINMENT 🇺🇸

P178: Credit & Commentary **Title:** True Detective Night Country | **Client:** HBO Max | **Agency:** ARSONAL

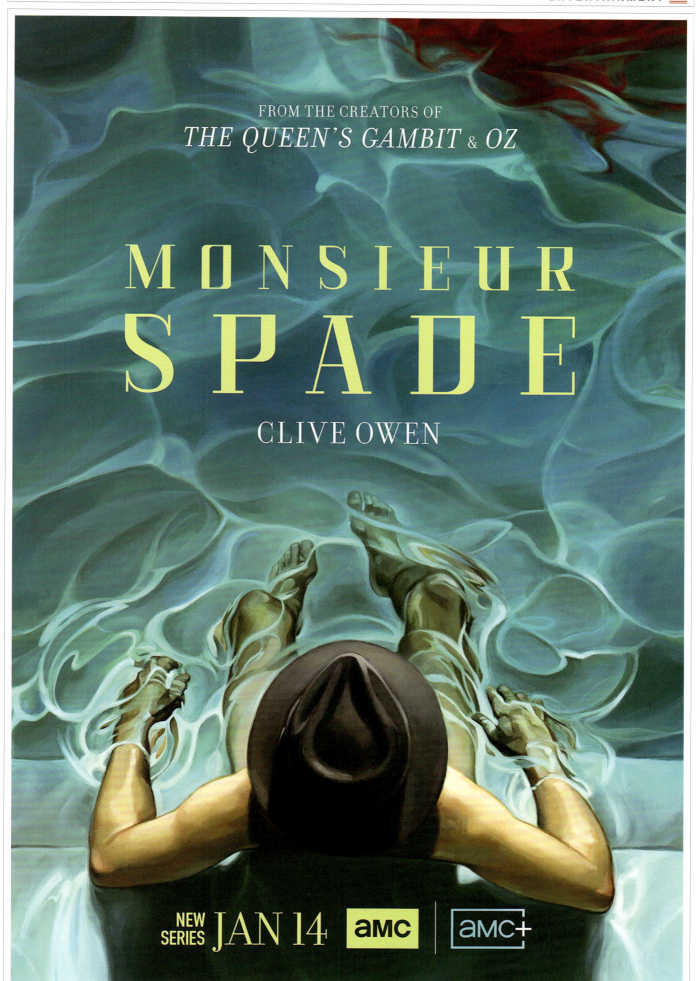

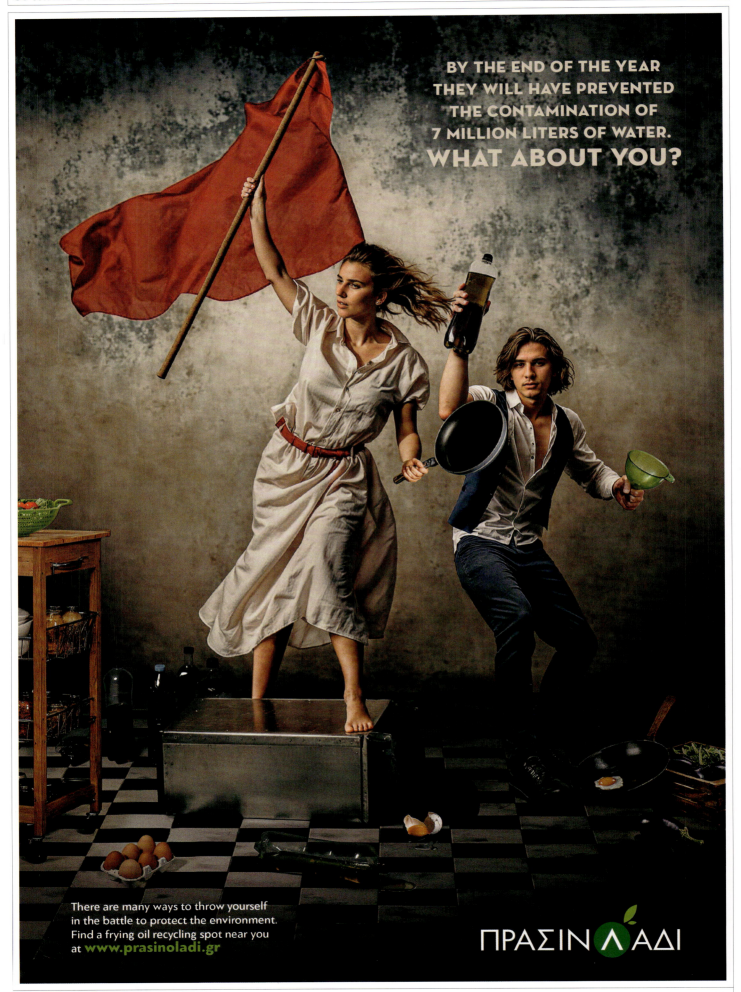

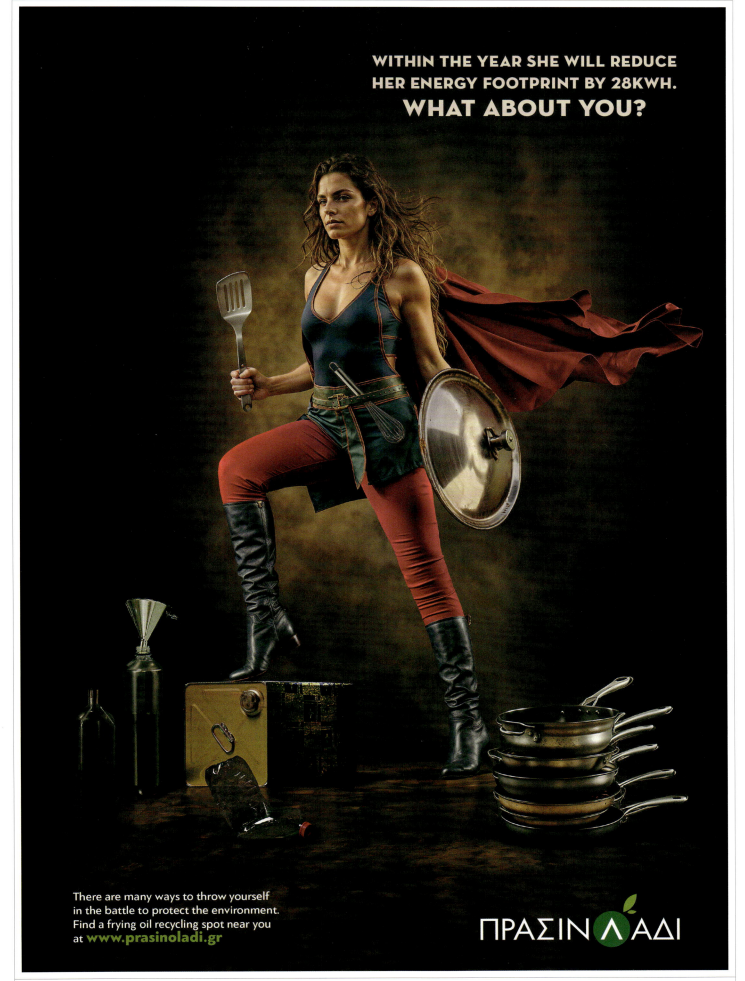

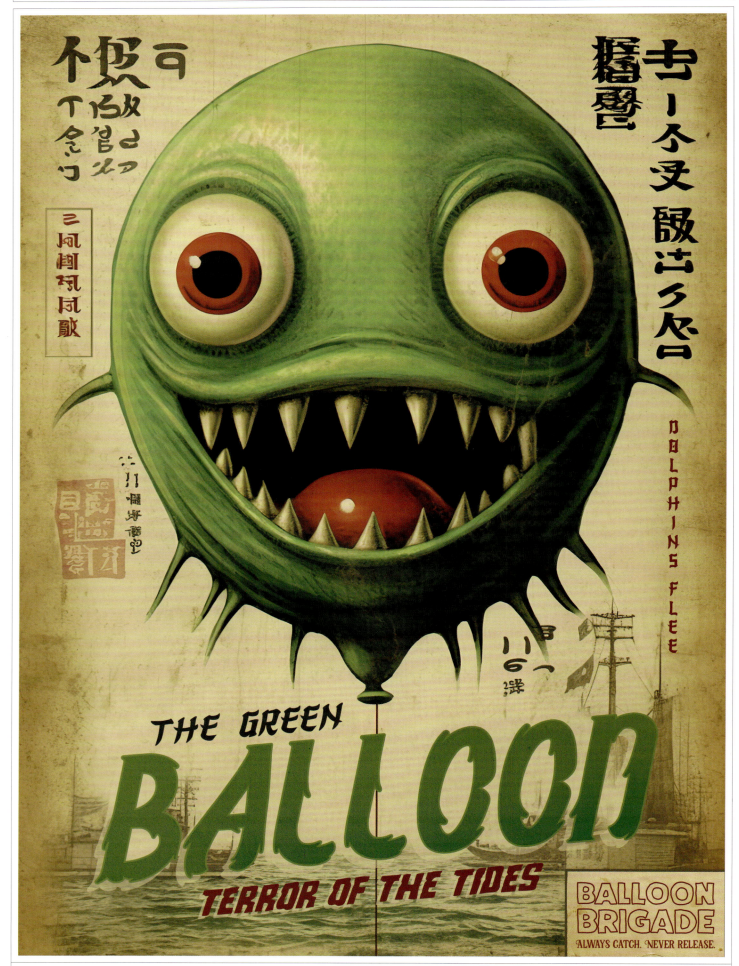

83 LEE WALTERS, SHANE HUTTON GOLD — ENVIRONMENTAL

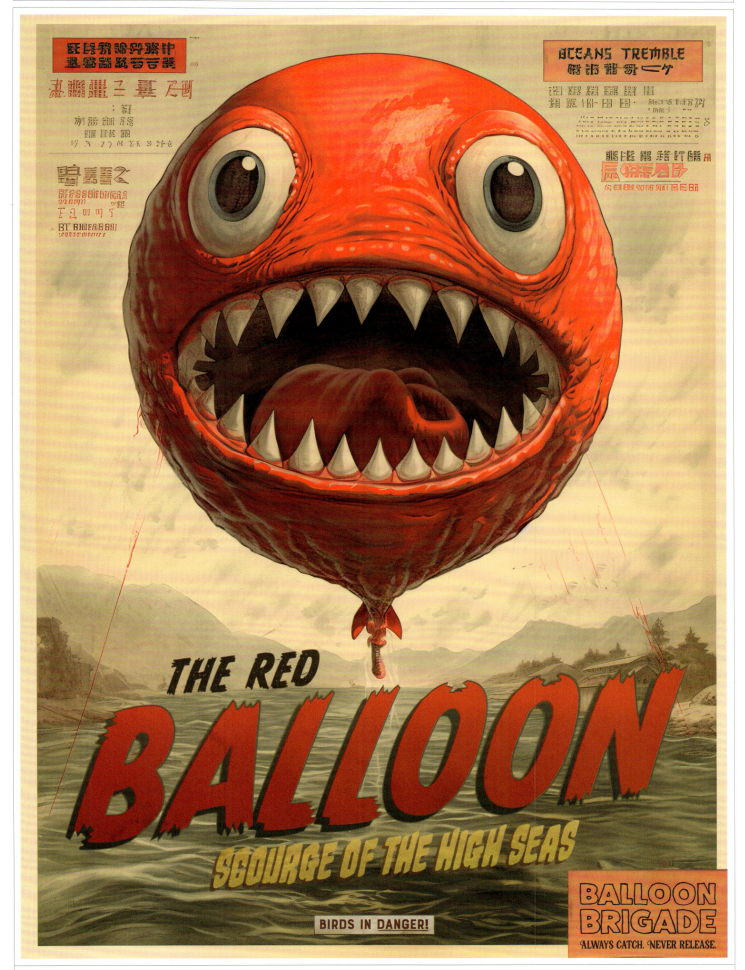

Title: Balloons are Monsters | Client: Balloon Brigade | Agency: Arcana Academy

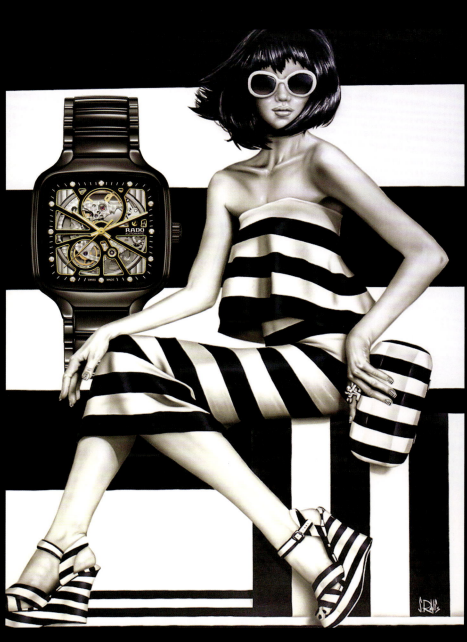

85 ARIEL FREANER GOLD — EVENTS

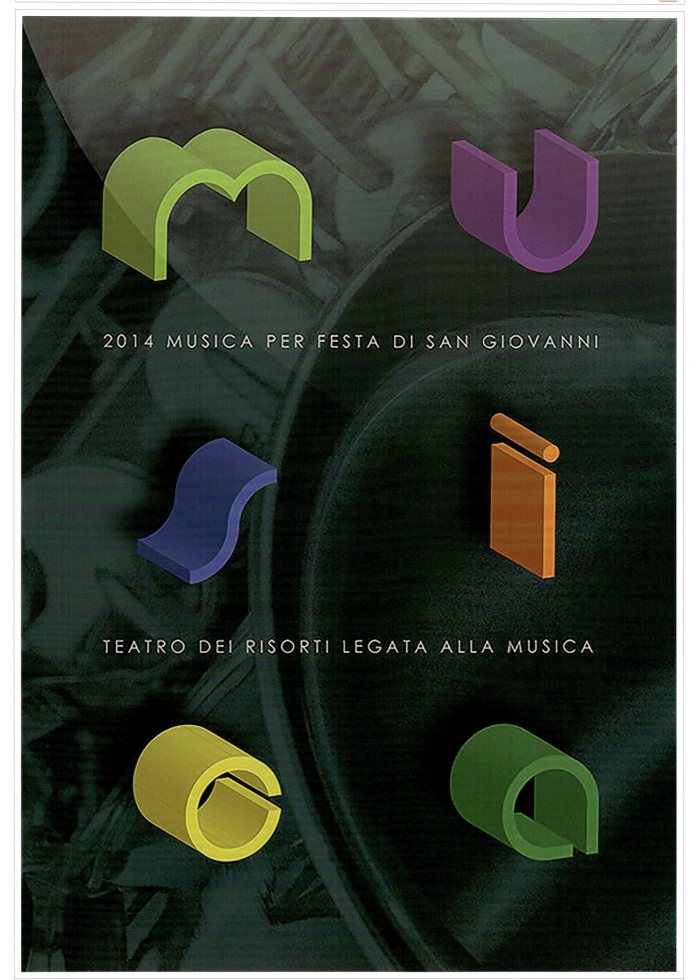

Title: Radicondoli Music Concert Poster | Client: City of Radicondoli, Italy
Agency: Freaner Creative & Design | P178: Credit & Commentary

86 MY.GAMES, PETROL ADVERTISING GOLD

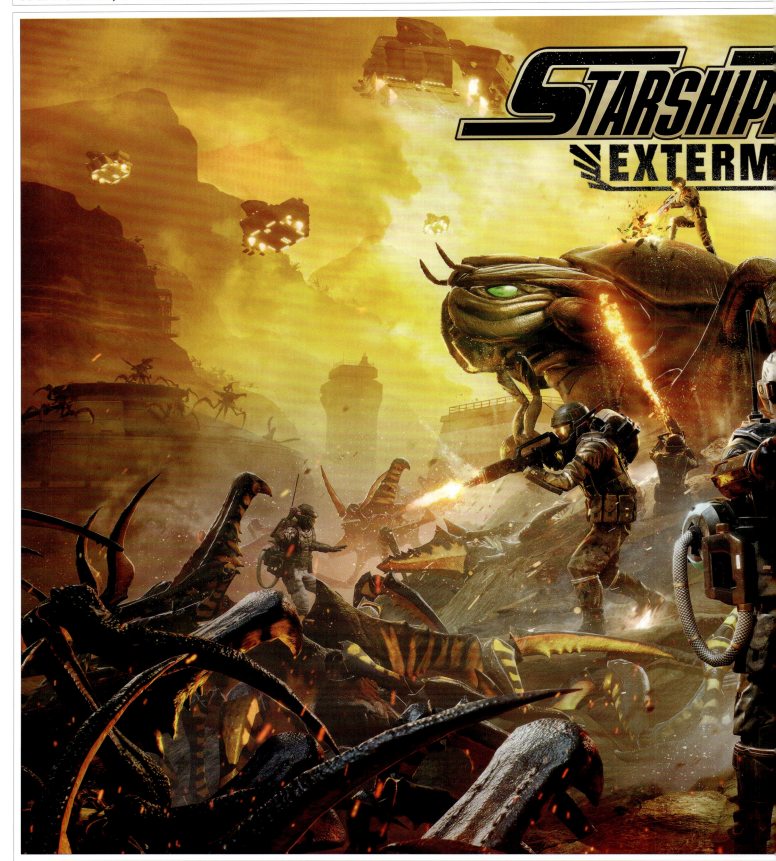

P178: Credit & Commentary

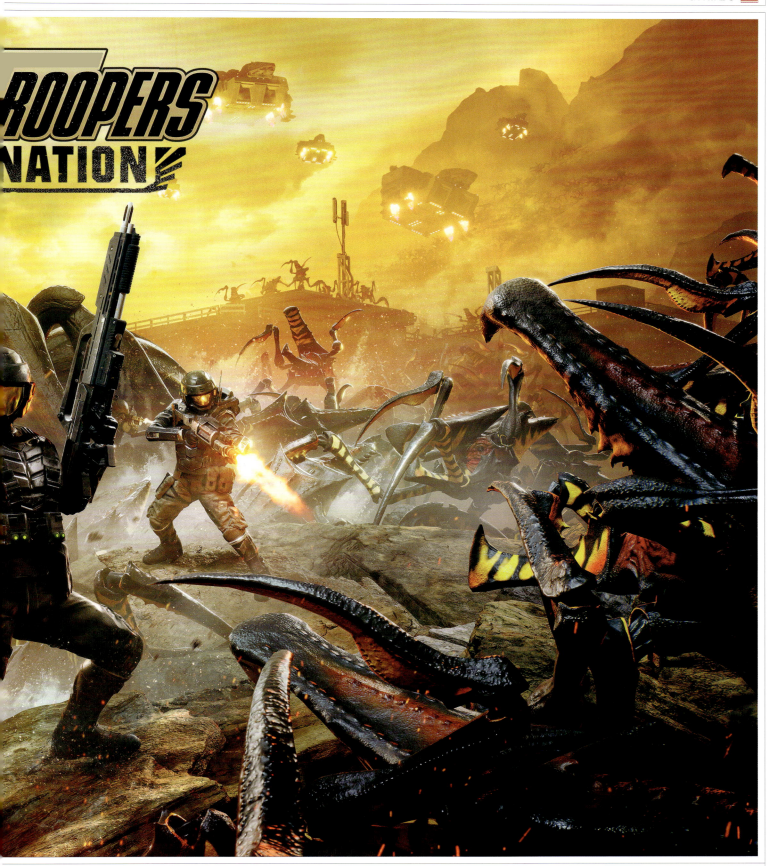

Title: Starship Troopers: Extermination Key Art | **Client:** My.Games | **Agency:** PETROL Advertising

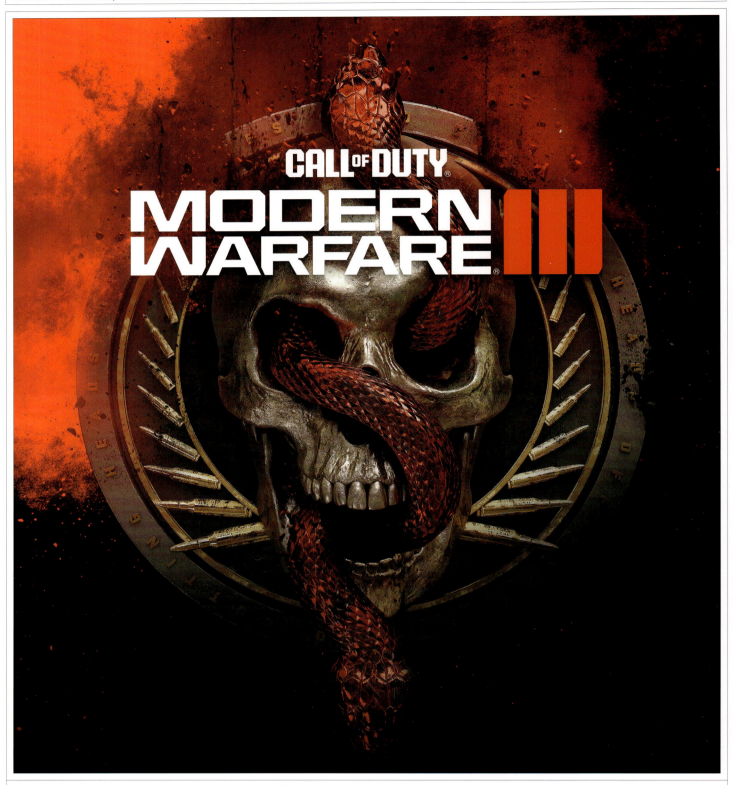

Title: Call of Duty: Modern Warfare III | Clients: Activision, Sledgehammer
Agency: PETROL Advertising | P178: Credit & Commentary | Image 1 of 5

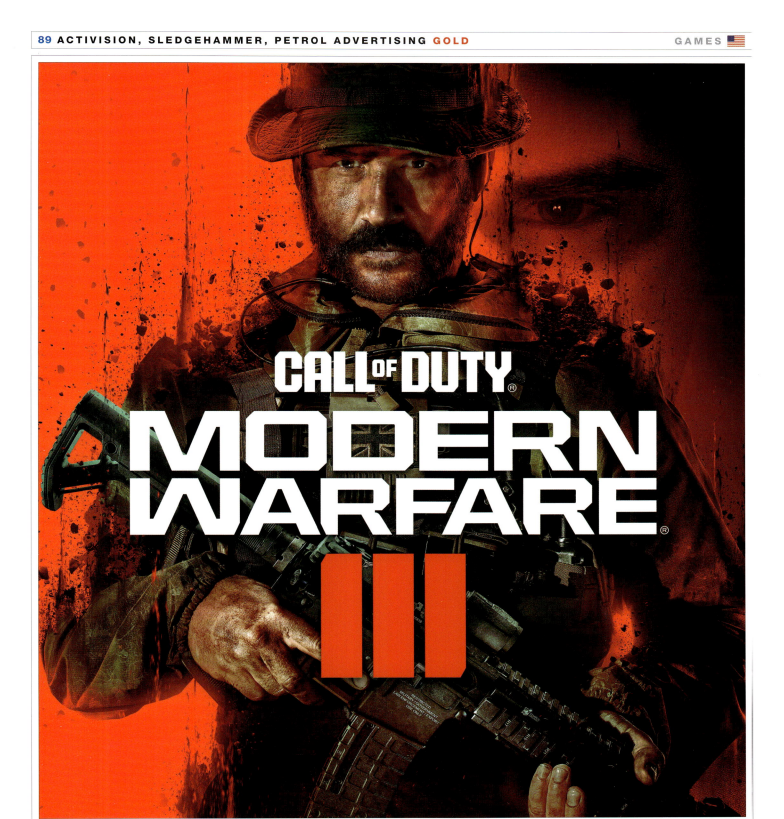

Title: Call of Duty: Modern Warfare III | **Clients:** Activision, Sledgehammer
Agency: PETROL Advertising | **P178:** Credit & Commentary | Image 2 of 5

90 ACTIVISION, TREYARCH, PETROL ADVERTISING GOLD

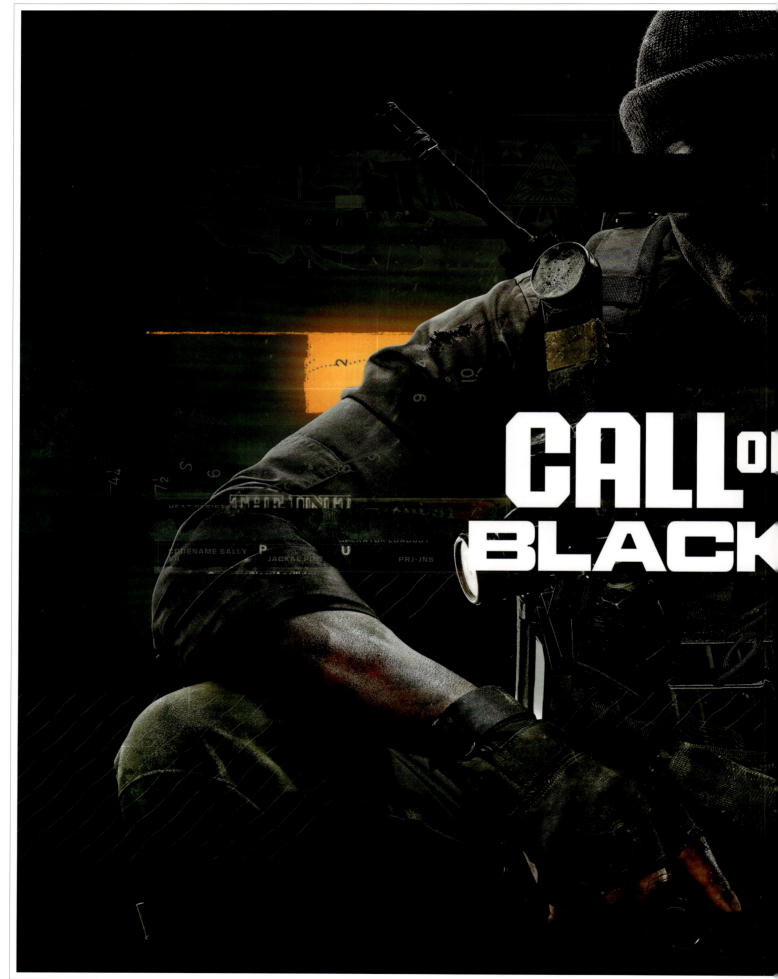

P178: Credit & Commentary

GAMES

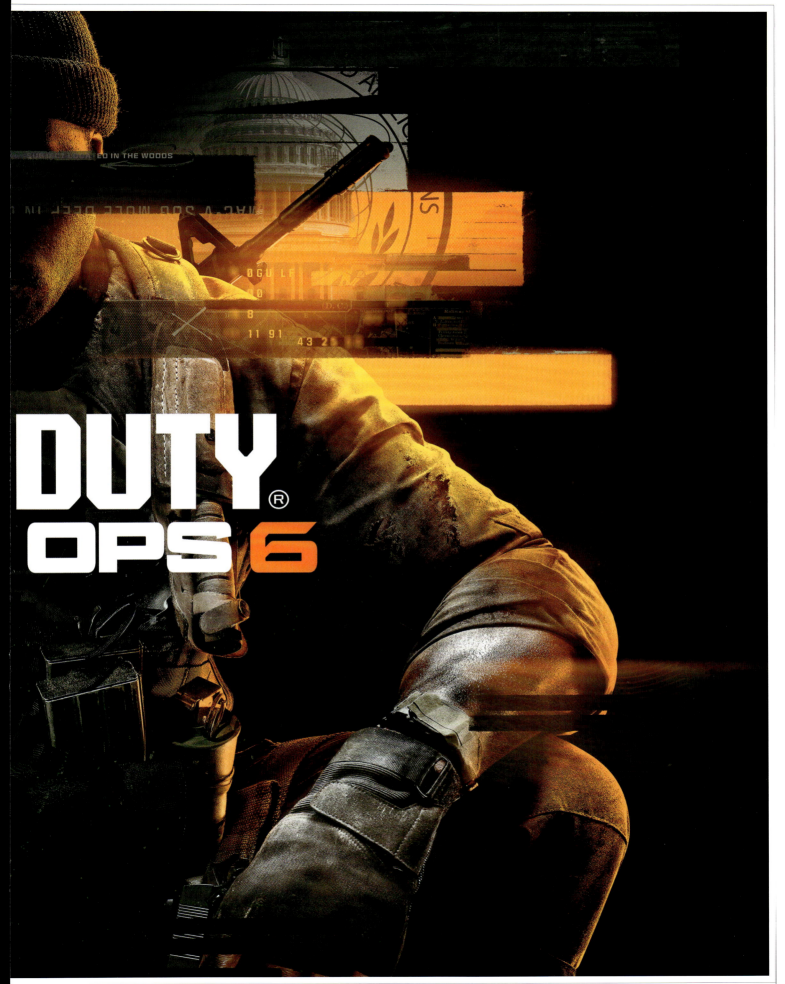

Title: Call of Duty: Black Ops 6 - Key Art Series | **Clients:** Activision, Treyarch | **Agency:** PETROL Advertising

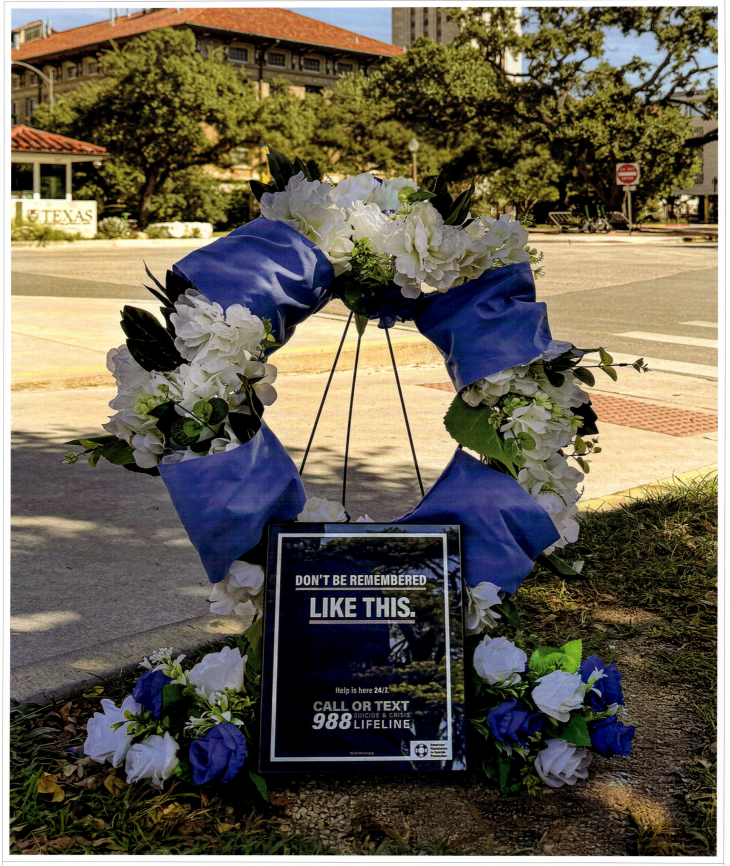

Title: Non-Memorials | Client: Foundation for Suicide Prevention
Agency: Boundless Life Sciences Group | P178: Credit & Commentary | Image 1 of 6

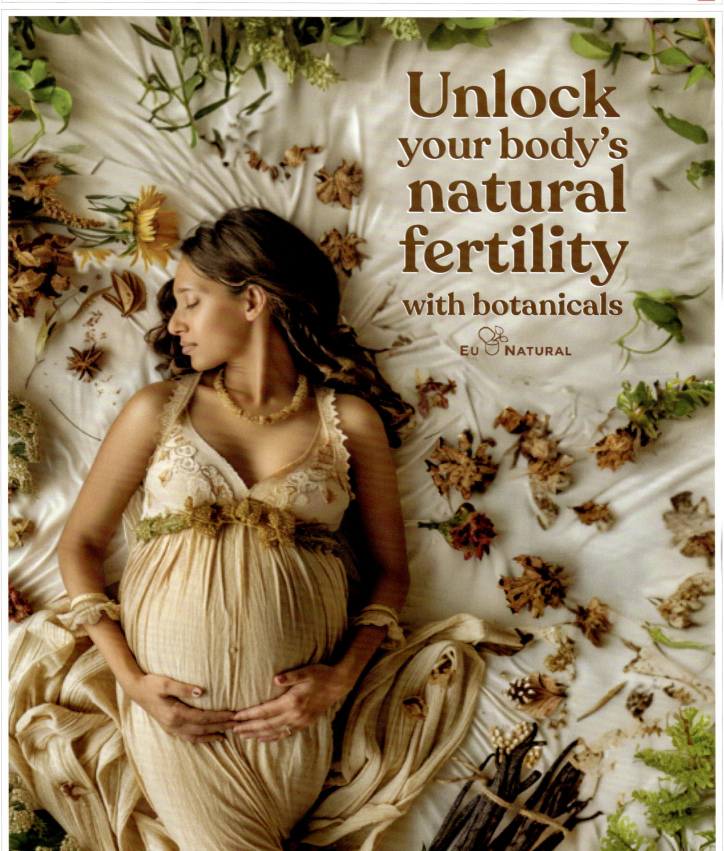

Title: Botanicals | Clients: Eu Natural, Wellbeam Consumer Health
Agency: The BAM Connection | P178: Credit & Commentary

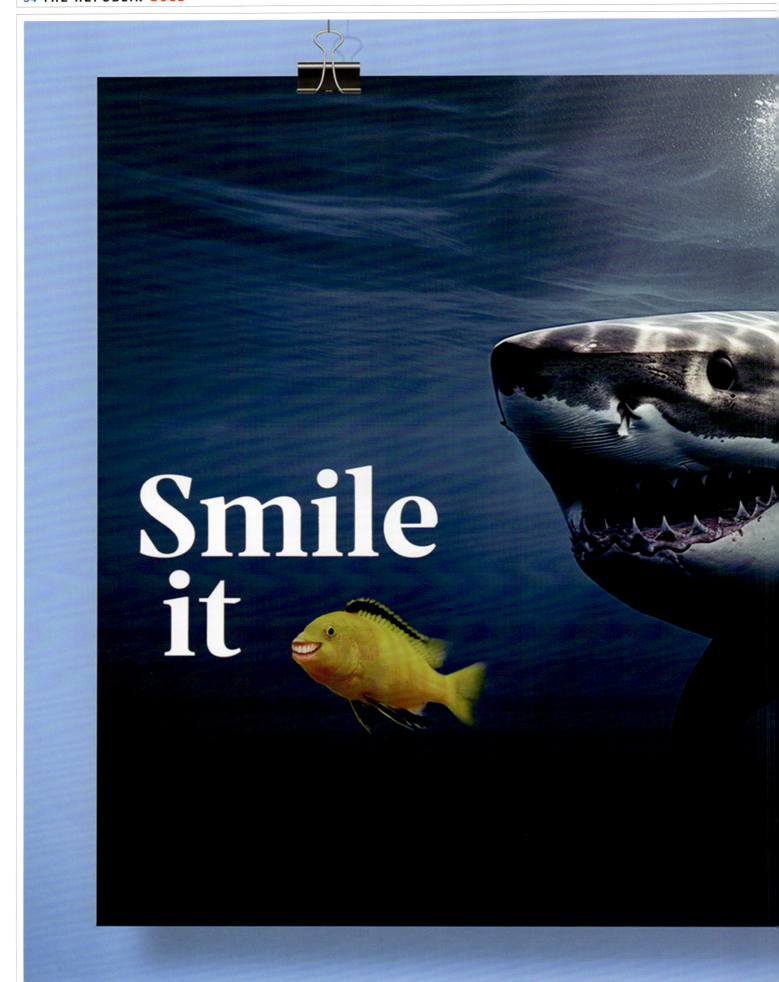

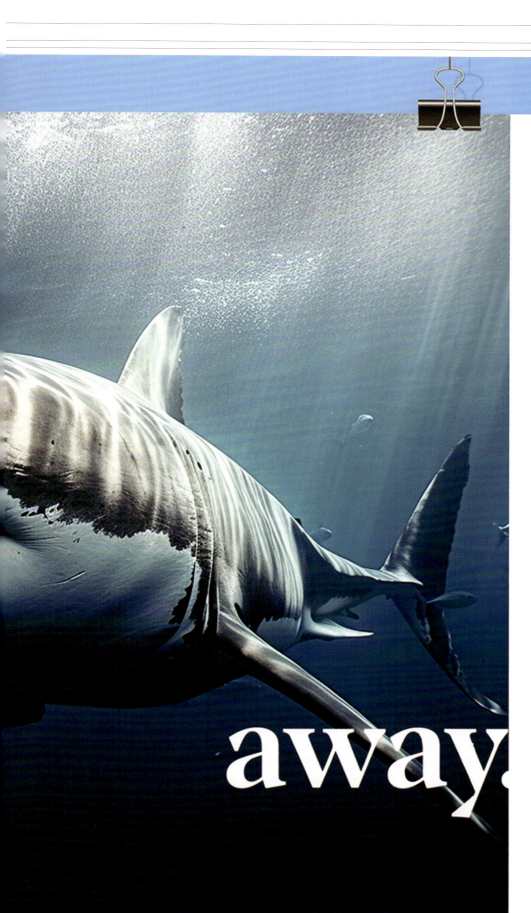

The best-rated hospital.

There is no second opinion.

At RUSH, our top-rated status in Chicago reflects our dedication to excellence in health care. RUSH is ranked #1 in Illinois by *U.S. News & World Report* and ranked #2 in the country by Vizient. Our expert team ensures you receive the best care. **Learn more at RUSH.edu**

RUSH

While they have our respect, no other hospital in Illinois has our rankings.

RUSH is ranked #1 in Illinois by *U.S. News & World Report* and ranked #2 in the country by Vizient. **Learn more at RUSH.edu**

RUSH

When bad things happen to good people, they want the best people.

RUSH is ranked #1 in Illinois by *U.S. News & World Report* and ranked #2 in the country by Vizient. We ensure that our dedicated health care professionals provide exceptional, compassionate and expert care. **Learn more at RUSH.edu**

RUSH

We're making the last place you want to go the first place on your list.

RUSH is ranked #1 in Illinois by *U.S. News & World Report* and ranked #2 in the country by Vizient. **Learn more at RUSH.edu**

RUSH

P178: Credit & Commentary **Title: RUSH | Client: RUSH University Medical Center | Agency: DeVito/Verdi** Images 1-4 of 7

97 ERIC SCHUTTE GOLD HEALTHCARE

We fix more broken hearts than ice cream.

The highest survival rate for heart failure in the country.
Learn more at RUSH.edu/

⊕ RUSH

P178: Credit & Commentary **Title: RUSH | Client: RUSH University Medical Center | Agency:** DeVito/Verdi Image 5 of 7

The race to our calling has no finish line.

PRODUCT

Fast is our addiction. A legendary carbon fiber hull is ours alone. All electric 70mph stealth is our weapon. Heed the call.

UNMATCHED TORQUE
70MPH
FULLY ELECTRIC

VOLTARI

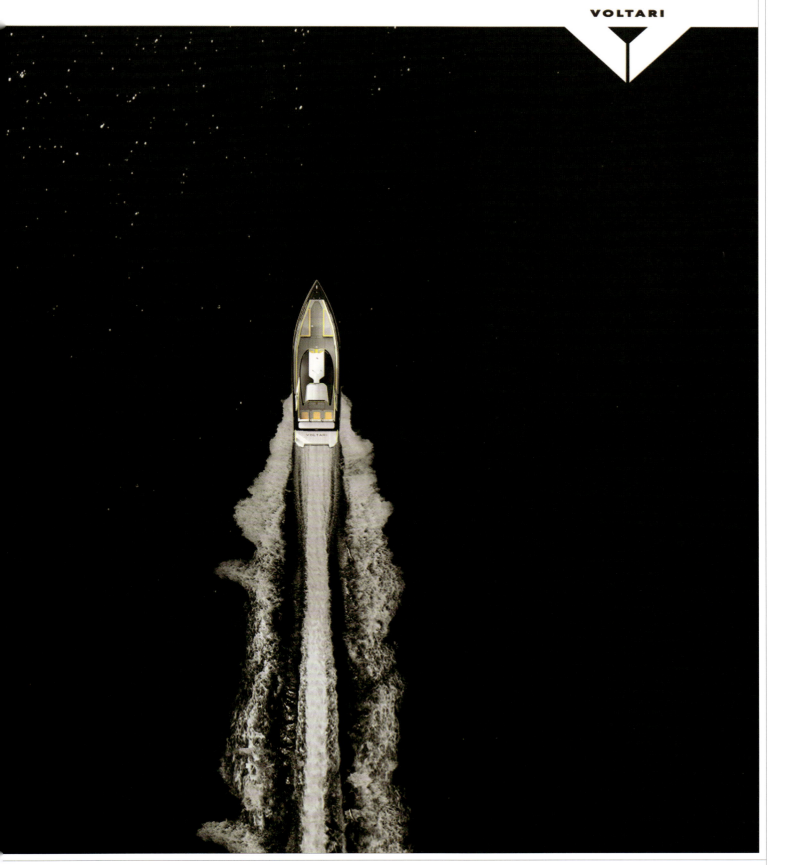

Title: Voltari Print Campaign | **Client:** Voltari | **Agency:** The Republik

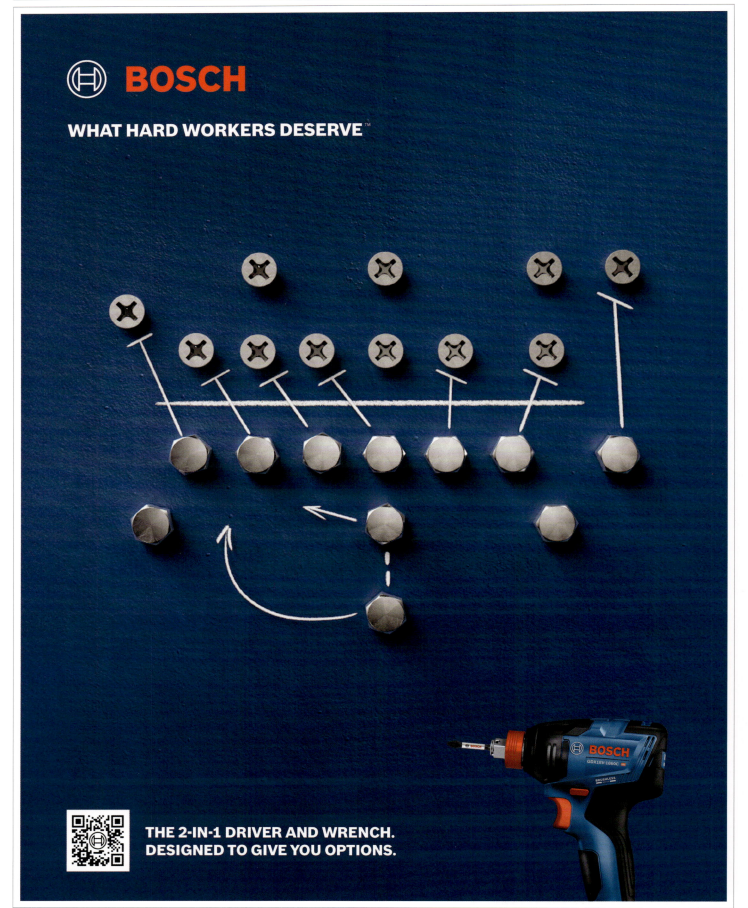

101 JINYOUNG KIM **GOLD** PROMOTION

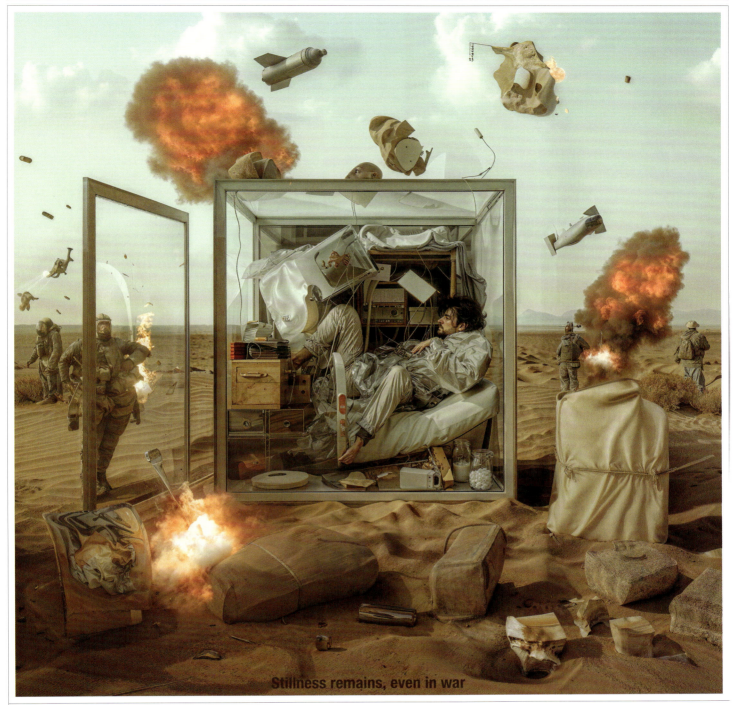

P179: Credit & Commentary | **Title:** Silent War | **Client:** Self-initiated | **Agency:** Collective Turn

Creativity is alive and well. That thought should encourage those of us who make our living as part of this community.

Scott Bucher, *President, Traction Factory*

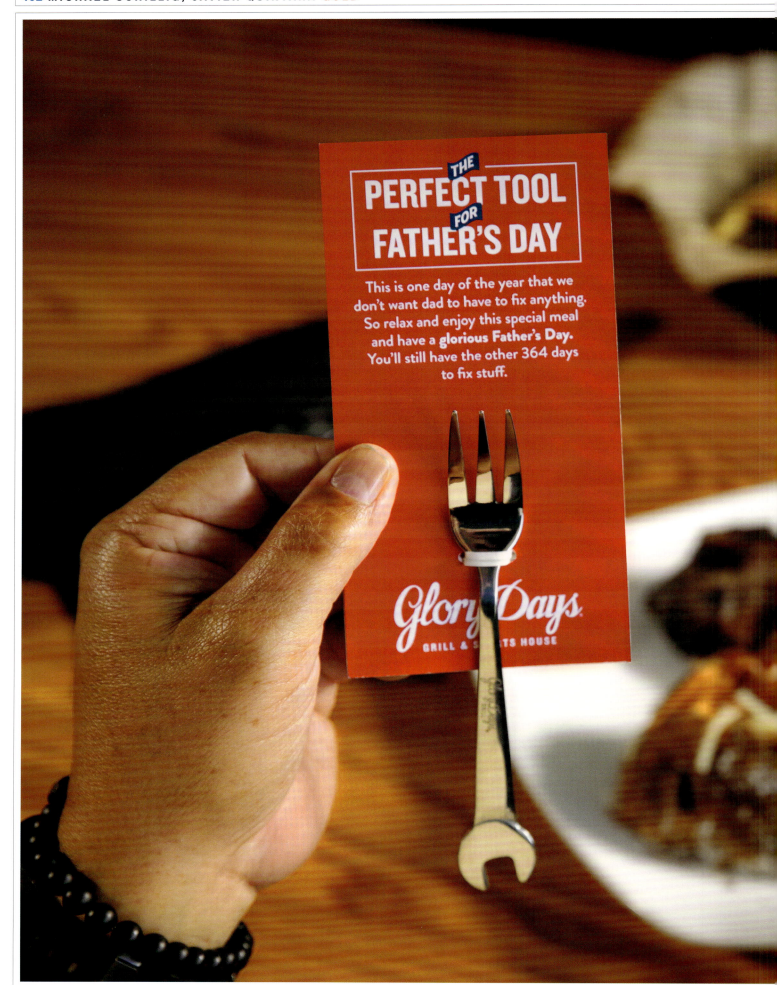

105 NOT WILLIAM **GOLD**

PROMOTION

NOW
ACCEPTING
STORIES
FOR
MISSION
03

DO SOMETHING ASIMOV, BRADBURY, AND CLARKE NEVER DID.

WRITE A STORY ABOUT SPACE. AND ACTUALLY SEND IT TO SPACE.

STORIES OF SPACE

► STORIESOFSPACE.COM

P179: Credit & Commentary **Title:** Send A Story to Space | **Client:** Stories of Space | **Agency:** Not William Image 2 of 4

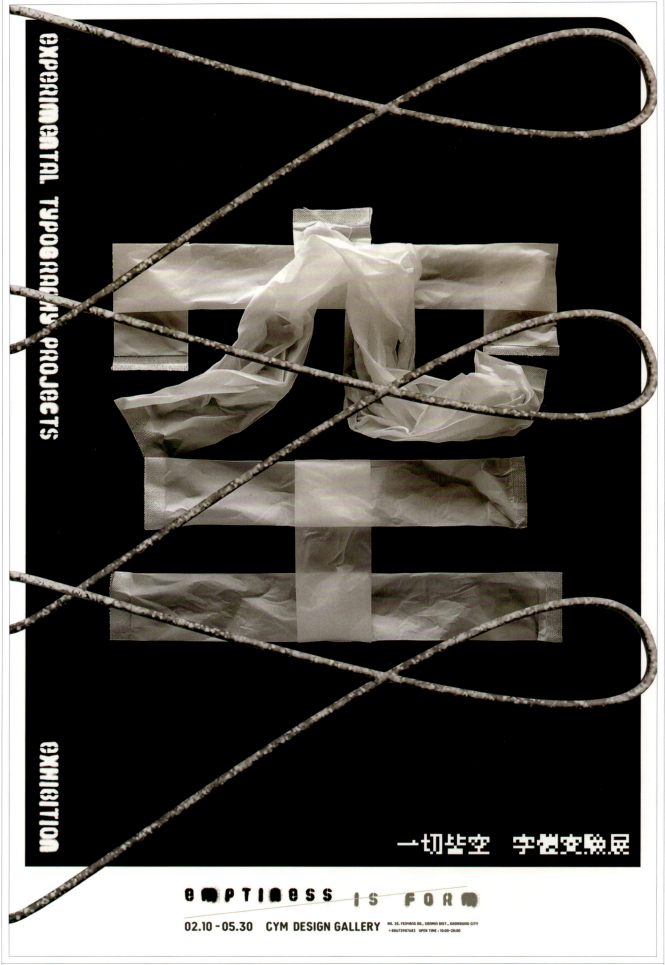

Title: Emptiness is Form - Experimental Typography Exhibition | **Client:** CYM Design Gallery
Agency: Chen Yu Min Design | **P179:** Credit & Commentary | Image 1 of 3

107 MICHAEL SCHILLIG, PIERRE DUCILON GOLD PUBLIC SERVICES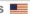

P179: Credit & Commentary | Title: Hang Head in Shame | Client: Big Cat Rescue | Agency: PPK

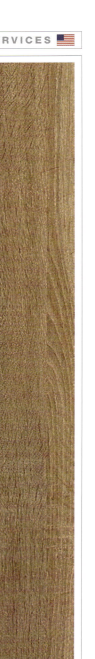

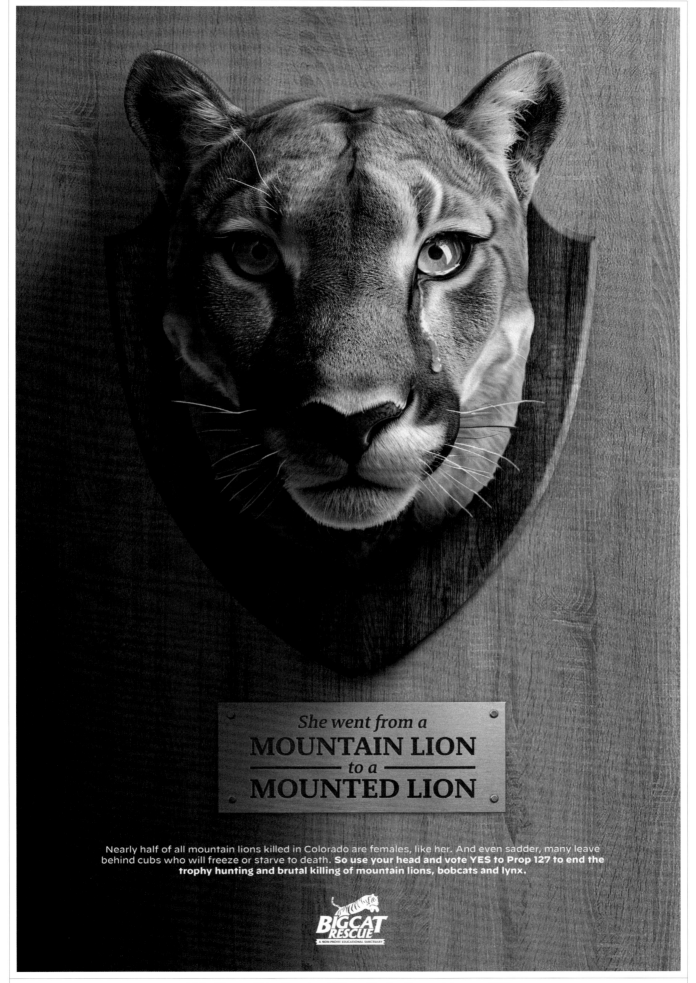

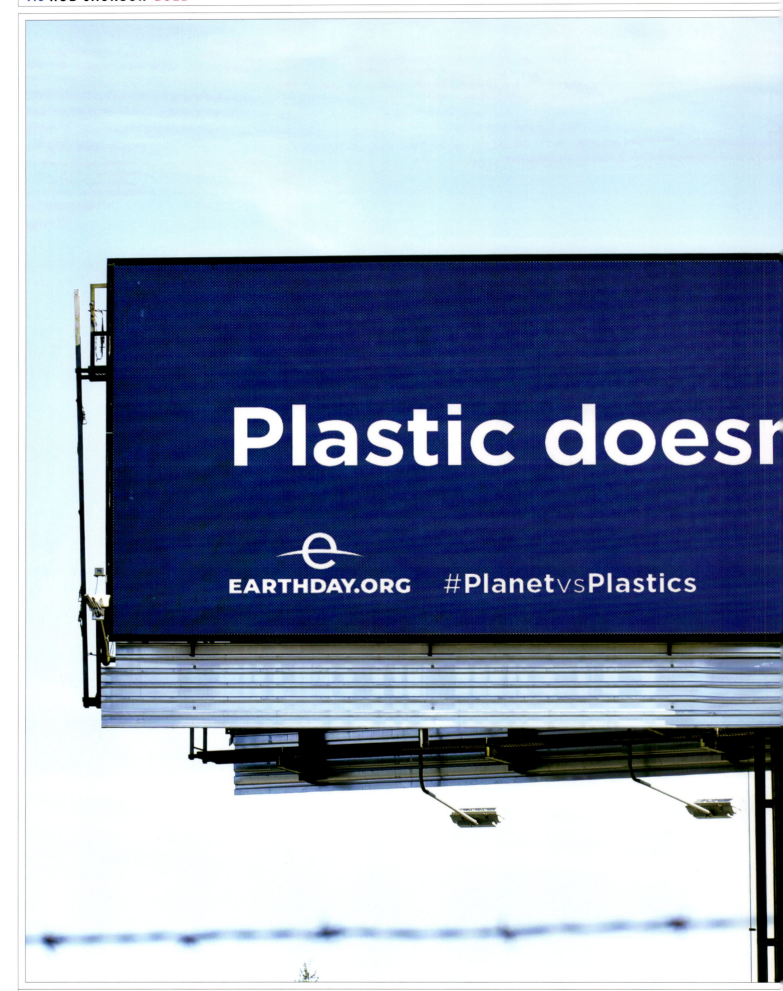

PUBLIC SERVICES

Title: Earth Day 2024 Out of Home Campaign | **Clients:** EarthDay.org, Out of Home Advertising Association of America | **Agency:** Extra Credit Projects

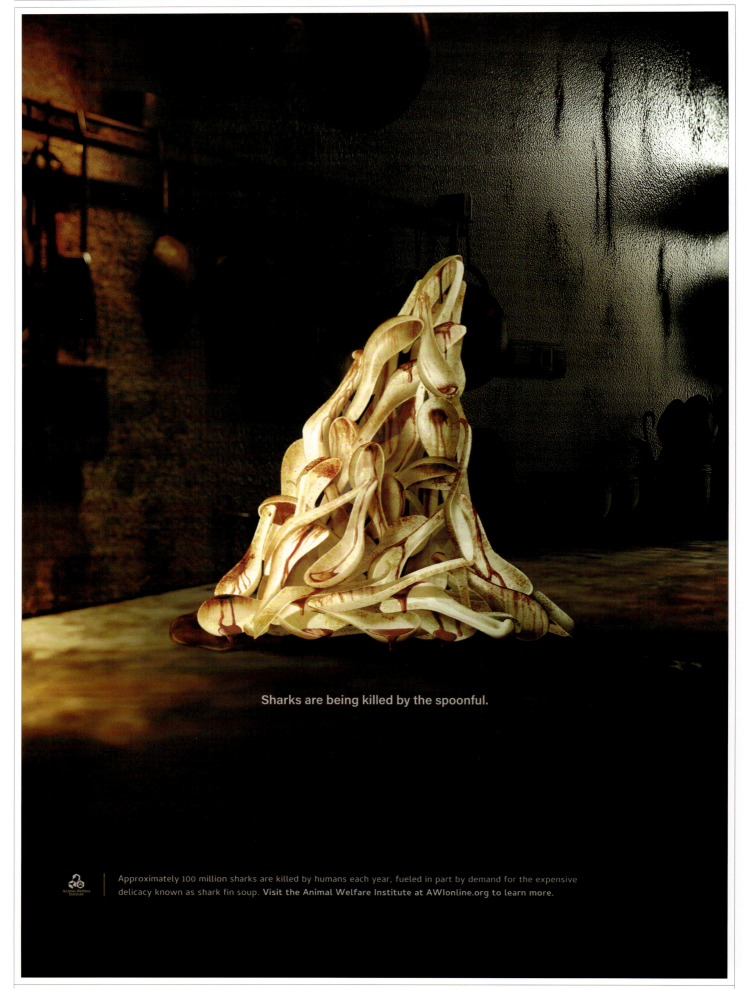

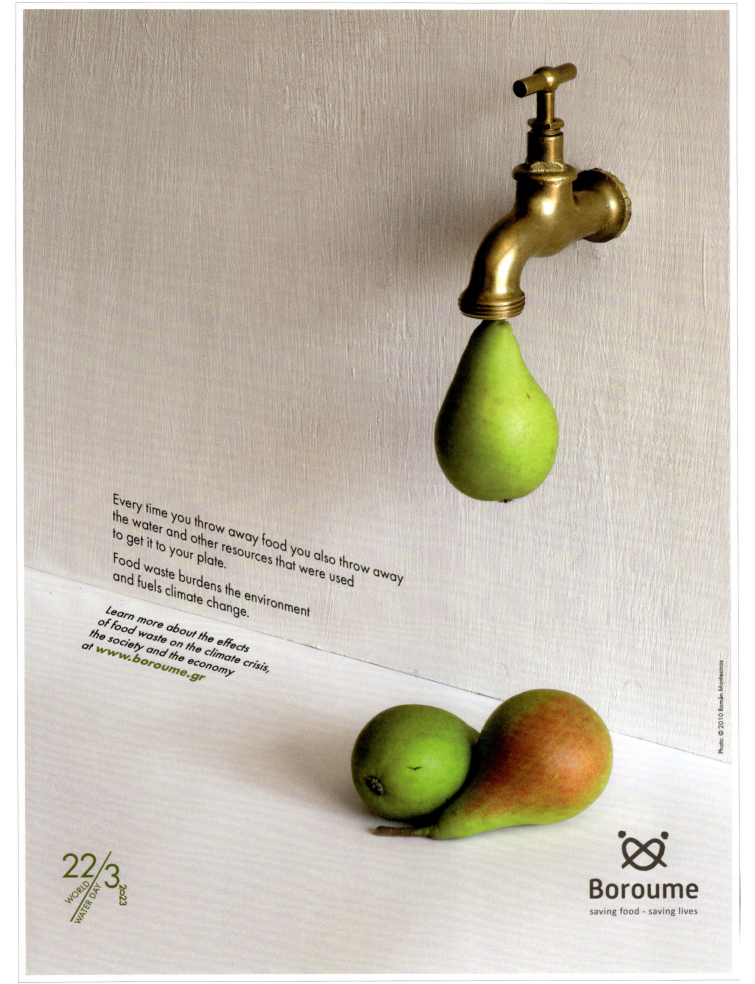

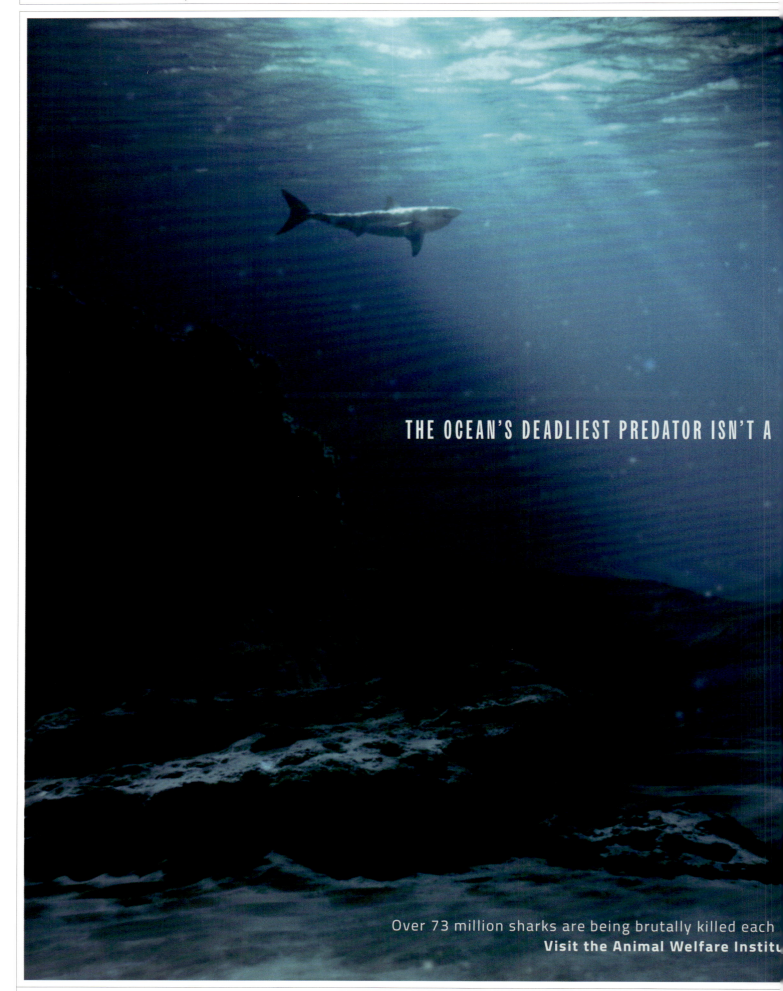

PUBLIC SERVICES

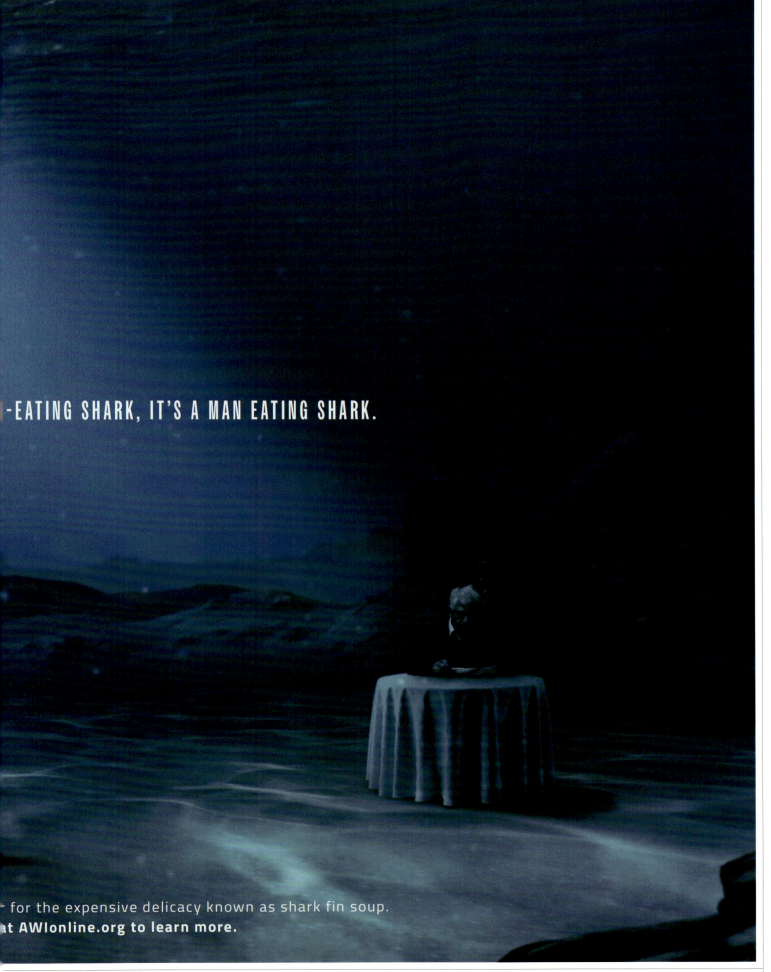

-EATING SHARK, IT'S A MAN EATING SHARK.

for the expensive delicacy known as shark fin soup.
at AWIonline.org to learn more.

Title: Man Eating Shark | **Client:** Animal Welfare Institute (AWI) | **Agency:** PPK

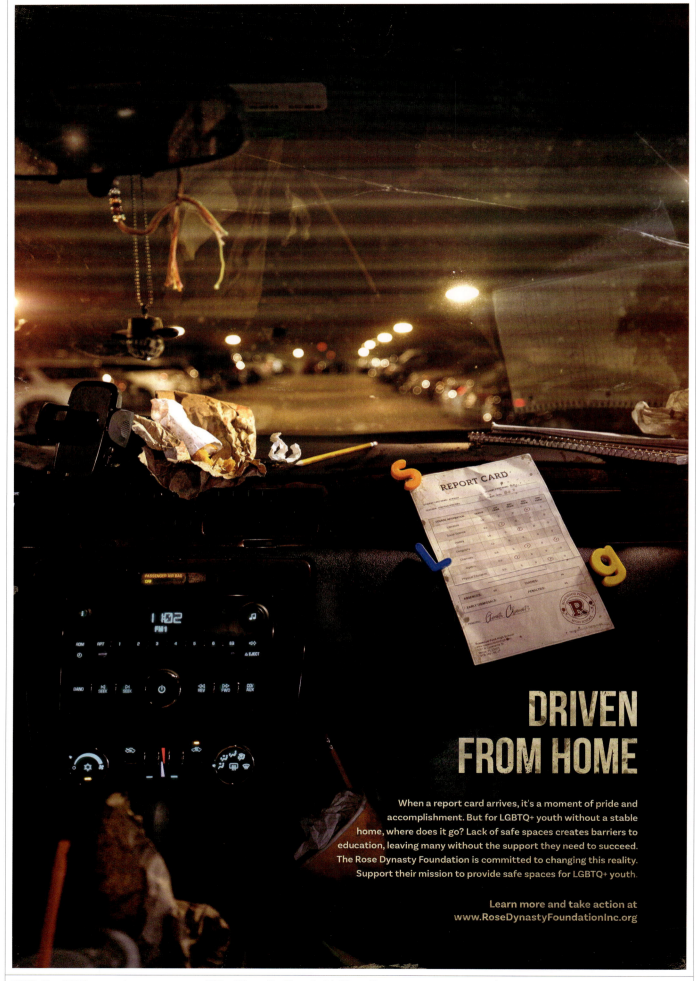

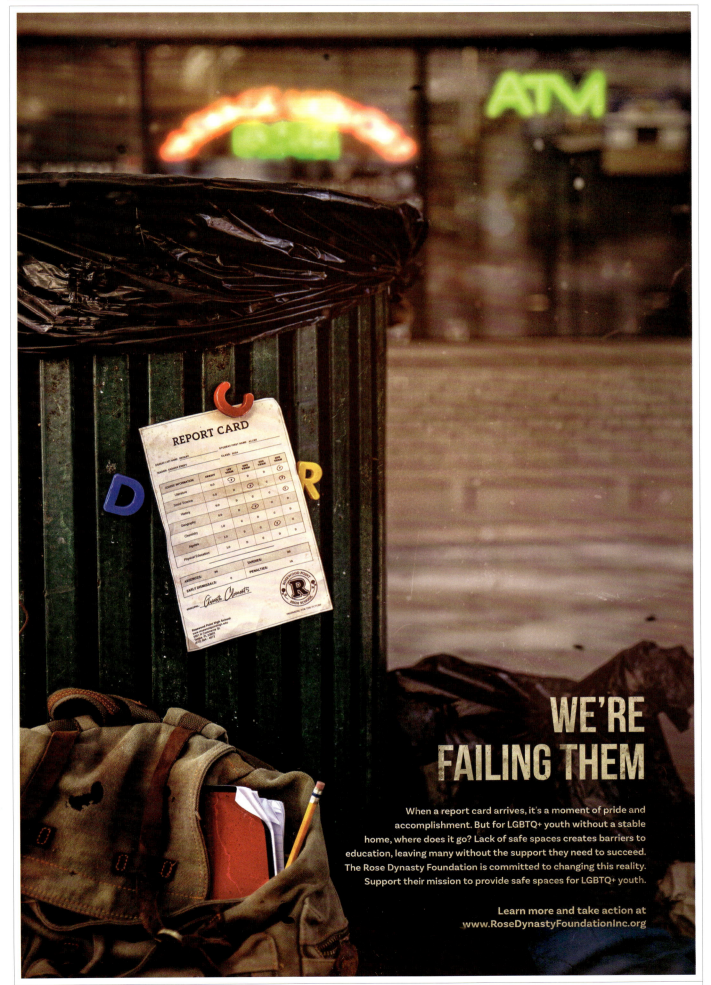

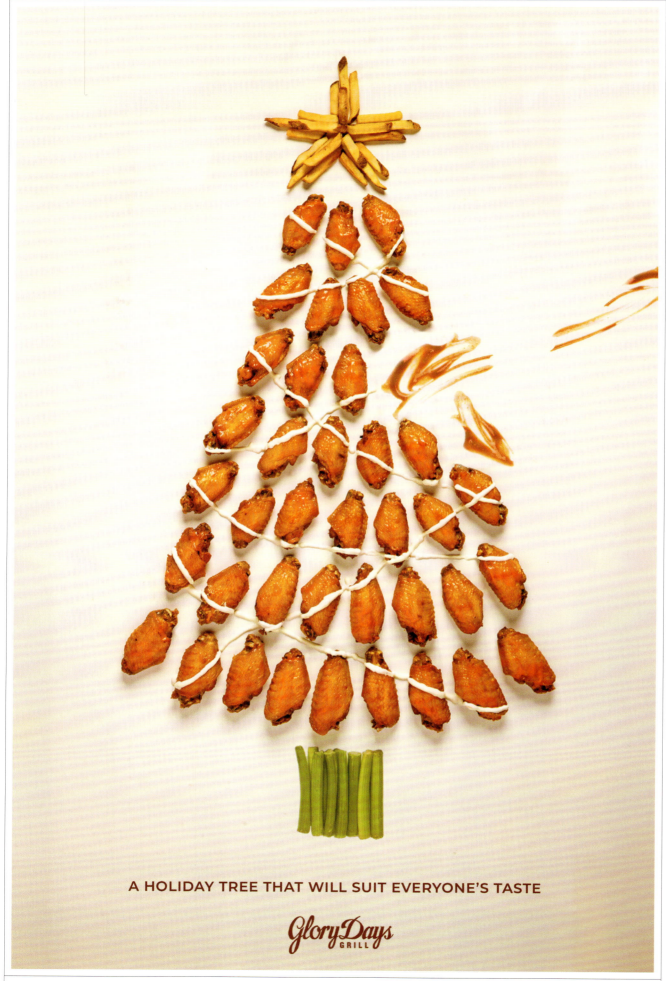

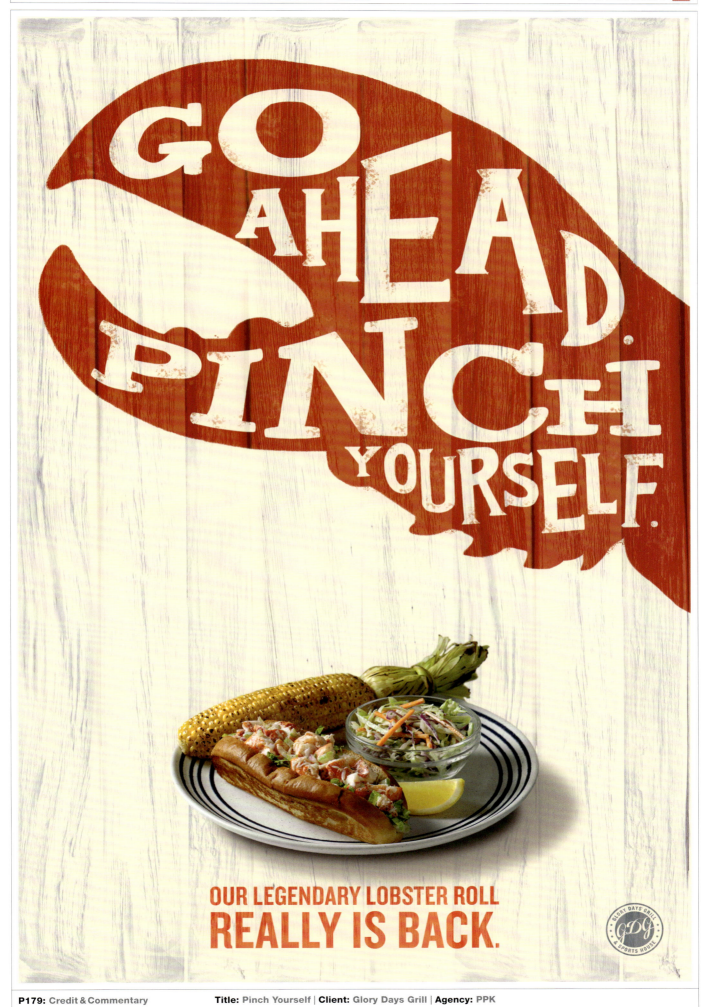

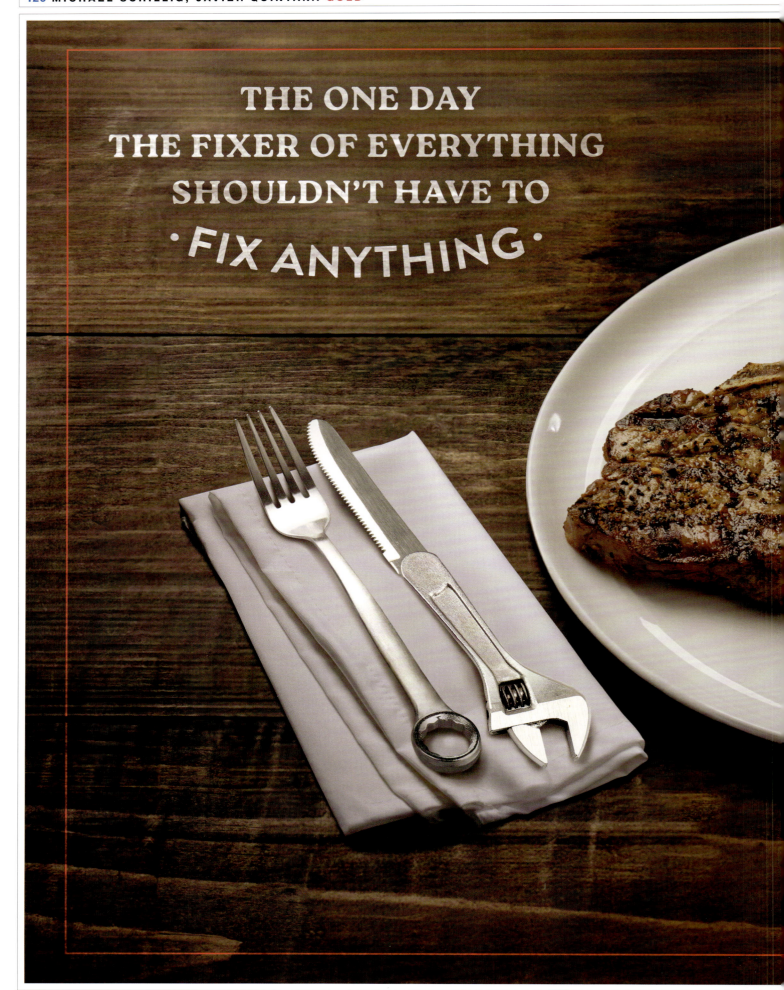

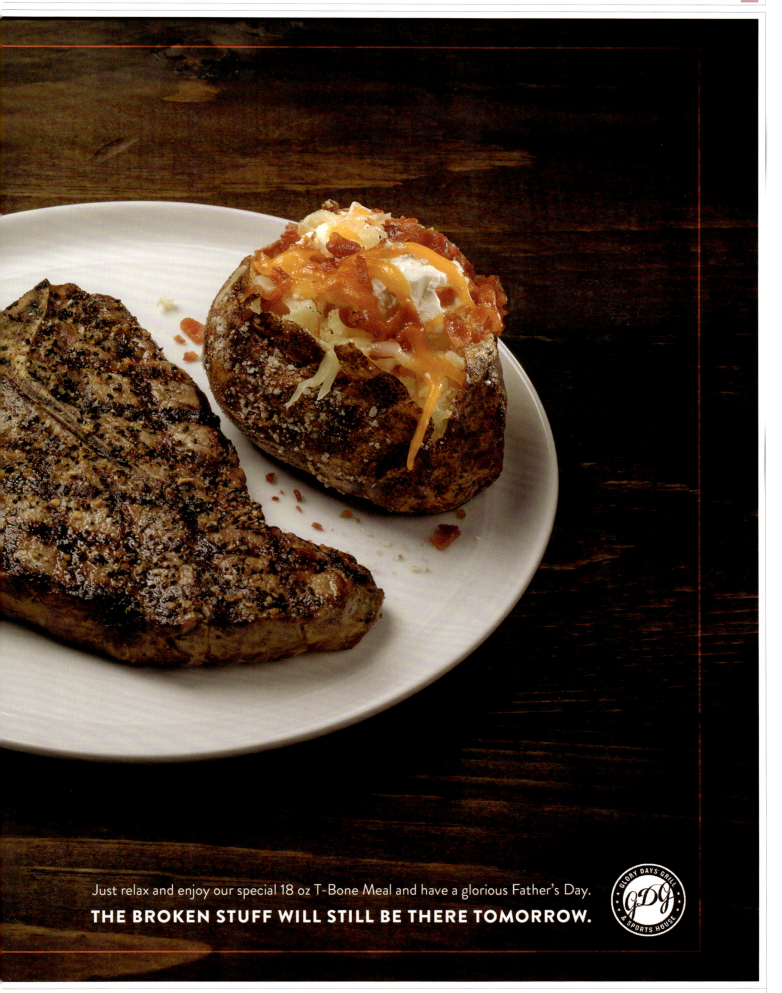

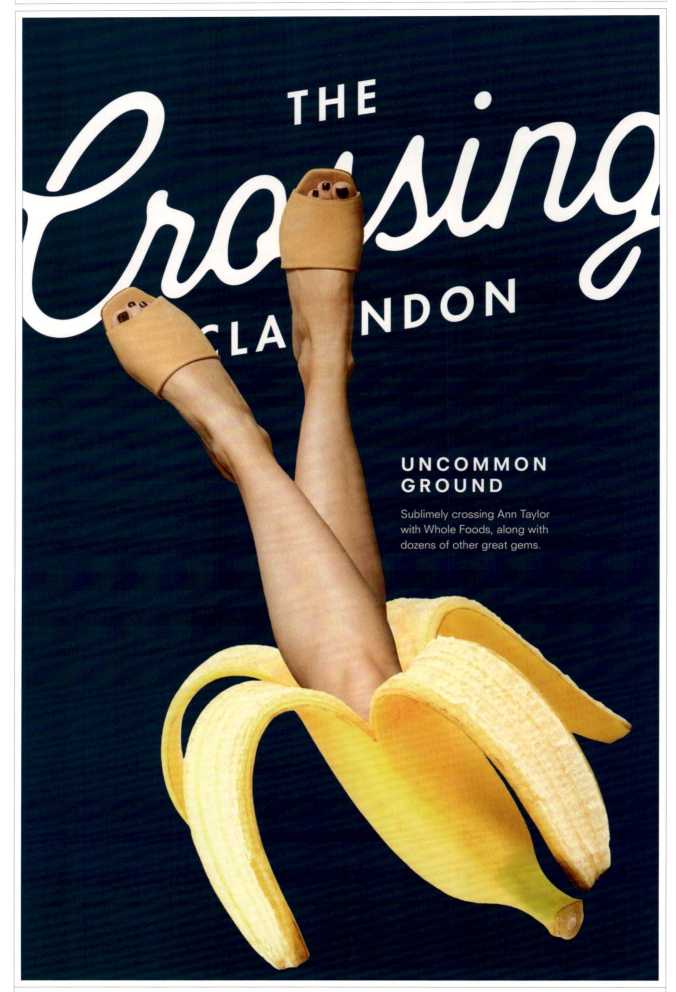

123 THE REPUBLIK GOLD RETAIL

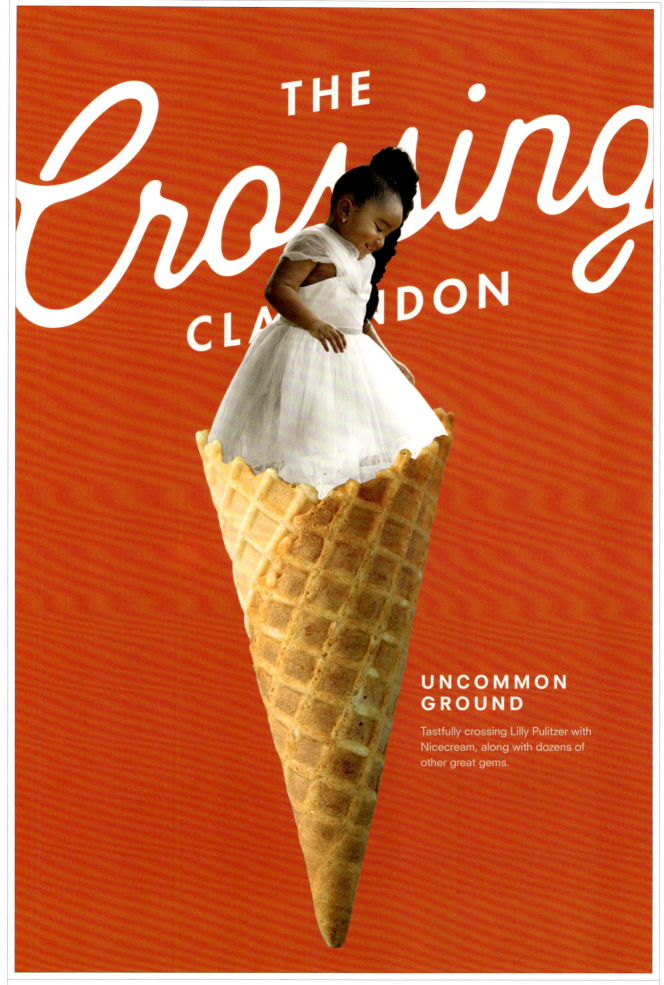

UNCOMMON GROUND

Tastfully crossing Lilly Pulitzer with Nicecream, along with dozens of other great gems.

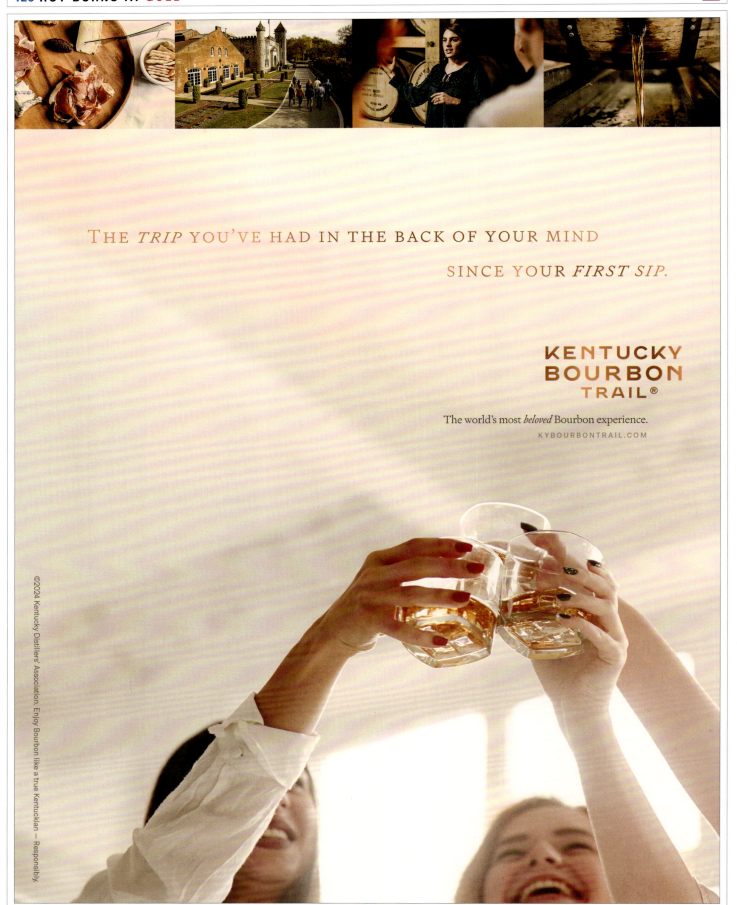

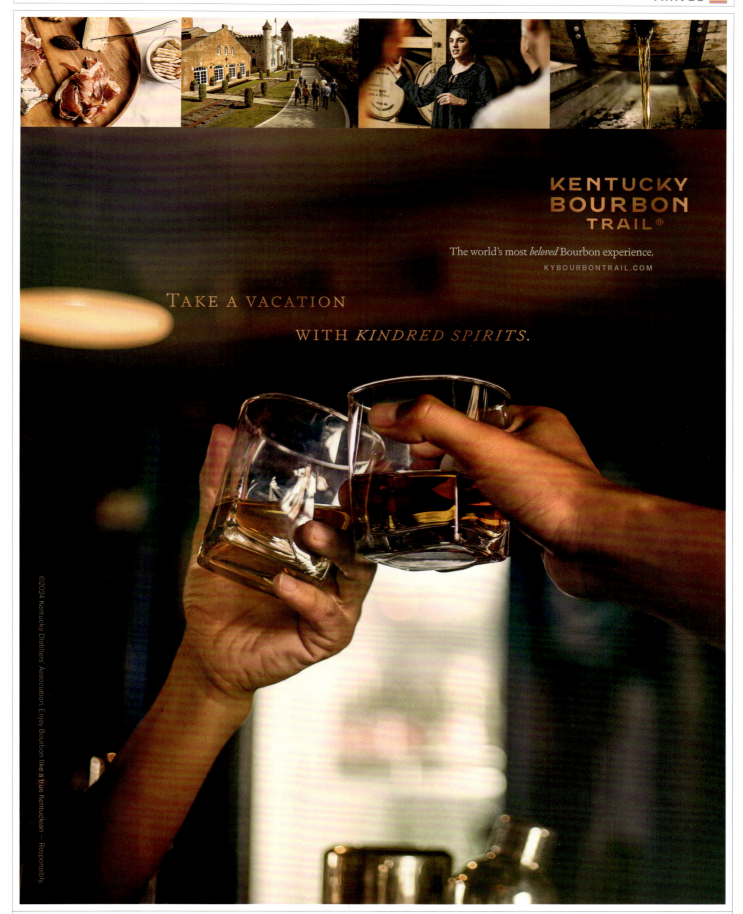

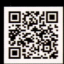

TRAVEL

Title: Kentucky Bourbon Trail — Airport Duratran | **Client:** Kentucky Distillers' Association | **Agency:** Lewis Communications

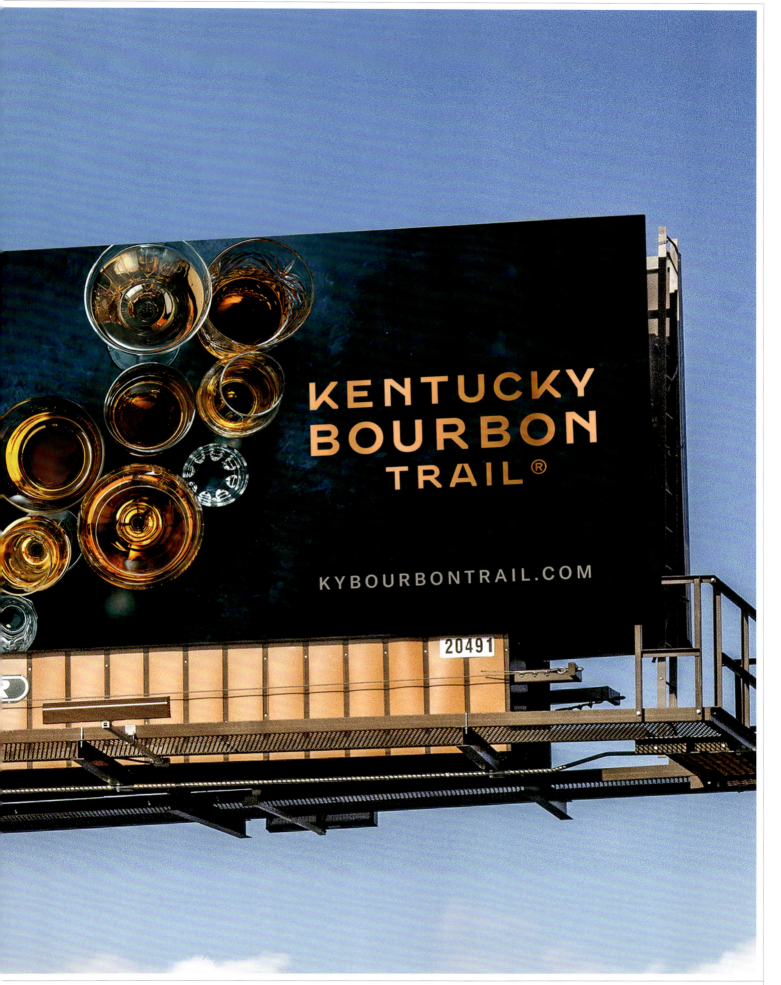

Title: Kentucky Bourbon Trail — Outdoor | Client: Kentucky Distillers' Association | Agency: Lewis Communications

Graphis Silver Awards

135 SILVER — BEVERAGE, BILLBOARD

FORCEMAJEURE DESIGN

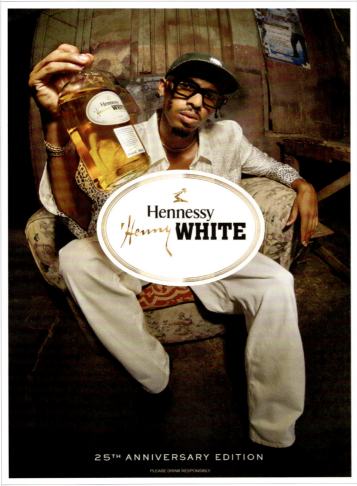

Title: Henny White 25 Year Drop
Client: Moet Hennessy | **Agency:** forceMAJEURE Design

FORCEMAJEURE DESIGN

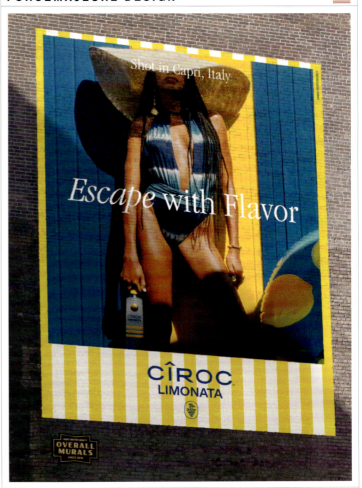

Title: Cîroc Limonata Campaign - Escape with Flavor
Clients: Cîroc Vodka, Diageo | **Agency:** forceMAJEURE Design

ERIC SCHUTTE

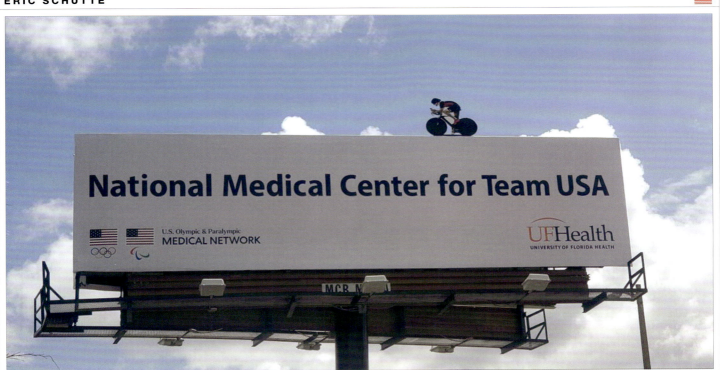

Title: National Medical Center for Team USA | **Client:** University of Florida Health | **Agency:** DeVito/Verdi

136 SILVER BROADCAST, CORPORATE

SJI ASSOCIATES

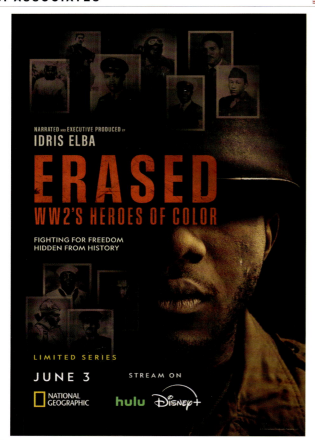

Title: Erased: WW2's Heroes of Color | **Clients:** National Geographic, Chris Spencer, Brian Everett, Mariano Barreiro, Mary Dunnington, Isabella Alonzo | **Agency:** SJI Associates

SJI ASSOCIATES

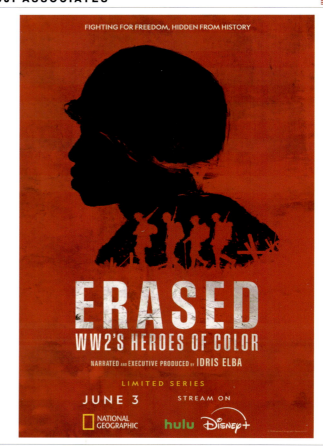

Title: Erased: WW2's Heroes of Color - Alternative Poster **Clients:** National Geographic, Chris Spencer, Brian Everett, Mariano Barreiro, Mary Dunnington, Isabella Alonzo | **Agency:** SJI Associates

NIKKEISHA, INC.

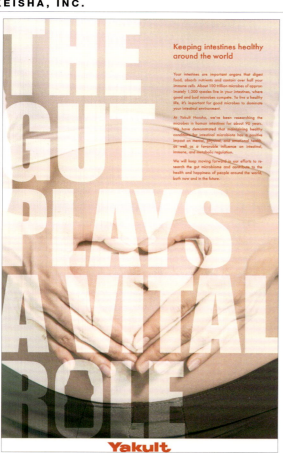

Title: THE GUT PLAYS A VITAL ROLE | **Client:** Yakult Honsha Co., Ltd. **Agency:** Nikkeisha, Inc.

NIKKEISHA, INC.

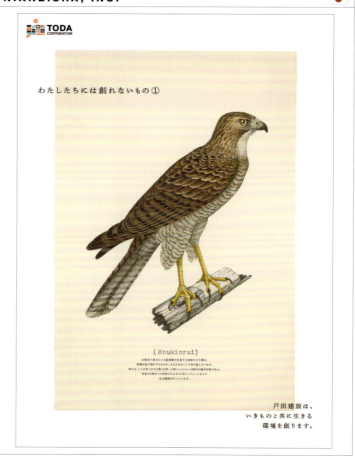

Title: What We Cannot Create | **Client:** TODA CORPORATION **Agency:** Nikkeisha, Inc.

137 SILVER — CORPORATE, EDITORIAL, EDUCATION

&BARR 🇺🇸

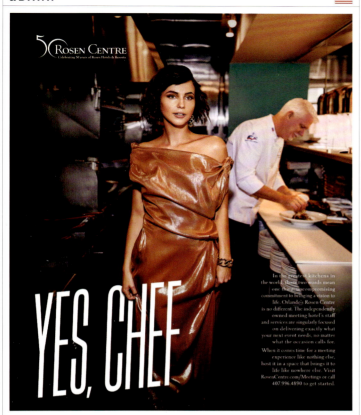

Title: Rosen Runway | **Client:** Rosen Hotels & Resorts
Agency: &Barr

ARIEL FREANER 🇺🇸

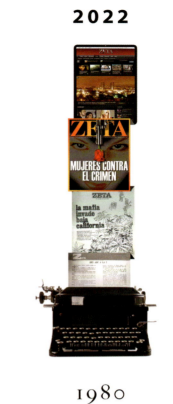

Title: ZETA 42nd Anniversary Poster | **Client:** ZETA Weekly
Agency: Freaner Creative & Design

MENGYI XIE 🇨🇳

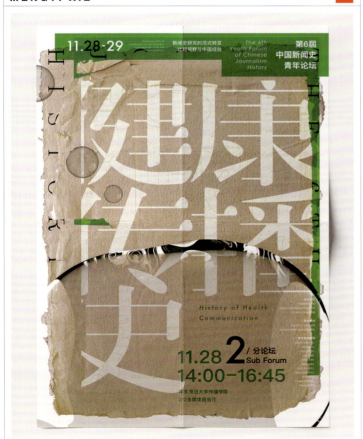

Title: Journalism History Forum
Client: School of Communication at East China Normal University
Agency: Shanghai Cary Branding Design Co., Ltd.

ERIC SCHUTTE 🇺🇸

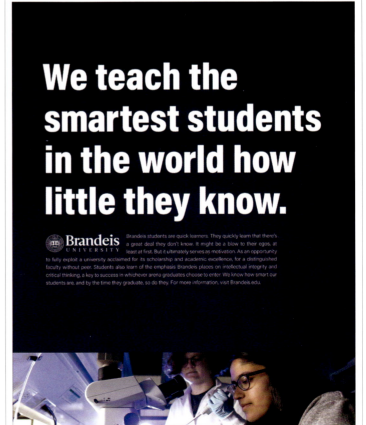

Title: Brandeis 75th Anniversary
Client: Brandeis University
Agency: DeVito/Verdi

138 SILVER | EDUCATION

MENGYI XIE

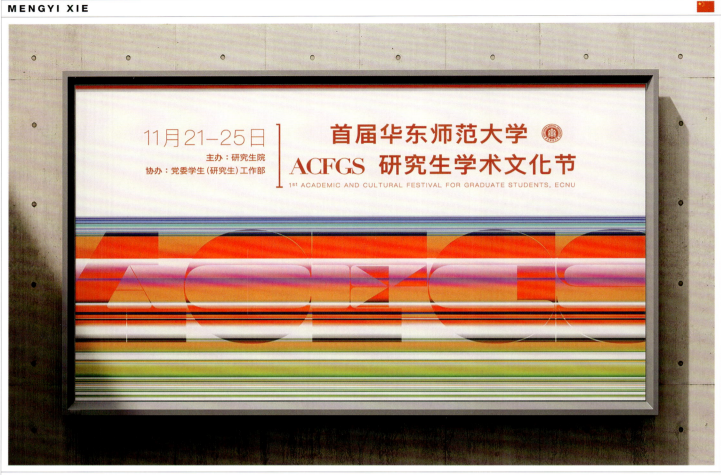

Title: RAY | Client: East China Normal University | Agency: Shanghai Cary Branding Design Co., Ltd.

CACTUS

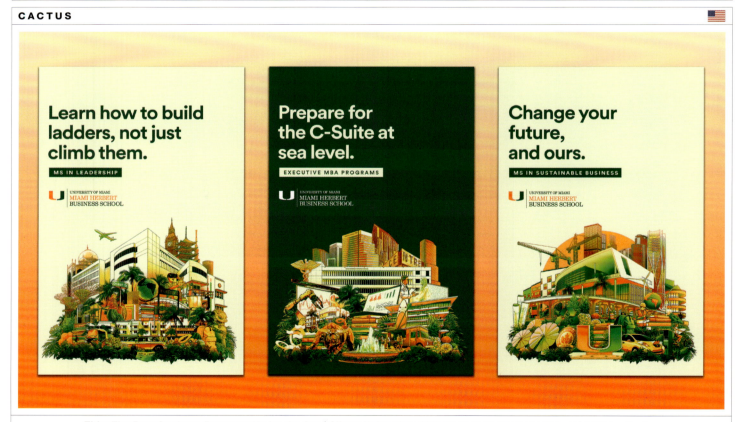

Title: The Best Graduate Programs Under the Sun | Client: University of Miami Herbert Business School | Agency: Cactus

139 SILVER EDUCATION, ENTERTAINMENT

ROB JACKSON

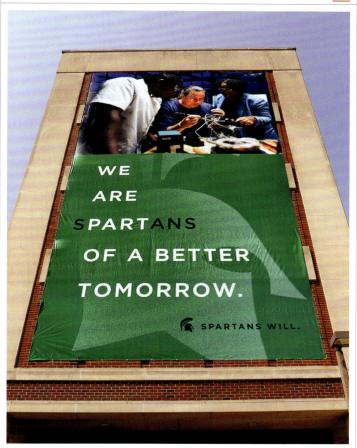

Title: Campus Campaign | **Client:** Michigan State University
Agency: Extra Credit Projects

ARSONAL, NETFLIX

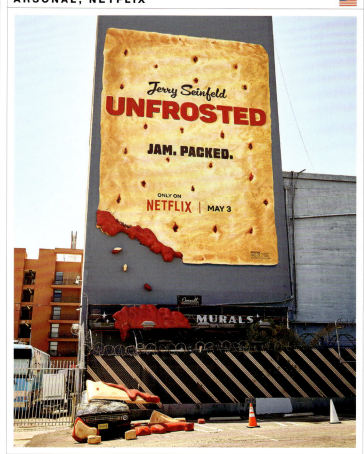

Title: UNFROSTED | **Client:** Netflix
Agency: ARSONAL

BARLOW.AGENCY

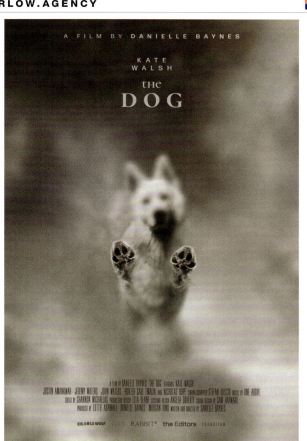

Title: The Dog Short Film Key Art
Client: Danielle Baynes Films
Agency: Barlow.Agency

SJI ASSOCIATES

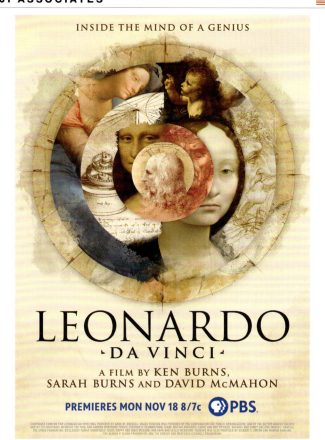

Title: Leonardo da Vinci | **Clients:** PBS Creative Services, Ira Rubenstein, Stacey Libbrecht, Derrick Chamlee, Jared Traver, Claire Quin
Agency: SJI Associates

140 SILVER | ENTERTAINMENT

ARSONAL, NETFLIX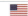

Title: UNFROSTED | **Client:** Netflix
Agency: ARSONAL

BARLOW.AGENCY

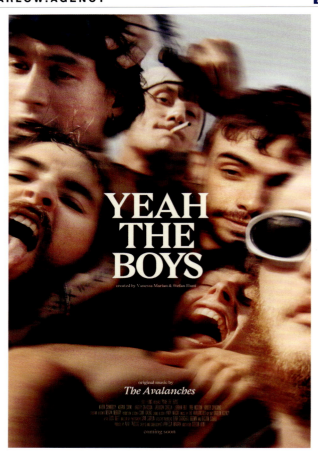

Title: Yeah The Boys Short Film Key Art | **Client:** Stefan Hunt Films
Agency: Barlow.Agency

BARLOW.AGENCY

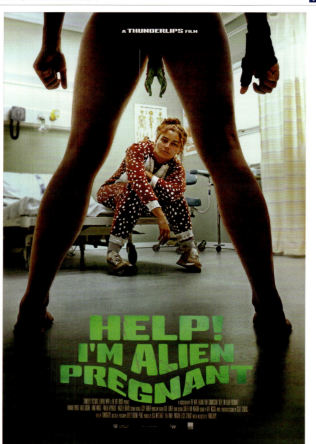

Title: Help! I'm Alien Pregnant Key Art | **Client:** Thunderlips Films
Agency: Barlow.Agency

CÉLIE CADIEUX

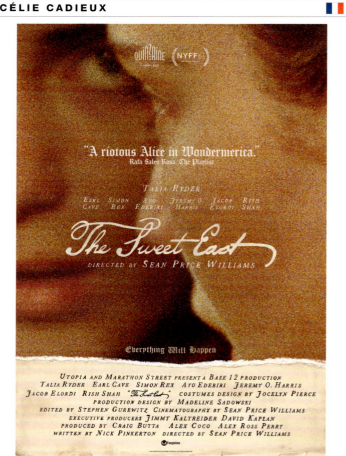

Title: The Sweet East | **Clients:** Utopia, The Match Factory
Agency: Célie Cadieux

141 SILVER — ENVIRONMENTAL, EVENTS

SEAN FREEMAN, EVE STEBEN

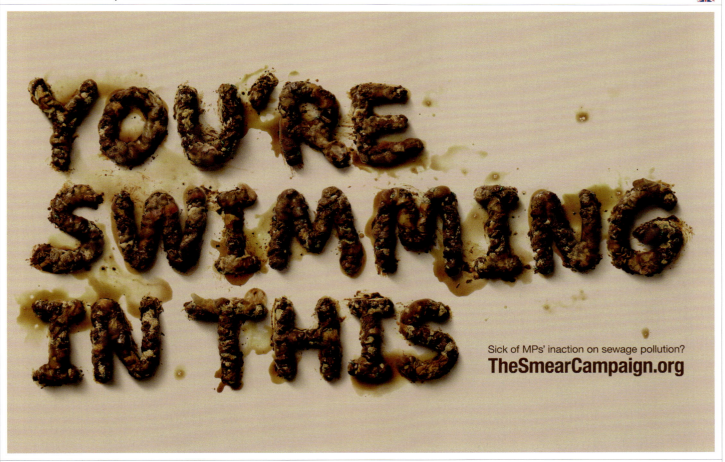

Title: The Smear Campaign | Clients: COPI (Central Office of Public Interest), Humphrey Milles | Agency: AMV BBDO

ARIEL FREANER

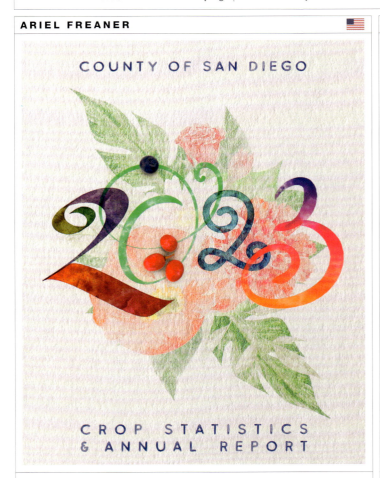

Title: AWM 2023 Promotional Launch Event Poster
Clients: County of San Diego Agriculture, Weights and Measures, Porfirio Mancillas | Agency: Freaner Creative & Design

KRISTIN STEVENSON

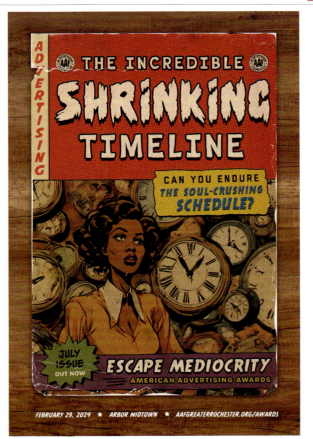

Title: Escape Mediocrity
Client: American Advertising Federation of Greater Rochester
Agency: Partners + Napier

142 SILVER — EVENTS, FASHION

ROB JACKSON

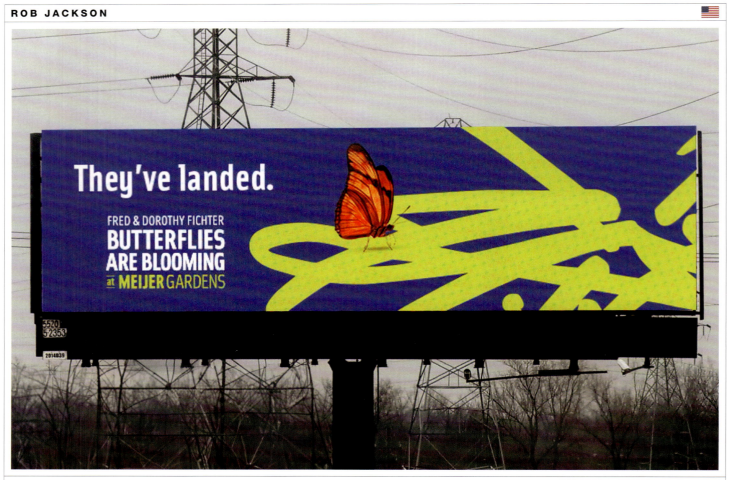

Title: Butterflies are Blooming Campaign | **Client:** Frederik Meijer Gardens & Sculpture Park | **Agency:** Extra Credit Projects

MEDIA.WORK

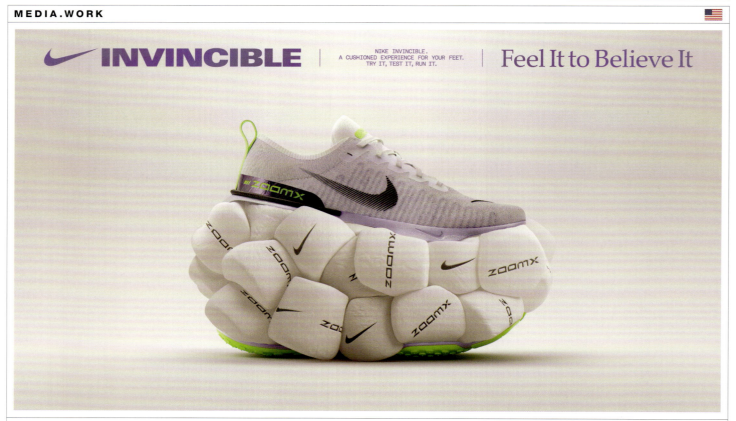

Title: Nike Invincible 3 | **Client:** Nike | **Agency:** Media.Work

Each campaign felt like a true masterclass in storytelling and strategy—leaving me truly inspired.

Mike Kriefski, *President & Chief Creative Officer, Shine United*

144 SILVER — FINANCIAL SERVICES, FOOD

STEPHANIE MORRISON

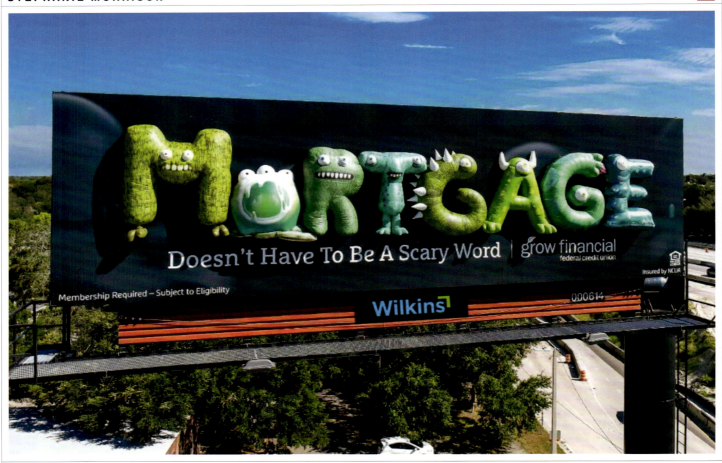

Title: Life Less Scary - Billboard Series | Client: Grow Financial Federal Credit Union | Agency: Dunn&Co.

INNERSPIN MARKETING

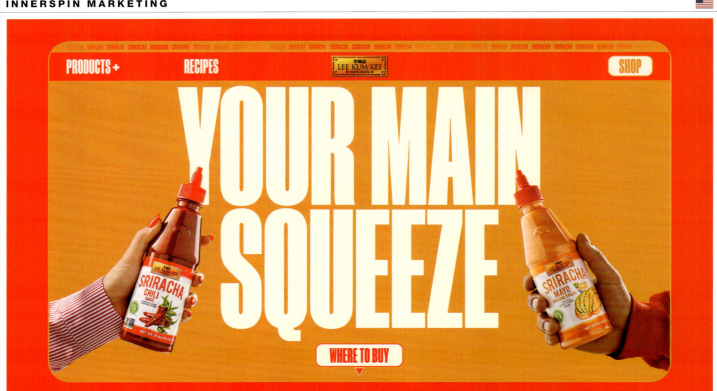

Title: Your Main Squeeze | Client: Lee Kum Kee | Agency: Innerspin Marketing

145 SILVER FOOD, GAMES

BAILEY LAUERMAN

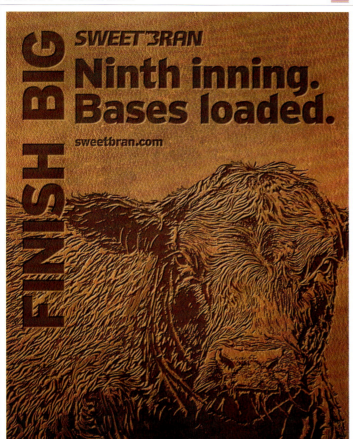

Title: Finish Big | Client: Cargill | Agency: Bailey Lauerman

BAILEY LAUERMAN

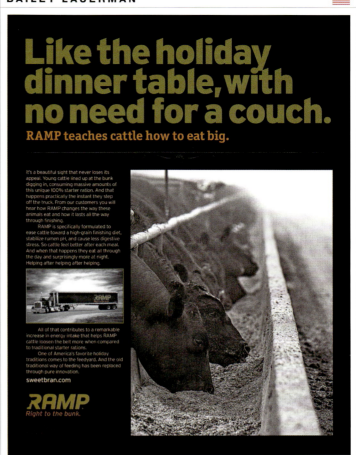

Title: Eat Big | Client: Cargill | Agency: Bailey Lauerman

NETFLIX, BOSS FIGHT ENTERTAINMENT, PETROL ADVERTISING

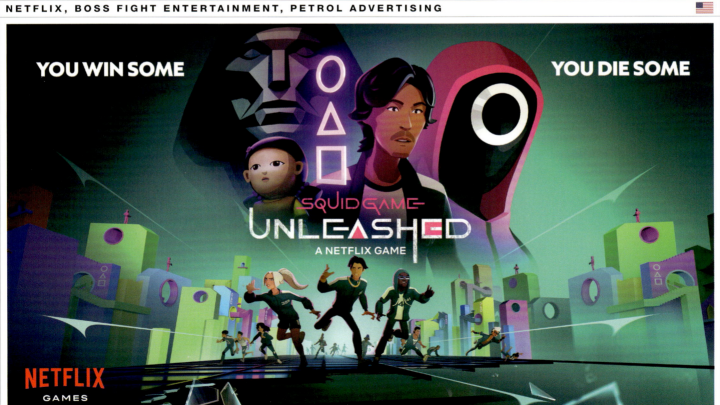

Title: Squid Game: Unleashed - Announce Key Art | Clients: Netflix, Boss Fight Entertainment | Agency: PETROL Advertising

146 SILVER — HEALTHCARE, MUSEUM, MUSIC

ERIC SCHUTTE

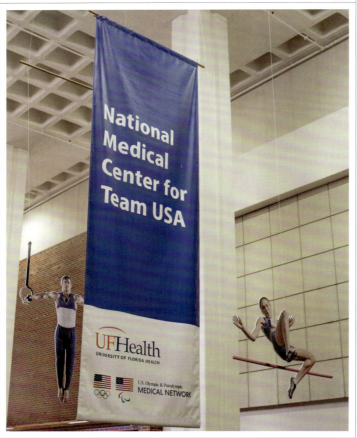

Title: National Medical Center of Team USA
Client: University of Florida Health
Agency: DeVito/Verdi

BORIS LJUBICIC

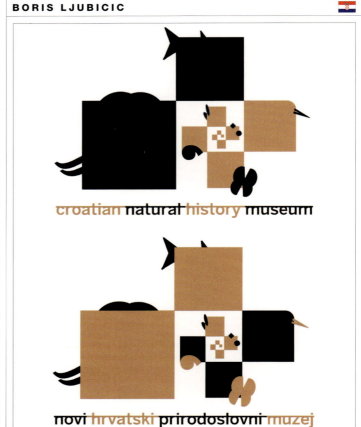

Title: Hrvatski Prirodoslovni Muzej - Croatian Natural History Museum
Client: Hrvatski Prirodoslovni Muzej (Croatian Natural History Museum)
Agency: STUDIO INTERNATIONAL

DANIELLE SMITH

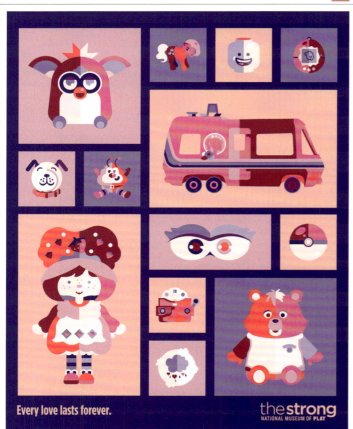

Title: Every Toy
Client: Strong National Museum of Play
Agency: Partners + Napier

LUIS CAMANO

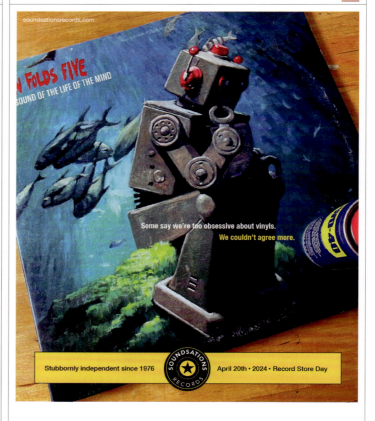

Title: Obsessed
Clients: Soundsations Records, Pete Grasso, Lee Wilson
Agency: Bald&Beautiful

147 SILVER MUSIC, PRODUCT, PROMOTION

EDUARD CEHOVIN

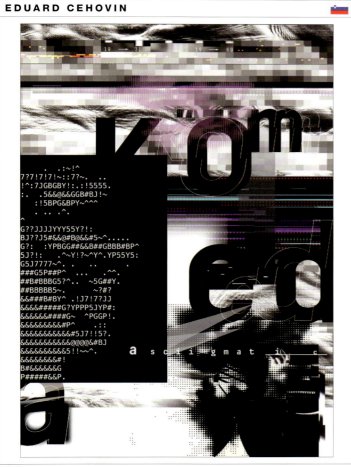

Title: ASCII-Gmatic | **Client:** EuroJAZZ Foundation
Agency: Studio Eduard Cehovin

MYTHIC

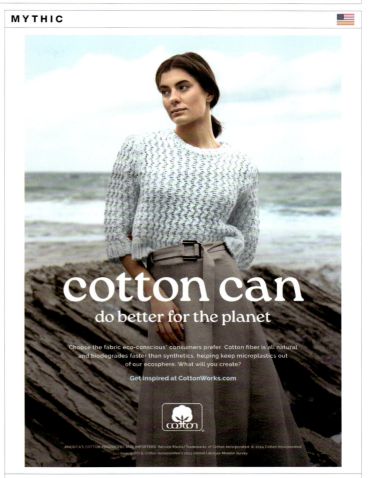

Title: Cotton Can | **Client:** Cotton Incorporated
Agency: Mythic

SJI ASSOCIATES

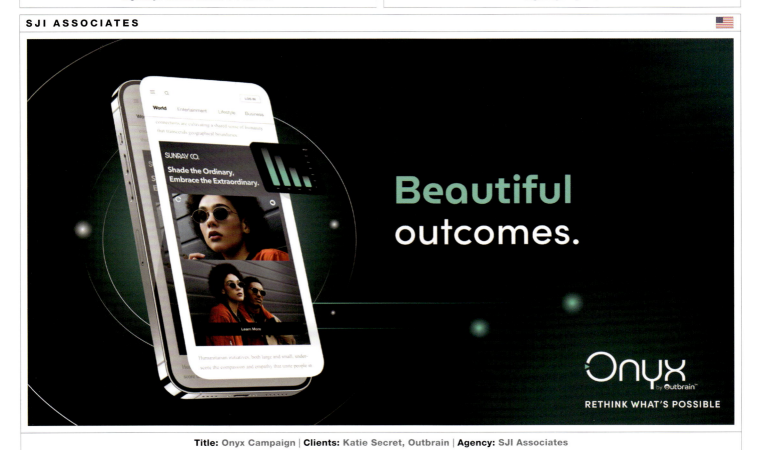

Title: Onyx Campaign | **Clients:** Katie Secret, Outbrain | **Agency:** SJI Associates

148 SILVER — PROMOTION, PUBLIC SERVICES

GAABOO INC.

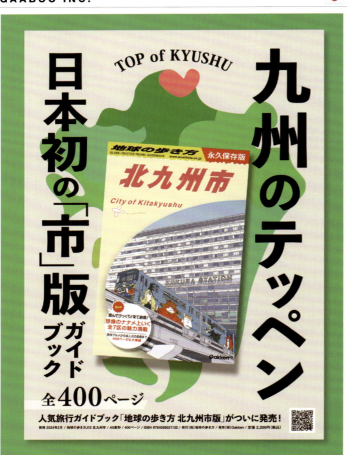

Title: TOP of KYUSHU | Client: Kitakyushu City | Agency: Gaaboo Inc.

MARIA SALGADO

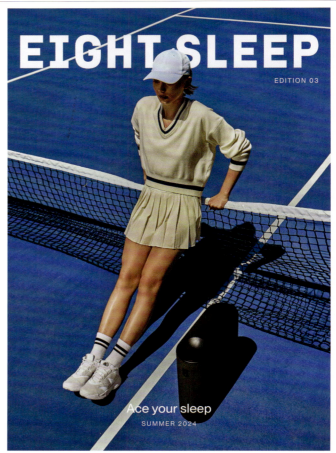

Title: Ace Your Sleep | Client: Self-initiated | Agency: Eight Sleep

ARIEL FREANER

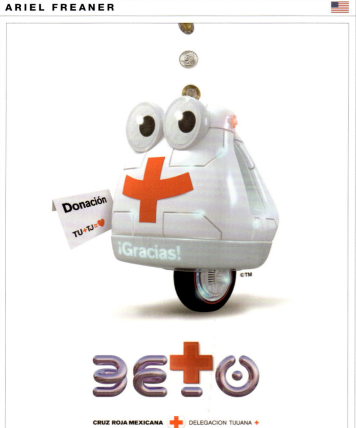

Title: Red Cross San Diego - Tijuana Binational Campaign Poster Series
Clients: Red Cross of Tijuana, Jorge Astiazaran
Agency: Freaner Creative & Design

ANNA STILIANAKI

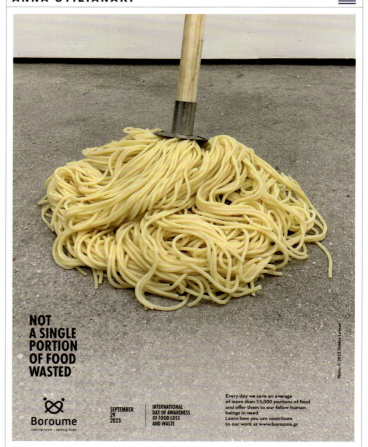

Title: SPAGHETTI MOP
Client: BOROUME
Agency: OUT TO LUNCH

149 SILVER PUBLIC SERVICES

SUKLE ADVERTISING

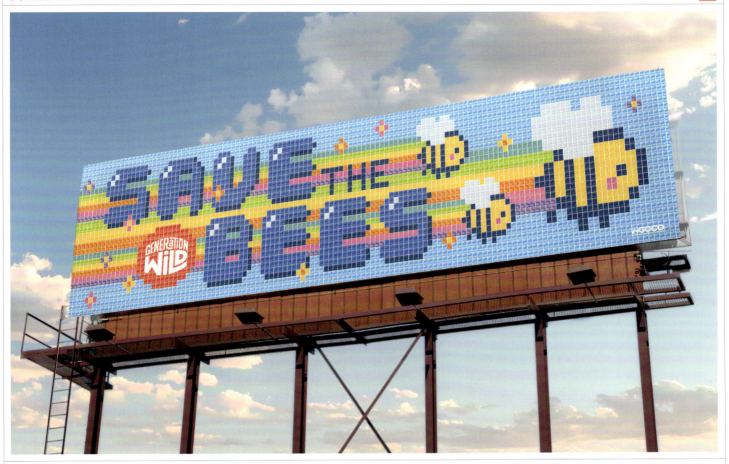

Title: Save the Bees. Spread Wildflowers. | **Client:** Great Outdoors Colorado | **Agency:** Sukle Advertising

BOUNDLESS LIFE SCIENCES GROUP

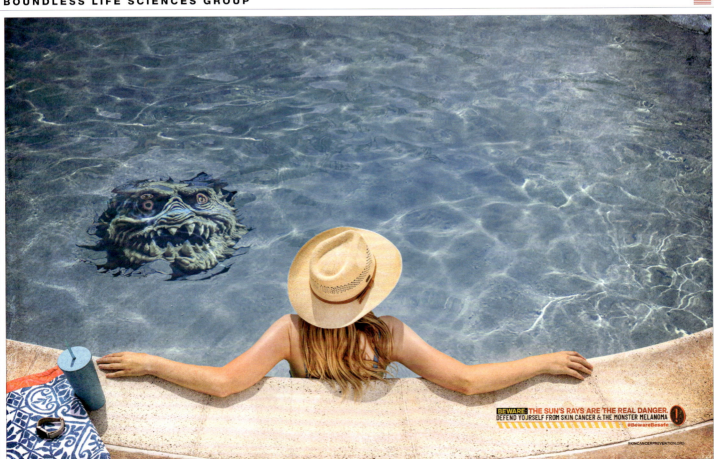

Title: Monster Melanoma Pool Decals | **Client:** National Council on Skin Cancer Prevention | **Agency:** Boundless Life Sciences Group

150 SILVER — PUBLIC SERVICES, PUBLISHING

ARIEL FREANER 🇺🇸

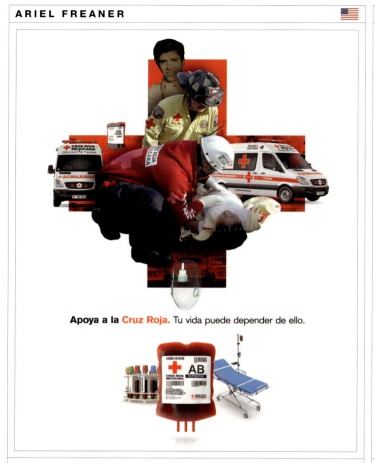

Title: Tijuana Red Cross Corporate Posters
Clients: Red Cross of Tijuana, Jorge Astiazaran
Agency: Freaner Creative & Design

ARIEL FREANER 🇺🇸

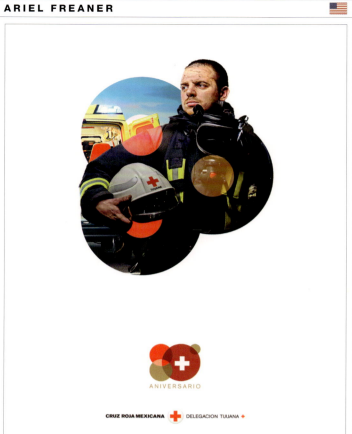

Title: Red Cross 80 Anniversary Poster Series Celebrating 80 Years of...
Clients: Red Cross of Tijuana, Jorge Astiazaran
Agency: Freaner Creative & Design

KURT NIEDERMEIER 🇺🇸

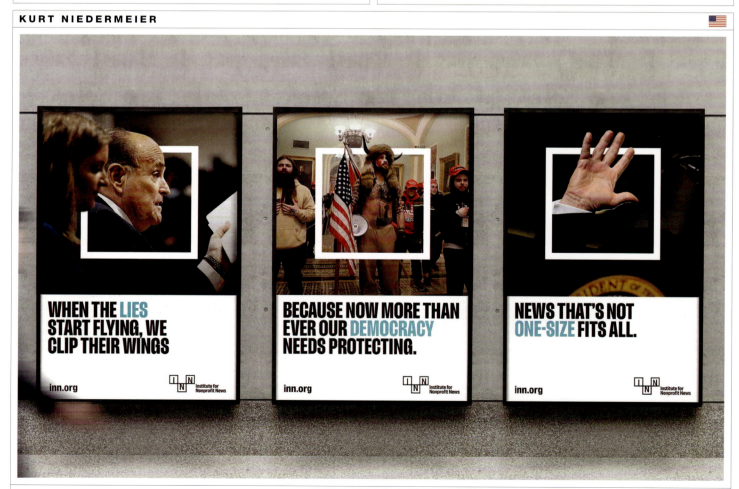

Title: Institute for Nonprofit News (INN) Awareness Campaign | **Client:** Institute for Nonprofit News (INN) | **Agency:** NIEDERMEIER DESIGN

TOOLBOX DESIGN

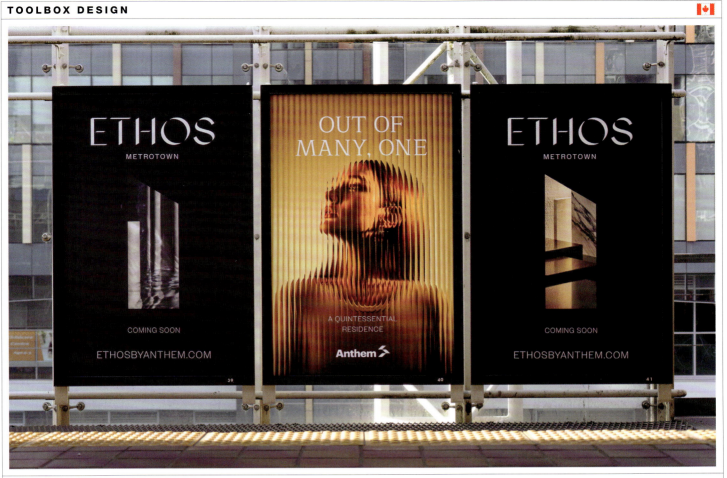

Title: ETHOS By Anthem | **Client:** Anthem Properties Group | **Agency:** Toolbox Design

TOOLBOX DESIGN

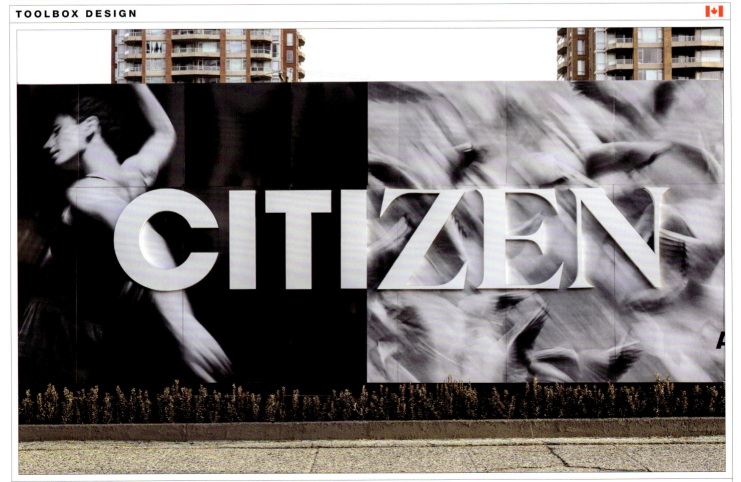

Title: Citizen By Anthem | **Client:** Anthem Properties Group | **Agency:** Toolbox Design

BE SOMEONE DESIGN CO.

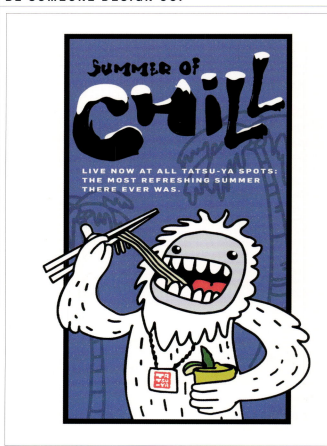

Title: Ramen Tatsu-ya Summer of Chill Campaign
Client: Ramen Tatsu-ya | **Agency:** Be Someone Design Co.

BILL KRESSE

Title: Wingman In-Store Engagement
Client: Wingman Gifts & Supplies | **Agency:** Disrupt Idea Co.

ROB JACKSON

Title: Quad Squad Summer Promos | **Client:** Sweetwaters Coffee & Tea
Agency: Extra Credit Projects

BRUNNER

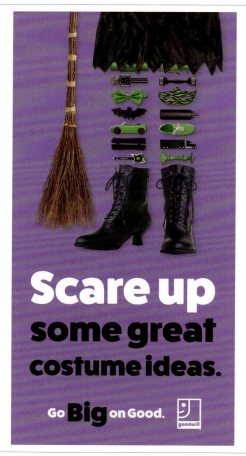

Title: Go Big on Good | **Client:** Goodwill of North Georgia
Agency: Brunner

153 SILVER — RETAIL, SELF PROMOTION

ROB JACKSON

Title: Year of the Dragon 2024 Campaign | Client: Sweetwaters Coffee & Tea | Agency: Extra Credit Projects

CRAIG BROMLEY PHOTOGRAPHY

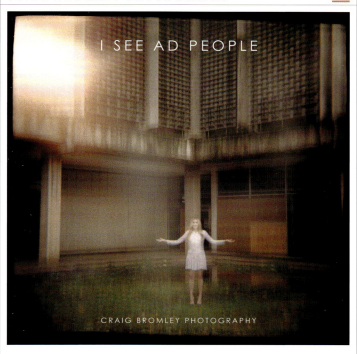

Title: I SEE AD PEOPLE | Client: Self-initiated
Agency: Craig Bromley Photography

RAFAEL FERNANDES

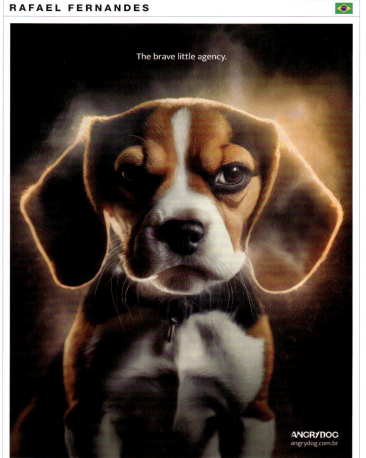

Title: The Brave Little Agency | Client: Self-initiated
Agency: Angry Dog

154 SILVER | TRAVEL

GREENHAUS

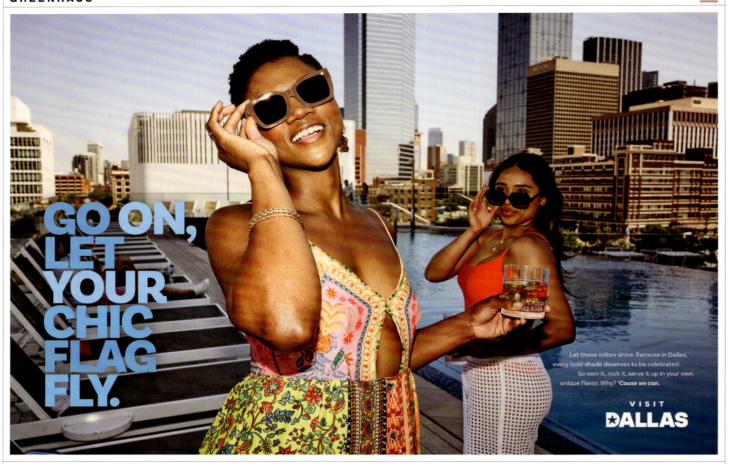

Title: 'Cause We Can | **Clients:** Visit Dallas, Jennifer Walker | **Agency:** Greenhaus

ROB JACKSON

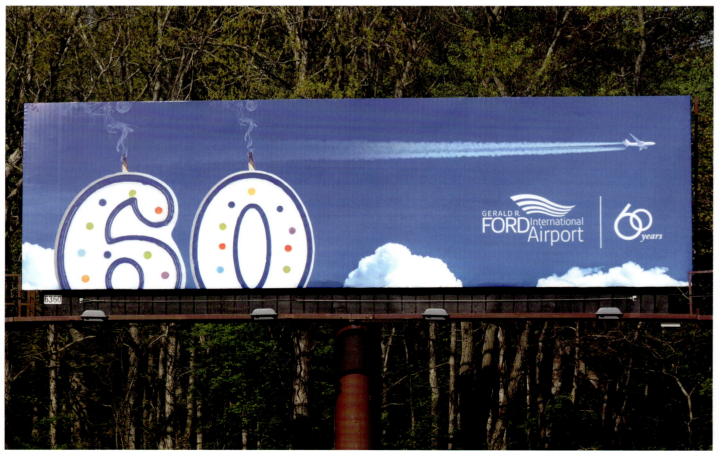

Title: 60th Anniversary Candles OOH | **Client:** Gerald R. Ford International Airport | **Agency:** Extra Credit Projects

Graphis Film/Vide

156 OGILVY BRAZIL PLATINUM

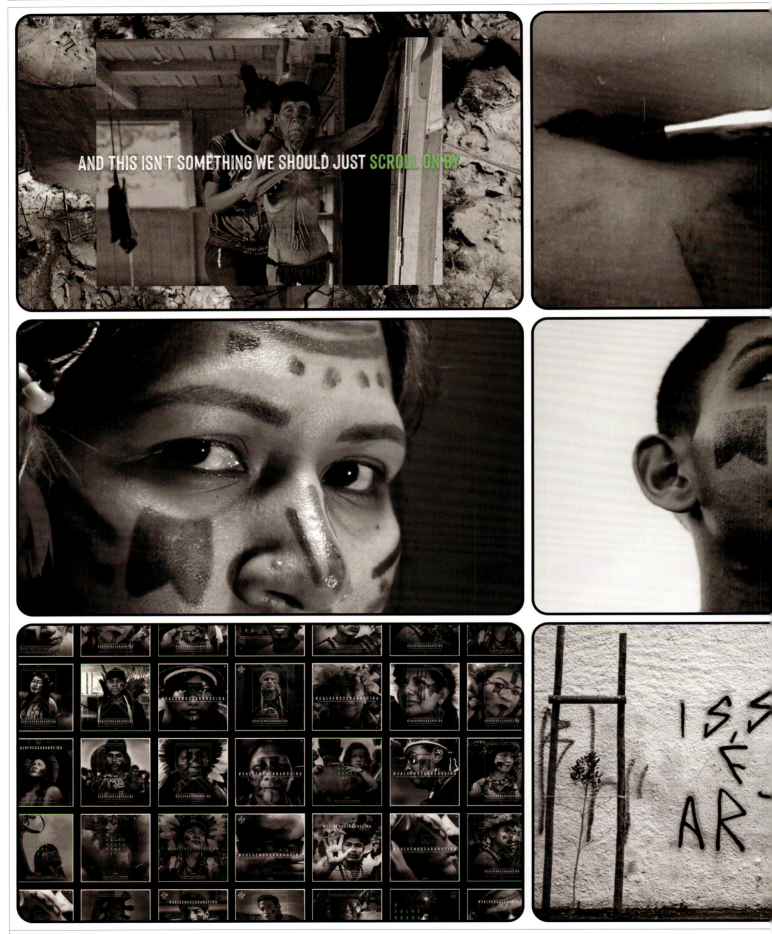

Title: #SavedFlags | **Clients:** Indigenous Peoples Movement, Indigenous Ancestry, TYBYRA Collective, Indigenous Media, ANIN, + 7 | **Agency:** Ogilvy Brazil

Assignment: As the entire world knows, the Indigenous people of the Amazon are not only suffering from land abuses but their very culture and survival are at stake. So, our goal was to make them more visible to the world and, therefore, help their cause gain more support.
Approach: Instagram's save button resembles a flag, so we hacked that icon and turned it into a symbol for the Indigenous movement.

ENVIRONMENTAL

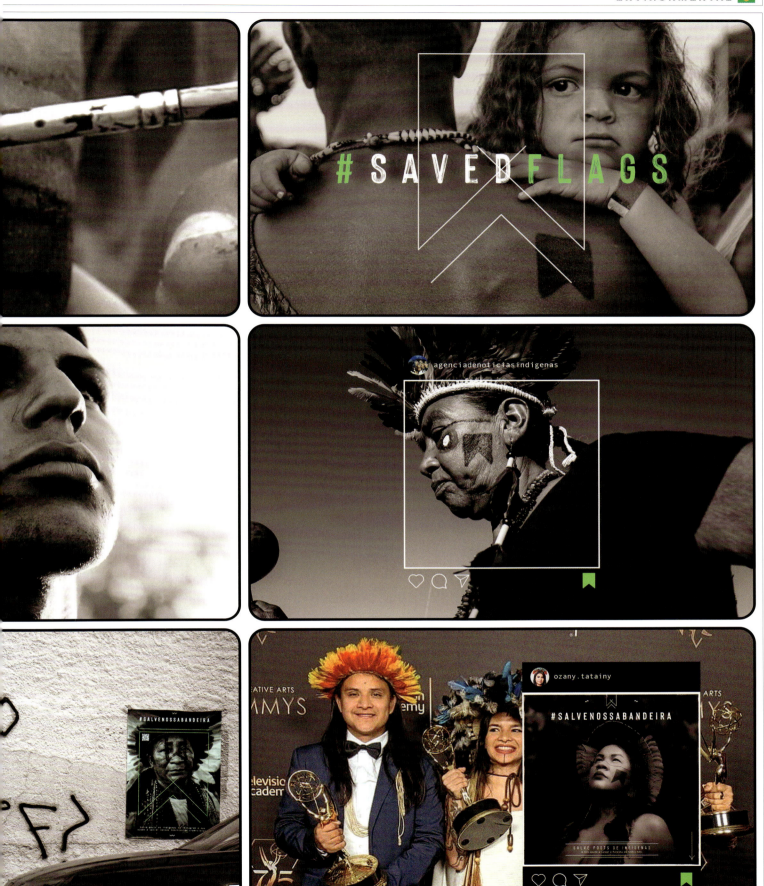

P182: Credit & Commentary

The symbol was painted on the natives' bodies, and the whole process was photographed by professionals from their community.
Results: The campaign went viral and tribal, gaining support from an Indigenous Emmy winner and influencers on Instagram. We achieved a 2,100% increase in views of Indigenous content and a 1,000% increase in searches about the demarcation of lands.

158 GOLD

BAILEY LAUERMAN — AUTOMOTIVE PRODUCTS

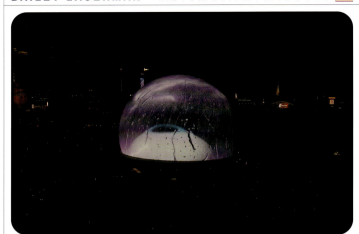
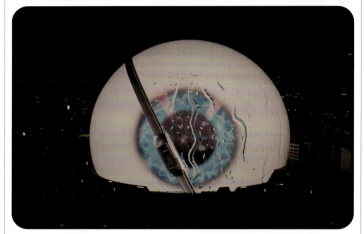
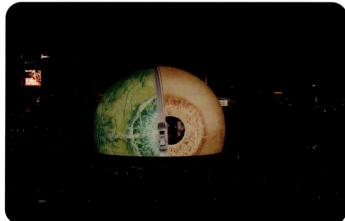
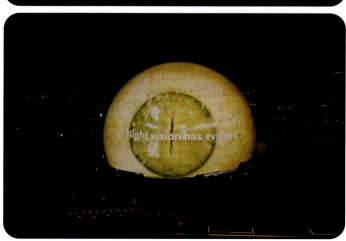

Title: Night Vision has Evolved
Client: Bosch
Agency: Bailey Lauerman
P182: Credit & Commentary

KABOOKABOO — BEVERAGE

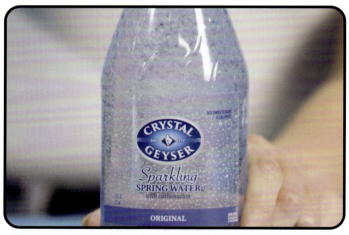

Title: Crystal Geyser ASMR Video
Client: Crystal Geyser
Agency: Kabookaboo
P182: Credit & Commentary

159 GOLD

BRAD BERG, SUNNY YANG + 3 — COMPUTERS

Title: Avira Free Security
Client: Avira
Agency: ID8 (In-house for Gen Digital)
P182: Credit & Commentary

PAULA WALLACE — EDUCATION

Title: This is SCAD
Client: Self-initiated
Agency: Savannah College of Art & Design
P182: Credit & Commentary

160 GOLD

ERIC SCHUTTE — EDUCATION

Title: Metal
Client: Lincoln Tech
Agency: DeVito/Verdi
P182: Credit & Commentary

ERIC SCHUTTE — EDUCATION

Title: Escape Restaurant
Client: Lincoln Tech
Agency: DeVito/Verdi
P182: Credit & Commentary

ERIC SCHUTTE — EDUCATION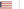

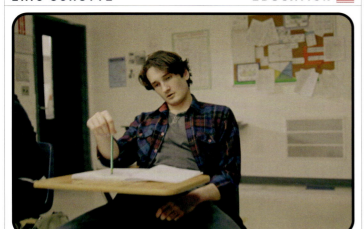
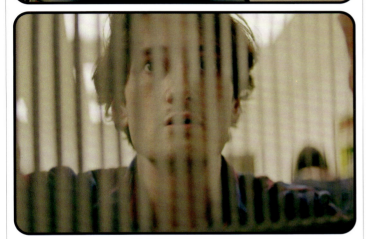

Title: Escape High School
Client: Lincoln Tech
Agency: DeVito/Verdi
P182: Credit & Commentary

ERIC SCHUTTE — EDUCATION

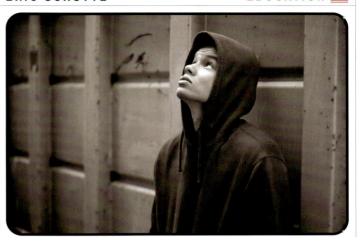

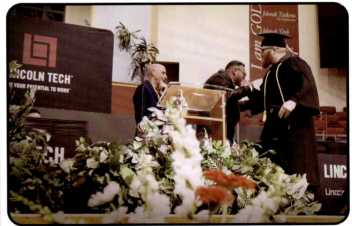

Title: Amazing Grace
Client: Lincoln Tech
Agency: DeVito/Verdi
P182: Credit & Commentary

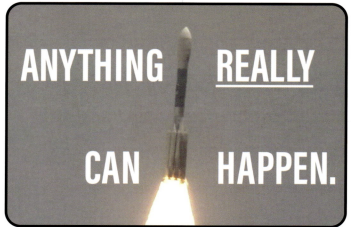

Title: Anything Really Can Happen
Client: Fayetteville State University
Agency: The Republik
P182: Credit & Commentary

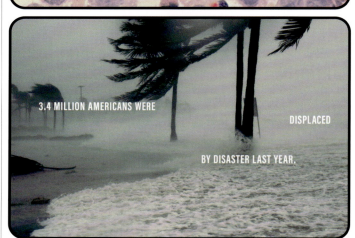
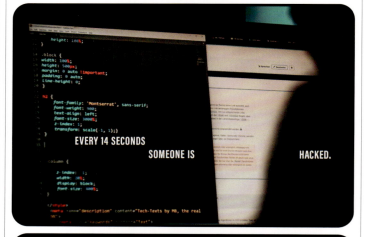
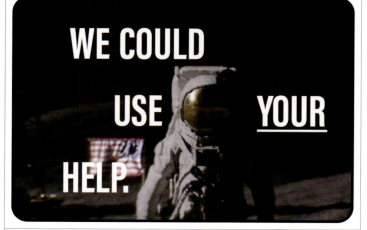

Title: We Could Use Your Help
Client: Fayetteville State University
Agency: The Republik
P182: Credit & Commentary

163 GOLD

| THE STORYHAUS AGENCY, CARLOW UNIV. EDUCATION 🇺🇸 | DAVID BERNSTEIN FINANCIAL SERVICES 🇺🇸 |

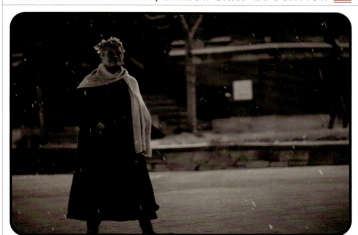

Title: Holiest of Nights at Carlow University
Client: Carlow University
Agency: The Storyhaus Agency
P182: Credit & Commentary

Title: Stress Test Campaign
Client: Federated Hermes, Inc.
Agency: The Gate
P182: Credit & Commentary

164 GOLD

ERIC SCHUTTE — FINANCIAL SERVICES

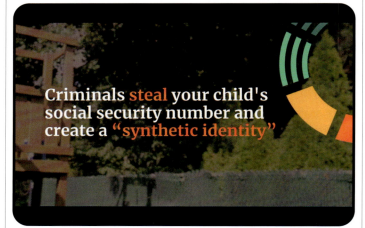
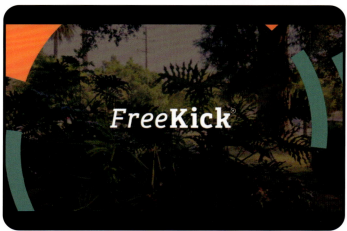

Title: FreeKick
Client: Austin Capital Bank
Agency: DeVito/Verdi
P182: Credit & Commentary

&BARR — FINANCIAL SERVICES

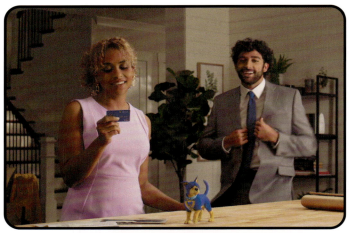

Title: Watch Dog
Client: Space Coast Credit Union
Agency: &Barr
P182: Credit & Commentary

165 GOLD

EMPTYVESSEL, PETROL ADVERTISING — GAMES

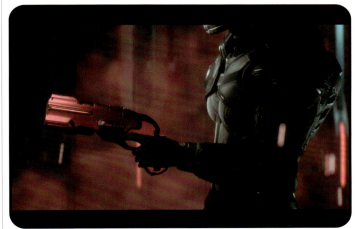
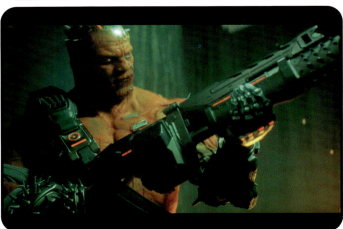

Title: DEFECT - Official Reveal Trailer
Client: EmptyVessel
Agency: PETROL Advertising
P182: Credit & Commentary

NETFLIX, BOSS FIGHT ENTMT., PETROL AD. — GAMES

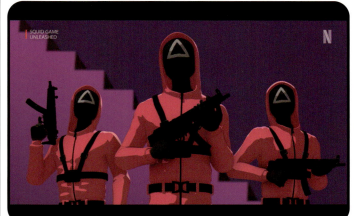
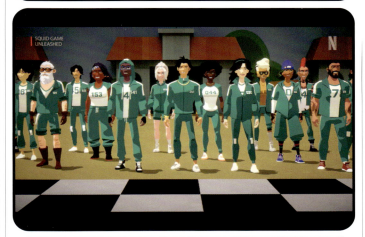
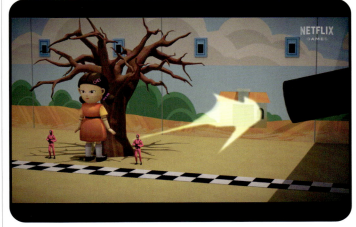
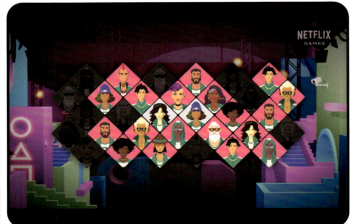

Title: Squid Game: Unleashed - Official Ann. Trailer
Clients: Netflix, Boss Fight Entertainment
Agency: PETROL Advertising
P182: Credit & Commentary

166 GOLD

ERIC SCHUTTE **HEALTHCARE**

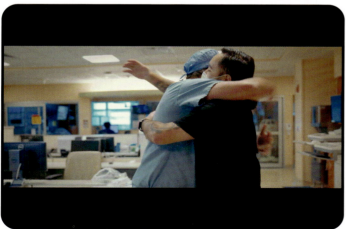

Title: Human Progress Has No Finish Line
Client: University of Florida Health
Agency: DeVito/Verdi
P183: Credit & Commentary

ROB SLOSBERG **HEALTHCARE**

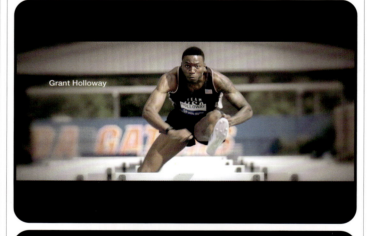

Title: Hurdles of Life
Client: University of Florida Health
Agency: DeVito/Verdi
P183: Credit & Commentary

167 GOLD

THE REPUBLIK — **HEALTHCARE**

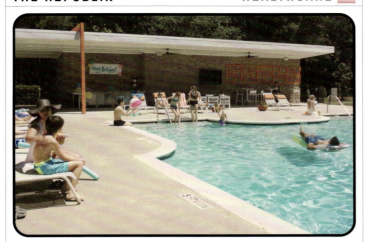

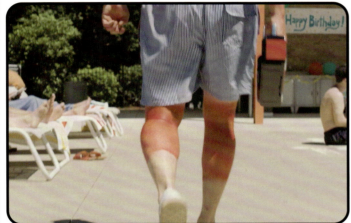

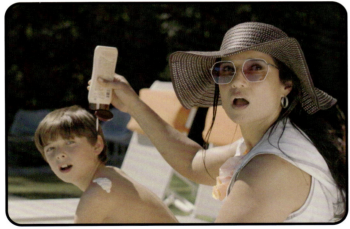

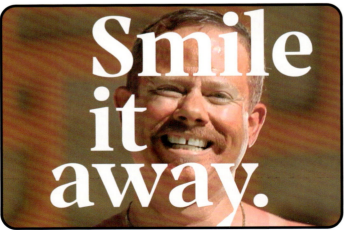

Title: Village Dental Television :30 Pool
Client: Village Dental
Agency: The Republik
P183: Credit & Commentary

THE REPUBLIK — **HEALTHCARE**

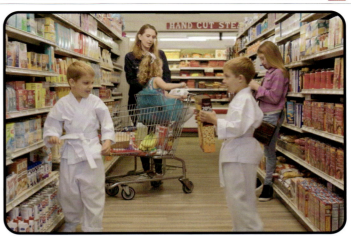

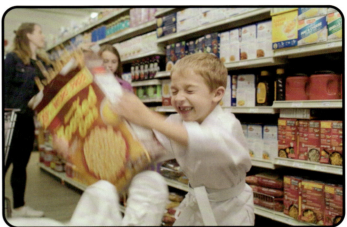

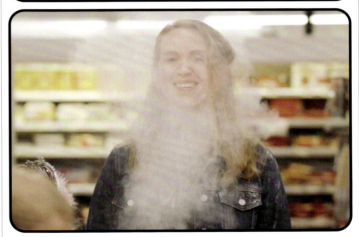

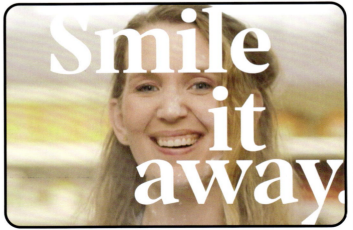

Title: Village Dental Television :30 Grocery
Client: Village Dental
Agency: The Republik
P183: Credit & Commentary

168 GOLD

BRAD BERG, SUNNY YANG + 3 PRODUCT

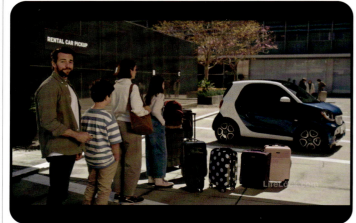

Title: Out of Control Campaign - Car Rental :30
Client: LifeLock
Agency: ID8 (In-house for Gen Digital)
P183: Credit & Commentary

BRAD BERG, SUNNY YANG + 3 PRODUCT

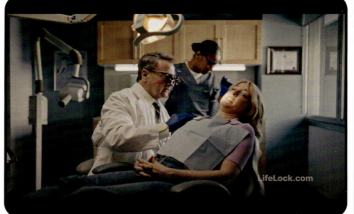
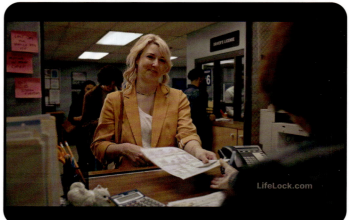
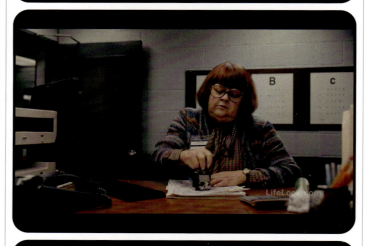

Title: Out of Control Campaign - Dentist :30
Client: LifeLock
Agency: ID8 (In-house for Gen Digital)
P183: Credit & Commentary

169 GOLD

ROY BURNS III — PROMOTION

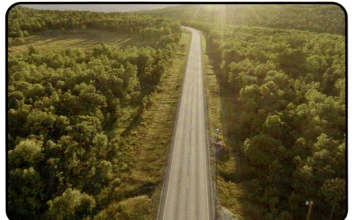
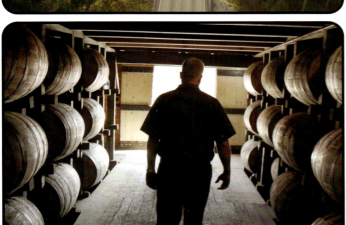

Title: Kentucky Bourbon Trail — Brand Launch Video
Client: Kentucky Distillers' Association
Agency: Lewis Communications
P183: Credit & Commentary

ROY BURNS III — TRAVEL

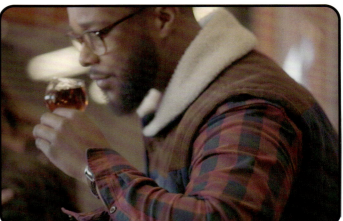

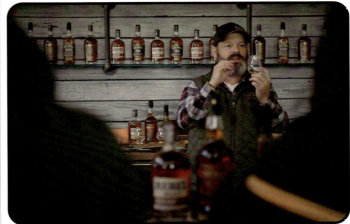

Title: Kentucky Bourbon Trail — :30 Video
Client: Kentucky Distillers' Association
Agency: Lewis Communications
P183: Credit & Commentary

170 SILVER AI, AUTOMOTIVE PRODUCTS, EDUCATION

WEIGHTS&PULLEYS, PALO ALTO NETWORKS

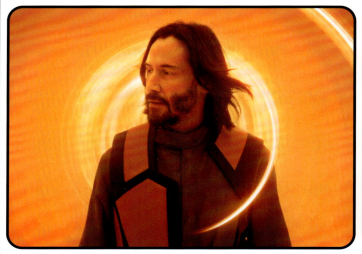
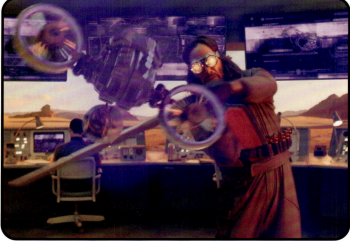

Title: This is Precision AI: Launch Campaign
Client: Palo Alto Networks
Agency: Weights&Pulleys

BAILEY LAUERMAN

Title: Promises In Lights
Clients: Phillips 66, Hunter Oil
Agency: Bailey Lauerman

ERIC SCHUTTE

Title: Anti-AI
Client: Lincoln Tech
Agency: DeVito/Verdi

171 SILVER EDUCATION, FOOD, HEALTHCARE

ERIC SCHUTTE

Title: Missing Persons
Client: Lincoln Tech
Agency: DeVito/Verdi

BRUNNER

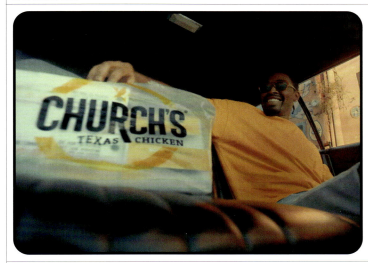
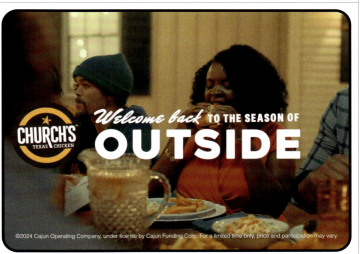

Title: The Season of Outside
Client: Church's Texas Chicken
Agency: Brunner

MANAS PARADKAR

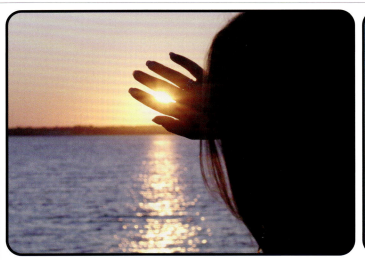
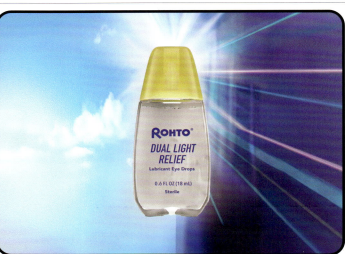

Title: Fear No Light
Client: Rohto Eye Drops
Agency: The BAM Connection

172 SILVER · PHARMACEUTICALS, PROFESSIONAL SERVICES, PUBLIC SERVICES

BRUNNER

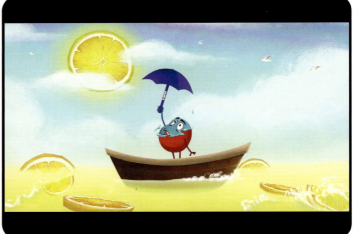

Title: The Cranky Canker Sore
Client: Blistex
Agency: Brunner

&BARR

Title: Miniature Moments
Client: Massey Services
Agency: &Barr

SUKLE ADVERTISING

Title: Unfortunate Endings: Goldilocks
Client: Wyoming Department of Health
Agency: Sukle Advertising

173 SILVER PUBLIC SERVICES, REAL ESTATE, PROMOTION

SUKLE ADVERTISING 🇺🇸

Title: Unfortunate Endings: Snow White
Client: Wyoming Department of Health
Agency: Sukle Advertising

TOOLBOX DESIGN 🇨🇦

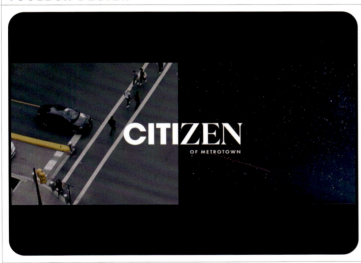
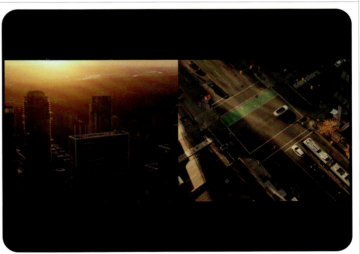

Title: Citizen by Anthem
Client: Anthem Properties Group
Agency: Toolbox Design

ARIEL FREANER 🇺🇸

Title: Red Cross Tijuana - San Diego Binational Campaign
Clients: Red Cross of Tijuana, Jorge Astiazaran
Agency: Freaner Creative & Design

Graphis Honorable Mentions

175 HONORABLE MENTIONS

Nikkeisha, Inc.

Nikkeisha, Inc.

Freaner Creative & Design

Célie Cadieux

Freaner Creative & Design

Boundless Life Sciences Group

Devon Ward

Roger Archbold

Media.Work

Partners + Napier

Freaner Creative & Design

Shenghan Gao

Freaner Creative & Design

Freaner Creative & Design

Credits & Commentary

177 CREDITS & COMMENTARY

PLATINUM WINNING WORKS:

30 FARGO | Ad Agency: ARSONAL | Art Director: ARSONAL | Client: FX Network
Others: Michael Brittain - Creative Director / SVP Print Design, Rob Wilson - VP Print Design, Sarin Markarian - Director Print Design, Laura Handy - Project Director/Print Design, Lisa Lejeune - Production Director/Print Design, Stephanie Gibbons - Creative Director/President, Creative, Strategy & Digital Marketing
Primary Credits: ARSONAL, FX Network
Assignment: For the 5th season, the goal for the key art campaign was to highlight how extreme the characters are as well as showcase the contrast between their personalities.
Approach: We pulled iconography from the story that symbolizes and communicates the tone of this season.
Results: The art successfully exhibits the quirkiness of the characters with an underlying sense of drama. The figurine art, in particular, was a bit hit.

31 DISARMED SHORT FILM KEY ART | Ad Agency: Barlow.Agency
Art Director: Barlow.Agency | Client: Last One Standing Productions
Primary Credit: Barlow.Agency
Assignment: We aimed to distill a short film's essence, portraying a woman grappling with PTSD from gun violence and self-sabotaging mental health.
Approach: Constrained by budget, we crafted an image using stock photography. The final image captures the narrative of self-sabotage and becoming one's own worst enemy.
Results: The artwork made its debut on social media, boosting promotion for the upcoming film and contributing to its acceptance into various short film festivals worldwide.

32-35 LIFE ON OUR PLANET | Ad Agency: Canyon
Art Directors: Julia Lambright, Molly Purcell | Client: Netflix
Marketing: Max Pezim, Joelle Shapiro, Netflix Marketing | Primary Credit: Canyon
Assignment: The goal was to create a campaign that would promote the series but also immerse viewers in the experience of exploring life on our planet across different eras.
Approach: The creative process began with an in-depth analysis of the series' content. The challenge was to create visuals that would seamlessly blend these two worlds. The visuals were meticulously designed to evoke a sense of wonder and discovery.
Results: Overall, the campaign not only met its objectives but also set a new standard for how nature documentaries can be marketed.

36, 37 QUEENS | Ad Agency: Canyon | Art Director: Canyon
Client: National Geographic | Primary Credit: Canyon
Assignment: The goal was to celebrate female power in the natural world by capturing the strength, resilience, and authority of the queens who lead and protect their families.
Approach: The campaign kicked off with a teaser featuring a lioness. The key art and character banners highlighted the queens' majestic presence and their wild queendom.
Results: The campaign was successful and received a positive reception.

38-41 DEFECT - ANNOUNCE KEY ART SERIES | Ad Agency: PETROL Advertising
Art Directors: PETROL Advertising, EmptyVessel | Client: EmptyVessel
Primary Credits: EmptyVessel, PETROL Advertising
Assignment: Create a Series of Key Art for the announcement of DEFECT.
Approach: We selected to create a Key Art Series -- one Key Art dedicated fully to the World and then combo Key Arts that showcase both Character and World.
Results: The Key Art was well received and used in all DEFECT Channel Branding.

42-45 CHAMPIONS OF WINTER | Ad Agency: Eight Sleep
Art Director: Jisoo Sim | Client: Self-initiated | Lead Designer: Maria Salgado
Photographer: Elena Iv-skaya | Brand Strategy: Frances Arnautou, Sabina Blankenberg
Director of Brand Marketing: Ryan Groffie | Primary Credit: Maria Salgado
Assignment: For Winter 2023, Eight Sleep launched their "Champions of Winter", the second edition of Eight Sleep's artistic representation of sleep throughout the seasons.
Approach: The shorter days and harsh weather of winter can drain energy and affect motivation, but the Pod ensures that users recharge fully each night. With restful sleep, users wake up ready to tackle any challenge, making them true champions of winter.
Results: This marketing campaign ensure a consistent and compelling brand experience.

46, 47 HALF TEA | Ad Agency: Chang Liu | Art Director: Chang Liu
Client: HALF TEA LLC | Primary Credit: Chang Liu
Assignment: Most tea brands suffer from excessive product volume, high prices, and outdated packaging. Half Tea is a company that wants to fix that.
Approach: 'Half' represents the the logo icon and and the Chinese character for tea. The use of strong colors and brand graphics helps consumers select the type of tea or product. The design included brand identity, packaging, information cards, and posters.
Results: Packaging concept designs and possibledirections for promotional posters.

48, 49 SPECIAL RETIREMENT GIFT | Ad Agency: PPK | Art Director: Javier Quintana
Client: Big Cat Rescue | Executive Creative Director: Paul Prato
Creative Directors: Michael Schillig, Javier Quintana | Copywriter: Michael Schillig
President: Garrett Garcia | Other: Tom Kenney - Agency Owner/CEO
Primary Credits: Michael Schillig, Javier Quintana
Assignment: Our assignment was to come up with a way to make people aware of how big cats who become too old to perform in circuses often face a not-so-happy retirement.
Approach: This poster helps convey how, for many circus cats, there is just literally a bullet—to the head. We wanted to help Big Cat Rescue educate people on the truth of what can happen to big cats once they lose their value in the eyes of some circuses.
Results: We hope this poster entices people to visit BigCatRescue.org to learn the real truth and find out how they can help support big cats.

50, 51 ARTERIORS OUTDOOR ADVERTISING | Ad Agency: Vanderbyl Design
Art Director: Michael Vanderbyl | Client: Arteriors | Designer: Tori Koch
Photographer: Geof Kern | Primary Credit: Michael Vanderbyl
Assignment: Advertising program developed to establish the Arteriors Outdoor brand, a high-end residential furniture manufacturer.
Approach: Our concept was to push the company in a high-fashion direction using models and company products to illustrate the brand statement.
Results: The new ad program has been received with great enthusiasm and recognition.

52-55 "GATHERING OF WARBIRDS & VAPOR PLUMES" (7 IMAGES)
Ad Agency: Darkhorse Design | Art Director: Robert Talarczyk
Clients: High And Mighty Photo.Com, Self-initiated | Photographer: Robert Talarczyk

Camera: NIKON | Studio: High And Mighty Photo.Com
Others: Aircraft Pilots: A6M Zero, Pilot Mark Murphy, F/A-18 Hornet, Blue Angels #4, Pilot Lt.Lance Benson, USN, F35A Lightning II USAF, Pilot Capt. Melanie "Mach" Kluesner, F16, Fighting Falcon, USAF Thunderbirds Pilot Unkown, P51D, Pilot Mark Murphy, FG1D Corsair, Pilot Charles Lynch, TP-40N Warhawk, Pilot Thom Richard
Primary Credit: Robert Talarczyk
Assignment: Create promotional awareness for Darkhorse Design, LLC. & High And Mighty Photo.Com as serious players in Aviation Photography and Graphic Design.
Approach: We selected strong images of WW2 and contemporary warbirds with high speed vapor plumes depicting strength and power while symbolizing our brand.

56, 57 KENTUCKY BOURBON TRAIL — POSTERS | Ad Agency: Lewis Communications
Art Director: Roy Burns III | Client: Kentucky Distillers' Association
Design Director: Roy Burns III | Creative Directors: Stephen Curry, Robert Froedge
Copywriter: Stephen Curry | Photo Retouching: Andy Cargile
Vice Presidents Brand Creative: Tom Johnson, Ryan Gernenz
Vice President: Katie Peninger | Partner: Robert Froedge
Account Director: Nick Michel | Primary Credit: Roy Burns III
Assignment: The Kentucky Bourbon Trail® celebrated its 25th anniversary with the unveiling of a new identity and rebrand.
Approach: Born of hundreds of hours of extensive research, site visits, and interviews, the advertising elements reinforce the new brand positioning while serving as an invitation to discover the birthplace of America's Native Spirit.
Results: The rebrand and advertising has been enthusiastically received.

GOLD WINNING WORKS:

59 QUESTIONS CONQUERED | Ad Agency: Traction Factory
Art Director: Mike Basse | Client: Snap-on Diagnostics | Creative Director: David Brown
Copywriter: S.J. Barlament | Retouching: Hac Job | Project Manager: Pam Sallis
Account Director: Shannon Egan | Primary Credit: Mike Basse
Assignment: Promote Snap-on Diagnostics' access to resources that are continuously updating with the latest repairs, parts, and components.
Approach: The campaign messaging and imagery needed to be intuitive and elegant in its simplicity yet disruptive in a category tending to be feature-laden.
Results: The sales channel in North America adopted the campaign to use globally.

60, 61 TESLA DESIGN STUDIO 15 YEARS ANNIVERSARY | Ad Agency: Qianzi Chao
Art Director: Qianzi Chao | Client: Tesla Design Studio | Primary Credit: Qianzi Chao
Assignment: Create a banner celebrating the 15th anniversary of the Tesla Design Studio.
Approach: Used white lines to represent a racetrack, with red geometric 3D rendering modules referencing Tesla's brand red, showcasing the structure of the car body.
Results: Selected as the main visual for the event.

62, 63 ESPOLÒN TEQUILA - TO THE BONE CAMPAIGN
Ad Agency: forceMAJEURE Design | Art Directors: Pierre Delebois, Akriti Malhotra
Client: Campari | Senior Designer: Bertha De La Torre | Strategy: Julia Lirekin
Strategy Director: Meilyn Weedge | Agency Producer: Veronica Tavizon
Production Partner: Canada | Group Account Director: Raphaelle Mahieu
Photographer: Lou Escobar | Account Management: Carla Sofia Elizundia
Primary Credit: forceMAJEURE Design
Assignment: Create the first global campaign in Espolòn's history based on the phrase "To the Bone." The campaign includes films and key visuals.
Approach: As part of a sentence, "To the Bone" allows each person who encounters the campaign to consider what qualities they are to their core. The script extends this sentiment giving color, specifics, and mood to the platform inviting each to be themselves.
Results: The campaign brings a dynamic, emotional story to life.

64, 65 FIRE OUT OF HOME | Ad Agency: DeVito/Verdi
Art Director: Matthew Thompson | Client: Foundation for Individual Rights in Education
Primary Credit: Eric Schutte
Assignment: In the aftermath of COVID and one of the largest racial equality movements, America became an environment of political divide, fear, and censorship.
Approach: The Foundation for Individual Rights in Education, FIRE, launched its first national ad campaign aimed at appealing to Americans across the political spectrum.
Results: The campaign exceeded all digital performance benchmarks and target costs.

66 SCIENCE FAIR, THE SERIES | Ad Agency: SJI Associates
Art Director: David O'Hanlon | Clients: National Geographic, Chris Spencer, Brian Everett, Mariano Barreiro, Leah Wojda | President: Suzy Jurist | Copywriter: Adam Selbst
Designers: Matt Birdoff, Chad Hornberger | Project Manager: Hannah Holdsworth
Production Artist: Michael Stampone | Primary Credit: SJI Associates
Assignment: Follow nine high school students as they navigate rivalries, setbacks, and more on their journey to compete at The International Science and Engineering Fair.
Approach: A fun, teen-focused approach featuring bright buttons highlighting the contestants and projects sets the stage for this high-stakes reality show.
Results: This key art drove interest and awareness for the new documentary, and was repurposed for social, digital, and on-air graphics, driving tune-in and streaming views.

67 SECRETS OF THE OCTOPUS | Ad Agency: SJI Associates
Art Director: David O'Hanlon | Clients: National Geographic, Chris Spencer, Brian Everett, Mariano Barreiro, Leah Wojda | President: Suzy Jurist | Designer: David O'Hanlon
Project Manager: Hannah Holdsworth | Production Artist: Michael Stampone
Primary Credit: SJI Associates
Assignment: Explore the world of one of Earth's most surprising creatures, the octopus.
Approach: This key art shows an octopus interacting with its own type treatment.
Results: This key art drove interest and awareness for the series, and was showcased in social, digital, OOH, and on-air graphics, driving tune-in and streaming views.

68 LIFE DOESN'T ALWAYS GO STRAIGHT AHEAD | Ad Agency: Gastdesign
Art Director: Wolfgang Gast | Client: NST Lawyers | Primary Credit: Gastdesign
Assignment: The task was to develop a campaign on the subject of insolvency and to implement NST's mission statement "We create prospects ..." in a positive way.
Approach: The campaign starts with an understanding of the "entrepreneurial risk" of an entrepreneur and at the same time conveys the prospect of a path after insolvency. The image analogy is represented by a winding road photographed from the air.
Results: There was positive feedback and repeated requests for advertising bookings.

178 CREDITS & COMMENTARY

69 FARGO | Ad Agency: ARSONAL | Art Director: ARSONAL | Client: FX Network
Others: Stephanie Gibbons, Creative Director/President, Creative, Strategy & Digital Marketing, Michael Brittain, Creative Director / SVP Print Design, Rob Wilson, VP Print Design, Sarin Markarian, Director Print Design, Laura Handy, Project Director, Print Design, Lisa Lejeune, Production Director, Print Design
Primary Credits: ARSONAL, FX Network
Assignment: For the 5th season, the goal for the key art campaign was to highlight how extreme the characters are as well as showcase the contrast between their personalities.
Approach: We pulled iconography from the story that symbolizes and communicates the tone of this season.
Results: The art successfully exhibits the quirkiness of the characters with an underlying sense of drama. The figurine art, in particular, was a bit hit.

70 TRAILBLAZERS | Ad Agency: Ron Taft Brand Innovation & Media Arts
Art Director: Ron Taft | Client: Creative Projects Group | Creative Director: Ron Taft
Copywriter: Dylan Gerber | Primary Credit: Ron Taft
Assignment: Create compelling key art for ad/poster for TRAILBLAZERS.
Approach: We wanted to create a powerful, iconic image, particular one that suggests a spanning of time, so we paired a basketball from 1904 with a contemporary basketball. We chose copy that was poetic in approach and communicated a sense of sport legacy.
Results: The client executive producer and television group were thrilled.

71 BETTER ANGELS: THE GOSPEL ACCORDING TO TAMMY FAYE
Ad Agency: Célie Cadieux | Art Director: Célie Cadieux | Client: Vice Studios
Primary Credit: Célie Cadieux
Assignment: The goal was to produce a poster that remained faithful to the story of Tammy Faye while breaking away from clichés and previous films about her.
Approach: I used 375+ shots from the series for the image. It represents the way she gathered people and her multifaceted personality, but also of how she was put in a box.
Results: The poster was displayed during the 2024 Sundance Film Festival and on social media where it gained attention.

72, 73 HOUSE OF THE DRAGON | Ad Agency: ARSONAL | Art Director: ARSONAL
Client: HBO | Primary Credits: ARSONAL, HBO
Assignment: Following King Aegon II's coronation and the death of Lucerys Targaryen, S2 follows the 'Greens' and the 'Blacks' as the "Dance of the Dragons" truly begins.
Approach: This was a stunty billboard that ran during Coachella. The idea was to incorporate provocative copy and clearly ground it in the look/feel of the series.
Results: This generated a lot of excitement towards the upcoming second season.

74, 75 AMERICAN IDOL | Ad Agency: Canyon | Art Director: Canyon
Client: ABC Branding & Design | Primary Credit: Canyon
Assignment: The goal was to emphasize the theme of "Going Home" and connect viewers with the personal stories of the participants.
Approach: The team aimed to capture the essence of each location. The solution was to craft key art and character banners styled as vintage postcards.
Results: The campaign strengthened the emotional connection between the audience and the show and reinforced the core message of American Idol.

76 HOW WE MET YOUR DAVE | Ad Agency: Todd Watts & Nick Fox
Art Directors: Todd Watts, Nick Fox | Client: Available For Download
Photo Retouching: Steven Simmonds | Primary Credits: Todd Watts, Nick Fox
Assignment: Capture/emphasize the humor and absurdity in "How We Met Your Dave."
Approach: We were given only a single image to work with, so we tessellated the two main characters into a captivating visual composition with a bold title graphic.
Results: Upon release, the series garnered widespread acclaim, achieving viral success.

77 THE CLEANING LADY S3 | Ad Agency: Rhubarb
Art Director: Rhubarb | Client: FOX Entertainment | Chief Creative Officer: Andrew Irving
Senior Vice President: Ian MacRitchie | Account Director: Geysel Junne
Photographer: Robert Ascroft | Others: Michael Bassett, VP Key Art,
Creative & Production, Alexia Pahl, Director, Key Art Operations
Primary Credits: Rhubarb, Fox Entertainment
Assignment: Continue to engage new and returning audiences with our female lead.
Approach: Build an arresting image of Thony and the dangerous worlds she must navigate as a cleaner and mother fighting to protect her family.
Results: The success of The Cleaning Lady has led to a S4 pick-up.

78 TRUE DETECTIVE NIGHT COUNTRY | Ad Agency: ARSONAL
Art Director: ARSONAL | Client: HBO Max | Photographer: Dan Winters
Primary Credits: ARSONAL, HBO Max
Assignment: The key art needed to leverage the True Detective brand while also distinguishing Night Country as an evolution of the franchise.
Approach: We reflected the dark, cold tones of the Arctic along with the duality between light and dark/hard and soft themes of the show. We also highlighted our female leads.
Results: The key art created a lot of excitement around the return of the franchise.

79 MONSIEUR SPADE | Ad Agency: ARSONAL | Art Director: ARSONAL
Clients: AMC, AMC+ | Illustrator: Michael Koelsch | Others: Ed Sherman, VP Brand & Design, Mark Williams, EVP Creative, Nancy Hennings, VP Production Brand & Design
Primary Credits: ARSONAL, AMC, AMC+
Assignment: Monsieur Spade shows Detective Sam Spade in a completely new light. To reflect that, we needed to find a unique approach for the art itself.
Approach: Instead of leaning into traditional noir visuals, we created a hand-painted portrait of Det. Spade unlike we've ever seen him - naked and completely vulnerable.
Results: The final piece was well received and has received many accolades.

80, 81 KITCHEN HEROES | Ad Agency: OUT TO LUNCH | Art Director: Tasos Georgiou
Client: Prasino Ladi | Creative Directors: Anna Stilianaki, Tasos Georgiou
Digital Artists: Konstantinos Protogeridis, Ampoo Studio
Account Director: Irini Sohoriti | Primary Credit: Anna Stilianaki
Assignment: Create a campaign to inform people on the environmental benefits of recycling frying oil for biodiesel production and urge them to make it part of their lives.
Approach: We presented the process as a daily gesture with tangible environmental results. Cooks can become heroes, helping to save the environment from their kitchens.
Results: The client had a major brand awareness increase.

82, 83 BALLOONS ARE MONSTERS | Ad Agency: Arcana Academy
Art Director: Lee Walters | Client: Balloon Brigade
Primary Credits: Lee Walters, Shane Hutton
Assignment: Runaway balloons are the #1 killer of seabirds and harm dolphins, whales, and turtles. Our assignment is to create awareness of this issue for Balloon Brigade.
Approach: We created artwork using Midjourney AI to help reduce illustration costs and chose an aesthetic influenced by vintage Japanese monster movie posters.
Results: The clients were ecstatic and plan to use the art in clothing and stickers as well.

84 TIME FOR ART | Ad Agency: Disrupt Idea Co. | Art Director: Scott Baitinger
Client: Minutes + Hours | Creative Director: Bill Kresse | Designer: Kris Ender
Writer: Bill Kresse | Artists: Magwire Art, Scott Rohlfs, Leroy's Place
Primary Credit: Scott Baitinger
Assignment: Inform watch and art enthusiasts of Minutes + Hours, who brings intriguing watches together in a unique location for watch fans to explore and experience.
Approach: Our campaign paired art with watches that matched in feel and vibe. Together they set the tone for the event in an unexpected way, appealing to a broader audience.
Results: Attendance was up over 100% from the previous show.

85 RADICONDOLI MUSIC CONCERT POSTER | Ad Agency: Freaner Creative & Design
Art Director: Ariel Freaner | Client: City of Radicondoli, Italy
Graphic Designer: Ariel Freaner | Creative Director: Ariel Freaner
Primary Credit: Ariel Freaner
Assignment: The City of Radicondoli needed to promote a music concert.
Approach: We design a music concert for the City of Radicondoli, mixing old and new designs to match the music style, the town's longevity, and predominant habitats.
Results: Increase in concurrency and sales.

86, 87 STARSHIP TROOPERS: EXTERMINATION KEY ART
Ad Agency: PETROL Advertising | Art Director: PETROL Advertising
Client: My.Games | Primary Credits: My.Games, PETROL Advertising
Assignment: Develop Key Art/packaging to best position the title with the FPS Market.
Approach: Starship Troopers: Extermination is a game about teamwork. This idea of working together took center stage during the creative process.
Results: The final image was easily identifiable but still exciting. Furthermore, it gave "new recruits" an expectation for what the game was about!

88, 89 CALL OF DUTY: MODERN WARFARE III | Ad Agency: PETROL Advertising
Art Director: PETROL Advertising | Clients: Activision, Sledgehammer
Primary Credits: Activision, Sledgehammer, PETROL Advertising
Assignment: Develop of suite of Key Art assets that builds on the momentum of MWII while establishing it's own unique identity as a standalone game.
Approach: Delivered strong exploration through establishing a new color palate and a graphic "destruction" device to provide storytelling across the suite of Viz-ID assets.

90, 91 CALL OF DUTY: BLACK OPS 6 - KEY ART SERIES
Ad Agency: PETROL Advertising | Art Director: PETROL Advertising
Clients: Activision, Treyarch | Primary Credits: Activision, Treyarch, PETROL Advertising
Assignment: Develop Key Art assets that provides a step change from the Modern Warfare sub-franchise and excites the fanbase on the return of the Black Ops sub-franchise.
Approach: Delivered strong exploration through a mix of poses and assets that have established brand equity with new takes on era appropriate iconography, the bold use of color, and redaction to provide through-line storytelling across the suite of Viz-ID assets.
Results: The project was a success with multiple placement and uses for the artwork.

92 NON-MEMORIALS | Ad Agency: Boundless Life Sciences Group
Art Director: Craig Mikes | Client: Foundation for Suicide Prevention
Copywriters: Kevin Couch, Craig Mikes | Primary Credit: Boundless Life Sciences Group
Assignment: Suicide is the second most cause of death among college students.
Approach: For suicide prevention week and the first ever #988 Crisis Line Awareness Day, we took our activation to the campuses installing our Non-Memorials around campus in high traffic areas that are sure to be noticed.
Results: The disruption helped us gain awareness for the 24/7 crisis hotline.

93 BOTANICALS | Ad Agency: The BAM Connection
Art Directors: Renata Baiocco, Julia Granger
Clients: Eu Natural, Wellbeam Consumer Health | Chief Creative Officer: Rob Baiocco
Creative Director: Gary Ennis | Associate Creative Director: Manas Paradkar
Managing Director: Anthony DelleCave | Social Media Managers: Mike Crocker, Katrina Culp | Primary Credit: Manas Paradkar
Assignment: To educate people on how Eu Natural's botanical products help with fertility for both men and women and increase the chances of pregnancy.
Approach: We emphasized the beauty of plants and botanicals with a pregnant woman.
Results: One of the highest performing posts for the brand.

94, 95 VILLAGE DENTAL POSTER SERIES | Ad Agency: The Republik
Art Director: Brad Magner | Client: Village Dental | Creative Director: Brad Magner
Designer: Brad Magner | Copywriters: Brad Magner, Dwayne Fry
Chief Creative Officer: Robert Shaw West | Primary Credit: The Republik
Assignment: Going to the dentist can be stressful. Our goal was to use humor to make the process less scary and let patients know they are not alone in their worries.
Approach: We were able to reach many current and potential patients to let them know that Village Dental understands their concerns and are here to help them Smile It Away.
Results: Village Dental was able to position themselves as the sympathetic, understanding option when it comes to oral health and bring in more patients.

96, 97 RUSH | Ad Agency: DeVito/Verdi | Art Directors: Scott Steidl, Matthew Thompson
Client: RUSH University Medical Center | Primary Credit: Eric Schutte
Assignment: RUSH University Medical Center is a nationally leading health system. We were charged with changing perceptions to drive an increase in commercially insured patients choosing RUSH for their conditions.
Approach: D/V developed a series of line-driven outdoor ads that were strategically positioned around Chicago.
Results: The campaign launched in May of 2024, so results have not yet been clear. However, so far the campaign has been well received by the community and the client.

179 CREDITS & COMMENTARY

98, 99 VOLTARI PRINT CAMPAIGN | Ad Agency: The Republik
Art Directors: Matt Shapiro, Rob McKinney | Client: Voltari | Writer: Scott Stripling
Chief Creative Officer: Robert Shaw West | Primary Credit: The Republik
Assignment: To boaters, it matters if a boat has the right stuff. Our mission was to convey this for Voltari in a multimedia campaign.
Approach: Using proprietary lightweight materials, a speed-inducing hull, and propulsion design, Voltari signals a new era of guiltless, kick-ass boating.

100 SUPER BOWL PROGRAM AD | Ad Agency: Bailey Lauerman
Art Director: Casey Stokes | Client: Bosch | Design Director: Jim Ma
Creative Directors: David Thornhill, Joey Googe, Casey Stokes
Copywriter: Joey Googe | Senior Account Executive: Cara Oldenhuis
Account Management: Gwen Ivey | Primary Credit: Bailey Lauerman
Assignment: Bosch Tools needed a Super Bowl program ad.
Approach: Their 2-IN-1 Driver and Wrench provides workers with an option in same tool functionality. The football option play became the perfect creative solution.
Results: The result was a unique tie between football and power tools.

101 SILENT WAR | Ad Agency: Collective Turn | Art Director: Jinyoung Kim
Client: Self-initiated | Primary Credit: Jinyoung Kim
Assignment: Hikikomori refers to young adults who withdraw from social activities and live in isolation for extended periods. This project seeks to shift the perception of Hikikomori from mere social outcasts to individuals fighting their own "silent war."
Approach: Images depict the lives of Hikikomori amidst external chaos, aiming to connect the concept of a "silent war" with the internal battles these individuals face.
Results: Though this campaign was self-initiated, it gained traction through SNS.

102, 103 PERFECT FATHER'S DAY TOOL | Ad Agency: PPK
Art Director: Javier Quintana | Client: Glory Days Grill | President: Garrett Garcia
Creative Directors: Michael Schillig, Javier Quintana | Copywriter: Michael Schillig
Graphic Designer: Melanie Mosquera | Account Director: Courtney Babic
Account Executive: Logan Haley | Director of Photography: Patrick Guyer
Executive Creative Director: Paul Prato | Other: Tom Kenney -Agency Owner/CEO
Primary Credits: Michael Schillig, Javier Quintana
Assignment: On Father's Day, we wanted to recognize how Dad shouldn't have to fix anything and leave with a special memento that he could keep in memory of this day.
Approach: We gave dads a special commemorative tool—a fork wrench. It came with a message that reminded him to enjoy his food and fix broken stuff another day.
Results: Our client really liked the idea.

104, 105 SEND A STORY TO SPACE | Ad Agency: Not William
Art Director: Rich Wallace | Client: Stories of Space | Writer: Marc Hartzman
Executive Creative Directors: Rich Wallace, Marc Hartzman | Designer: Rich Wallace
Photographer: Rich Wallace | Client Support: Beth Mund
Typographer: Rich Wallace | Primary Credit: Not William
Assignment: Can a story change the way we explore space? Stories of Space, a non-profit, asks of writers and space enthusiasts. Open to all, Stories of Space launches space-themed stories into the cosmos on various rocket missions.
Approach: We created four individual posters all of which had a unique look and feel, while still feeling like a unified campaign.
Results: The client was thrilled with the posters and social media assets.

106 EMPTINESS IS FORM - EXPERIMENTAL TYPOGRAPHY EXHIBITION
Ad Agency: Chen Yu Min Design | Art Director: Chen Yu Min
Client: CYM Design Gallery | Primary Credit: Chen Yu Min
Assignment: Typography has become a cultural and aesthetic issue. This exhibition will deconstruct and combine words into aesthetic thinking, emphasize the importance of the environment and environmental protection, and let people see a better future.
Approach: I wanted to let more people to understand the beauty and culture of words through the creativity of the discarded objects to develop amazing design works.

107 HANG HEAD IN SHAME | Ad Agency: PPK | Art Director: Pierre Ducilon
Client: Big Cat Rescue | Executive Creative Director: Paul Prato
Creative Directors: Michael Schillig, Javier Quintana | Copywriter: Michael Schillig
President: Garrett Garcia | Other: Agency Owner/CEO, Tom Kenney
Primary Credits: Michael Schillig, Pierre Ducilon
Assignment: Our assignment was to create print elements to convince voters to vote YES on Prop 127, which will end wildcat trophy hunting in Colorado.
Approach: We centered everything around the dramatic image of a crying mother mountain lion trophy head. This emotional, heartfelt image and theme were liked so much that we even created TV and radio spots around it.

108 TROPHY HEAD TEARDROP | Ad Agency: PPK | Art Director: Pierre Ducilon
Client: Big Cat Rescue | Executive Creative Director: Paul Prato
Creative Directors: Michael Schillig, Javier Quintana | Copywriter: Michael Schillig
President: Garrett Garcia | Other: Agency Owner/CEO, Tom Kenney
Primary Credits: Michael Schillig, Pierre Ducilon
Assignment: Our assignment was to create print elements to convince voters to vote YES on Prop 127, which will end wildcat trophy hunting in Colorado.
Approach: We centered everything around the dramatic image of a crying mother mountain lion trophy head. This emotional, heartfelt image and theme were liked so much that we even created TV and radio spots around it.

109 MOUNTED LION TEARDROP | Ad Agency: PPK | Art Director: Pierre Ducilon
Client: Big Cat Rescue | Executive Creative Director: Paul Prato
Creative Directors: Michael Schillig, Javier Quintana | Copywriter: Michael Schillig
President: Garrett Garcia | Other: Agency Owner/CEO, Tom Kenney
Primary Credits: Michael Schillig, Pierre Ducilon
Assignment: Our assignment was to create print elements to convince voters to vote YES on Prop 127, which will end wildcat trophy hunting in Colorado.
Approach: We centered everything around the dramatic image of a crying mother mountain lion trophy head. This emotional, heartfelt image and theme were liked so much that we even created TV and radio spots around it.

110, 111 EARTH DAY 2024 OUT OF HOME CAMPAIGN
Ad Agency: Extra Credit Projects | Art Director: Jackie Foss

Clients: EarthDay.org, Out of Home Advertising Association of America
Creative Director: Chad Hutchison | Executive Creative Director: Rob Jackson
Primary Credit: Rob Jackson
Assignment: Promote the 2024 theme "Planet vs Plastics" to a broad audience.
Approach: The creative was distributed by the Out of Home Advertising Association of America, and was broadcast on digital out of home units across the U.S., Africa, and as a building projection in Ottawa, Canada targeting the United Nations Summit.
Results: The creative was well-received and was used across all campaign efforts.

112 SPOON FIN | Ad Agency: PPK | Art Director: Sergio Rodriguez
Client: Animal Welfare Institute (AWI) | Executive Creative Director: Paul Prato
Creative Directors: Michael Schillig, Sergio Rodriguez | Copywriter: Michael Schillig
President: Garrett Garcia | Other: Agency Owner/CEO, Tom Kenney
Primary Credits: Michael Schillig, Sergio Rodriguez
Assignment: Help the Animal Welfare Institute (AWI) to educate the public on a critical worldwide issue: the devastating effects of shark finning.
Approach: A spoon plays a huge role in the decimation of shark populations since that's what people use to consume shark fin soup. We formed a shark fin out of a bunch of spoons, then paired it off with a strong, compelling headline.
Results: The Shark Fin Sales Elimination Act was passed into law, prohibiting the commercial trade of shark fins and products containing shark fins in the US.

113 DROPS | Ad Agency: OUT TO LUNCH | Art Director: Tasos Georgiou
Client: BOROUME | Creative Directors: Anna Stilianaki, Tasos Georgiou
Artist: Roman Montesinos | Account Director: Irini Sohoriti
Primary Credit: Anna Stilianaki
Assignment: Shed light on a different angle of the issue of food waste, informing the public about the fact that it is also related to the climate crisis, affecting us all.
Approach: The solution was a powerful visual metaphor, that works at a glance without a headline, in the form of a faucet with pears as drops of water created by an artist.
Results: The organization had major increase in the number of site visitors and a great deal of extra free media publicity on the subject.

114, 115 MAN EATING SHARK | Ad Agency: PPK | Art Director: Alan Schneller
Client: Animal Welfare Institute (AWI) | Executive Creative Director: Paul Prato
Creative Director: Michael Schillig | Copywriter: Michael Schillig
President: Garrett Garcia | Other: Agency Owner/CEO, Tom Kenney
Primary Credits: Michael Schillig, Alan Schneller
Assignment: Help the Animal Welfare Institute (AWI) to educate the public on a critical worldwide issue: the devastating effects of shark finning.
Approach: We used a memorable image and play on words to make a shocking point: 73 million sharks a year are killed for their fins to make shark fin soup.
Results: The Shark Fin Sales Elimination Act was passed into law, prohibiting the commercial trade of shark fins and products containing shark fins in the US.

116, 117 WHERE DO THEY GO? | Ad Agency: PPK
Art Directors: Alan Schneller, Carmen Masterson | Client: Rose Dynasty Foundation
President: Garrett Garcia | Creative Director: Steve Bowen | Copywriter: Meg Chamlee
Marketing Assistant: Kayla Goucher | Account Executive: Cecil Robinson
Director of Photography: Patrick Guyer | Other: Agency Owner/CEO, Tom Kenney
Primary Credits: Alan Schneller, Meg Chamlee
Assignment: Our goals were to drive awareness on an underlying issue within the LGBTQ+ youth and increase support for the Rose Dynasty Foundation.
Approach: We created a social film that appeared to be a video chat, disguised brochures as failing report cards, and created posters that show the realities of homeless LGBTQ+ youth in a creative and impactful way.
Results: We brought awareness to the issue and support for the Rose Dynasty by having our campaign featured on Little Black Book, The Drum, Ads of the World, and AdAge.

118 GLORIOUS WING TREE | Ad Agency: PPK | Art Director: Gabby Cotilla
Client: Glory Days Grill | Executive Creative Director: Paul Prato
Creative Director: Michael Schillig | Copywriter: Michael Schillig
Graphic Designer: Melanie Mosquera | Account Director: Courtney Babic
Account Executive: Logan Haley | Other: Agency Owner/CEO, Tom Kenney
President: Garrett Garcia | Primary Credits: Michael Schillig, Gabby Cotilla
Assignment: Create a tasty, eye-catching poster that had a fun, general Christmas message and, at the same time, would whet our guest's appetite for some delicious wings.
Approach: We created a delicious Christmas tree out of wings, with dipping sauce for tinsel, a French fry tree topper, and a celery stick trunk.
Results: Our client loved this approach and used the image in a variety of ways.

119 PINCH YOURSELF | Ad Agency: PPK | Art Director: Melanie Mosquera
Client: Glory Days Grill | Executive Creative Director: Paul Prato
Creative Directors: Michael Schillig, Javier Quintana | President: Garrett Garcia
Copywriter: Michael Schillig | Account Director: Courtney Babic
Account Executive: Logan Haley | Other: Agency Owner/CEO, Tom Kenney
Primary Credits: Michael Schillig, Melanie Mosquera
Assignment: Glory Days Grill has become famous for their tasty yet limited time only Lobster Roll. They tasked us with creating a poster to promote that the Roll was back.
Approach: We showed the image of a big lobster claw with a fun, memorable, tongue-in-cheek message and headline.
Results: Our client loved the poster and playful approach we took.

120, 121 FATHER'S DAY FIX | Ad Agency: PPK | Art Director: Javier Quintana
Client: Glory Days Grill | Executive Creative Director: Paul Prato
Creative Directors: Michael Schillig, Javier Quintana | President: Garrett Garcia
Director of Photography: Patrick Guyer | Copywriter: Michael Schillig
Account Director: Courtney Babic | Other: Agency Owner/CEO, Tom Kenney
Primary Credits: Michael Schillig, Javier Quintana
Assignment: Our goal was to increase traffic for Father's Day by creating excitement for the one day when Dad could relax and enjoy a T-Bone steak meal.
Approach: We wanted to emphasize how dad may be the fixer of everything but on this special day Glory Days Grill wanted to give him a break and fix everything for him. We even created unique fork and knife wrench tools for silverware.
Results: Our client loved this approach and used the image in a variety of ways.

180 CREDITS & COMMENTARY

122, 123 THE CROSSING POSTER SERIES | Ad Agency: The Republik
Art Director: Matt Shapiro | Client: Regency Centers
Chief Creative Officer: Robert Shaw West | Producer: Mark Scoggins
Designer: Dylan West | Chief Strategy Officer: Dwayne Fry
Copywriter: Dwayne Fry | Primary Credit: The Republik
Assignment: Clarendon Commons was a shopping area in Arlington, VA. Our job was to reinstill a sense of vibrancy and relevance similar to newer shopping centers.
Approach: Rebranded as The Crossing, we took inspiration from this new name to show how this aging classic has a style all her own.

124, 125 UP YOUR FLOWER GAME | Ad Agency: Not William
Art Director: Rich Wallace | Client: Anything Floral | Creative Director: Rich Wallace
Executive Creative Directors: Rich Wallace, Debbie Kasher | Copywriter: Debbie Kasher
Photographer: Rich Wallace | Primary Credit: Not William
Assignment: We wanted to encourage people to buy flowers beyond the traditional times, so we created a campaign about how flowers are a great gift for every occasion.
Approach: We featured many flower arrangements and pair them with playful messages.
Results: The client was very happy and customers engaged with the campaign.

126, 127 KENTUCKY BOURBON TRAIL® — PRINT ADVERTISEMENTS
Ad Agency: Lewis Communications | Art Director: Roy Burns III
Client: Kentucky Distillers' Association | Copywriter: Stephen Curry
Vice Presidents Brand Creative: Tom Johnson, Ryan Gernenz
Vice President: Katie Peninger | Photo Retouching: Andy Cargile
Partner: Robert Froedge | Creative Directors: Robert Froedge, Stephen Curry
Design Director: Roy Burns III | Account Director: Nick Michel
Primary Credit: Roy Burns III
Assignment: The Kentucky Bourbon Trail® celebrated its 25th anniversary with the unveiling of a new identity and rebrand.
Approach: Born of hundreds of hours of extensive research, site visits, and interviews, the advertising elements reinforce the new brand positioning while serving as an invitation to discover the birthplace of America's Native Spirit.
Results: Still in its initial launch phase, the rebrand has been enthusiastically received.

128, 129 KENTUCKY BOURBON TRAIL — AIRPORT DURATRAN
Ad Agency: Lewis Communications | Art Director: Roy Burns III
Client: Kentucky Distillers' Association | Partner: Robert Froedge
Design Director: Roy Burns III | Creative Directors: Stephen Curry, Robert Froedge
Copywriter: Stephen Curry | Photo Retouching: Andy Cargile
Vice Presidents Brand Creative: Tom Johnson, Ryan Gernenz
Vice President: Katie Peninger | Account Director: Nick Michel
Primary Credit: Roy Burns III
Assignment: The Kentucky Bourbon Trail® celebrated its 25th anniversary with the unveiling of a new identity and rebrand.
Approach: Born of hundreds of hours of extensive research, site visits, and interviews, the advertising elements reinforce the new brand positioning while serving as an invitation to discover the birthplace of America's Native Spirit.
Results: Still in its initial launch phase, the rebrand has been enthusiastically received.

130, 131 KENTUCKY BOURBON TRAIL — OUTDOOR
Ad Agency: Lewis Communications | Art Director: Roy Burns III
Client: Kentucky Distillers' Association | Design Director: Roy Burns III
Creative Directors: Stephen Curry, Robert Froedge | Copywriter: Stephen Curry
Vice Presidents Brand Creative: Tom Johnson, Ryan Gernenz
Vice President: Katie Peninger | Photo Retouching: Andy Cargile
Partner: Robert Froedge | Account Director: Nick Michel | Primary Credit: Roy Burns III
Assignment: The Kentucky Bourbon Trail® celebrated its 25th anniversary with the unveiling of a new identity and rebrand.
Approach: Born of hundreds of hours of extensive research, site visits, and interviews, the advertising elements reinforce the new brand positioning while serving as an invitation to discover the birthplace of America's Native Spirit.
Results: Still in its initial launch phase, the rebrand has been enthusiastically received.

132, 133 GANDY DOGS GONE COMFY CAMPAIGN | Ad Agency: AG Creative Group
Art Director: Stewart Jung | Client: Gandy Installations | Copywriter: Stewart Jung
Graphic Designer: Stewart Jung | Account Director: Dave Ancrum
Primary Credit: Stewart Jung
Assignment: Gandy Installations approached us to work on their Winter campaign.
Approach: Having done several of their campaigns before, we decided to go to the dogs for this one. A tongue and cheek messaging based on one of our favorite companions gave Gandy a unique campaign that got people's attention and put a smile on their faces.
Results: Gandy was so pleased with the ad that they used them in print and digital.

SILVER WINNING WORKS:
135 HENNY WHITE 25 YEAR DROP | Ad Agency: forceMAJEURE Design
Art Directors: Pierre Delebois, Lea Bissiau | Client: Moet Hennessy
Executive Creative Director: Pierre Delebois | Creative Director: Hugo Chevallier
Account Director: Raphaelle Mahieu | Production: Canada
Photographer: Lou Escobar | Primary Credit: forceMAJEURE Design

135 CÎROC LIMONATA CAMPAIGN - ESCAPE WITH FLAVOR
Ad Agency: forceMAJEURE Design | Art Director: Pierre Delebois
Clients: Cîroc Vodka, Diageo | Account Director: Griffin Heller
Photographer: Yulia Gorbachenko | Primary Credit: forceMAJEURE Design

135 NATIONAL MEDICAL CENTER FOR TEAM USA | Ad Agency: DeVito/Verdi
Art Director: Scott Steidl | Client: University of Florida Health
Primary Credit: Eric Schutte

136 ERASED: WW2'S HEROES OF COLOR | Ad Agency: SJI Associates
Art Director: David O'Hanlon | Clients: National Geographic, Chris Spencer, Brian Everett, Mariano Barreiro, Mary Dunnington, Isabella Alonzo | President: Suzy Jurist
Production Artist: Michael Stampone | Primary Credit: SJI Associates

136 ERASED: WW2'S HEROES OF COLOR - ALTERNATIVE POSTER
Ad Agency: SJI Associates | Art Director: David O'Hanlon

Clients: National Geographic, Chris Spencer, Brian Everett, Mariano Barreiro, Mary Dunnington, Isabella Alonzo | President: Suzy Jurist
Designer: Adam Selbst | Primary Credit: SJI Associates

136 THE GUT PLAYS A VITAL ROLE | Ad Agency: Nikkeisha, Inc.
Art Director: Hiroyuki Nakamura | Client: Yakult Honsha Co., Ltd.
Creative Director: Hidetaka Sugiyama | Copywriter: Takeshi Wakabayashi
Designers: Hiroyuki Nakamura, Hikari Maesaka
Account Executives: Kunihiro Sawada, Rikako Tanaka
Primary Credit: Nikkeisha, Inc.

136 WHAT WE CANNOT CREATE | Ad Agency: Nikkeisha, Inc.
Art Director: Hidetaka Sugiyama | Client: TODA CORPORATION
Copywriter: Shu Morihira | Primary Credit: Nikkeisha, Inc.

137 ROSEN RUNWAY | Ad Agency: &Barr | Art Director: Jordan Stewart
Client: Rosen Hotels & Resorts | Account Executive: Kimberly Blaylock
Copywriter: Jack Polly | Associate Creative Director: Jacqui Garcia
Creative Director: Christian Wojciechowski | Studio: Rick Andrews
Account Director: Rebekah Essick | Producers: Lynn Whitney Smith, Caitlin McManus
Photographer: Mark DeLong | Primary Credit: &Barr

137 ZETA 42ND ANNIVERSARY POSTER | Ad Agency: Freaner Creative & Design
Art Director: Ariel Freaner | Client: ZETA Weekly | Creative Director: Ariel Freaner
Digital Artist: Ariel Freaner | Primary Credit: Ariel Freaner

137 JOURNALISM HISTORY FORUM
Ad Agency: Shanghai Cary Branding Design Co., Ltd. | Art Director: Mengyi Xie
Client: School of Communication at East China Normal University
Primary Credit: Mengyi Xie

137 BRANDEIS 75TH ANNIVERSARY | Ad Agency: DeVito/Verdi
Art Directors: Scott Steidl, Matthew Thompson | Client: Brandeis University
Copywriters: Vinny Tulley, John DeVito, Mark Teringo, David Bromberg, Wayne Winfield
Chief Creative Directors: Vinney Tulley, John DeVito
Print Producers: Rodney Pringle, Steve Gordon | Primary Credit: Eric Schutte

138 RAY | Ad Agency: Shanghai Cary Branding Design Co., Ltd.
Art Director: Mengyi Xie | Client: East China Normal University
Primary Credit: Mengyi Xie

138 THE BEST GRADUATE PROGRAMS UNDER THE SUN
Ad Agency: Cactus | Art Directors: Jeff Strahl, Sammie O'Sullivan
Client: University of Miami Herbert Business School
Chief Creative Officer: Norm Shearer | Chief Marketing Officer: Jeff Graham
Executive Creative Director: Brian Watson | Copywriters: Dan Hawes, Jay Roth
Print Producer: Raven Checkush | Instructor: Matt Taylor | Production: Stephen Hausrath
Account Supervisor: Mikela Parker | Group Account Director: Ainslie Fortune
Primary Credit: Cactus

139 2023 CAMPUS CAMPAIGN | Ad Agency: Extra Credit Projects
Art Directors: Courtney French, Summer Michmerhuizen, Evan Hatch, Aaron Sullivan
Client: Michigan State University | Creative Director: Chad Hutchison
Executive Creative Director: Rob Jackson | Account Director: Jake Stidham
Primary Credit: Rob Jackson

139 UNFROSTED | Ad Agency: ARSONAL | Art Director: ARSONAL | Client: Netflix
Creative Marketing: Missy Rawnsley, Javier Crespo | Primary Credits: ARSONAL, Netflix

139 THE DOG SHORT FILM KEY ART | Ad Agency: Barlow.Agency
Art Director: Barlow.Agency | Client: Danielle Baynes Films
Primary Credit: Barlow.Agency

139 LEONARDO DA VINCI | Ad Agency: SJI Associates
Art Director: David O'Hanlon | Clients: PBS Creative Services, Ira Rubenstein, Stacey Libbrecht, Derrick Chamlee, Jared Traver, Claire Quin | President: Suzy Jurist
Designer: Adam Selbst | Copywriter: Carole Mayer | Production Artist: Michael Stampone
Project Manager: Hannah Holdsworth | Primary Credit: SJI Associates

140 UNFROSTED | Ad Agency: ARSONAL | Art Director: ARSONAL
Client: Netflix | Creative Marketing: Missy Rawnsley, Javier Crespo
Photographer: John P. Johnson | Primary Credits: ARSONAL, Netflix

140 YEAH THE BOYS SHORT FILM KEY ART | Ad Agency: Barlow.Agency
Art Director: Barlow.Agency | Client: Stefan Hunt Films | Photographer: Leo Harunah
Primary Credit: Barlow.Agency

140 HELP! I'M ALIEN PREGNANT KEY ART | Ad Agency: Barlow.Agency
Art Director: Barlow.Agency | Client: Thunderlips Films | Primary Credit: Barlow.Agency

140 THE SWEET EAST | Ad Agency: Célie Cadieux
Art Director: Célie Cadieux | Clients: Utopia, The Match Factory
Font Designer: Lenny Vigden | Primary Credit: Célie Cadieux

141 THE SMEAR CAMPAIGN | Ad Agency: AMV BBDO | Art Director: Mario Kerkstra
Clients: COPI (Central Office of Public Interest), Humphrey Milles
Creative Directors: Jack Smedley, George Hackforth-Jones | Art Producer: Eve Steben
Design Firm: THERE IS STUDIO | Typographers: Sean Freeman, Eve Steben
Copywriters: Laurens Grainger, Alicia Cliffe | Photographer: Sean Freeman
Agency Producers: Maggie Scriven, Ella Dolding | Digital Artist: Sean Freeman
Primary Credits: Sean Freeman, Eve Steben

141 AWM 2023 PROMOTIONAL LAUNCH EVENT POSTER
Ad Agency: Freaner Creative & Design | Art Director: Ariel Freaner
Clients: County of San Diego Agriculture, Weights and Measures, Porfirio Mancillas
Digital Artist: Ariel Freaner | Creative Director: Ariel Freaner
Primary Credit: Ariel Freaner

181 CREDITS & COMMENTARY

141 ESCAPE MEDIOCRITY
Ad Agency: Partners + Napier | Art Director: Kristin Stevenson
Client: American Advertising Federation of Greater Rochester | Copywriter: Scott Allen
Production Artist: JP Smith | Associate Creative Director: Rob Warchol
Project Managers: Lauren Cole, Sylvia DiStefano | Project Coordinator: Daniela Mercado
Production Manager: Wendy DiSalvo | Account Supervisor: Claire Harvey
Account Executive: Rachel Rockwell | Group Account Director: Elyse Kowsakowski
Group Creative Director: Dan O'Donnell | Chief Creative Officer: Rob Kottkamp
Primary Credit: Kristin Stevenson

142 BUTTERFLIES ARE BLOOMING CAMPAIGN
Ad Agency: Extra Credit Projects | Art Directors: Aaron Sullivan, Jackie Foss
Client: Frederik Meijer Gardens & Sculpture Park | Creative Director: Chad Hutchison
Executive Creative Director: Rob Jackson | Account Director: Jake Stidham
Primary Credit: Rob Jackson

142 NIKE INVINCIBLE 3 | Ad Agency: Media.Work
Art Director: Dmitry Ponomarev | Client: Nike
Designers: Roman Eltsov, Denis Semenov, Sergey Shurupov, Alexandra Vorobeva,
Aleksei Komarov, Artur Gadzhiev, Kirill Makhin, Daniil Makhin, Vasily Zinchuk
Producers: Alexandra Kotova, Andrey Sukhoruchkin
Creative Director: Igor Sordokhonov | Music & Sound: Artem Markaryan
Model Maker: Lubov Lobanova | Primary Credit: Media.Work

143 FARGO FYC | Ad Agency: Canyon | Art Director: Canyon
Client: FX | Primary Credit: Canyon

143 NACHO Ad Agency: Canyon | Art Director: Canyon
Client: Lionsgate+ | Primary Credit: Canyon

144 LIFE LESS SCARY - BILLBOARD SERIES | Ad Agency: Dunn&Co.
Art Director: Mitchell Goodrich | Client: Grow Financial Federal Credit Union
Creative Directors: Stephanie Morrison, Max Dempster | Copywriter: Michala Jackson
Chief Creative Officer: Troy Dunn | Designers: Cris Trespando, Cody Davis
Account Supervisor: Rachel Jensen | Account Executive: Anna Butler
Primary Credit: Stephanie Morrison

144 YOUR MAIN SQUEEZE | Ad Agency: Innerspin Marketing
Art Directors: Colin Schur, Davina Roshansky Victor | Client: Lee Kum Kee
Executive Creative Director: Colin Schur | Senior Art Director: Davina Roshansky Victor
Brand Strategy: Miles McWilliam | Copywriter: Zach Links
President: Elcid Choi | Director of Project Management: Gloria Yi
Web Designer: Jeff Kardos | Website: Wanted for Nothing
Marketing Manager: Itzel Alvarez | Photography Studio: Teez Agency
Others: Mary Yun, Steven Montes, Constantine Spyrou
Primary Credit: Innerspin Marketing

145 FINISH BIG | Ad Agency: Bailey Lauerman
Art Director: Jared Brdicko | Client: Cargill | Creative Director: Carter Weitz
Senior Account Executive: Emma Gallagher | Illustrator: Joe McDermott
Production Manager: Gayle Adams | Others: Megan Storm, Alison Andersen
Primary Credit: Bailey Lauerman

145 EAT BIG | Ad Agency: Bailey Lauerman | Art Director: Jared Brdicko
Client: Cargill | Creative Director: Carter Weitz | Production Manager: Gayle Adams
Illustrator: Joe McDermott | Senior Account Executive: Emma Gallagher
Head of Media: Megan Storm | Digital Media Specialist: Alison Andersen
Primary Credit: Bailey Lauerman

145 SQUID GAME: UNLEASHED - ANNOUNCE KEY ART
Ad Agency: PETROL Advertising | Art Director: PETROL Advertising
Clients: Netflix, Boss Fight Entertainment
Primary Credits: Netflix, Boss Fight Entertainment, PETROL Advertising

146 NATIONAL MEDICAL CENTER OF TEAM USA | Ad Agency: DeVito/Verdi
Art Director: Scott Steidl | Client: University of Florida Health
Primary Credit: Eric Schutte

146 HRVATSKI PRIRODOSLOVNI MUZEJ - CROATIAN NATURAL HISTORY MUSEUM
Ad Agency: STUDIO INTERNATIONAL | Art Director: Boris Ljubicic
Client: Hrvatski Prirodoslovni Muzej - Croatian Natural History Museum

146 EVERY TOY | Ad Agency: Partners + Napier | Art Director: Danielle Smith
Client: Strong National Museum of Play | Copywriter: Scott Allen
Production Manager: Lauren Cole | Account Supervisors: Christine Scott, Claire Harvey
Group Creative Director: Dan O'Donnell | Chief Creative Officer: Rob Kottkamp
Primary Credit: Danielle Smith

146 OBSESSED | Ad Agency: Bald&Beautiful
Art Director: Luis Camano | Clients: Soundsations Records, Pete Grasso, Lee Wilson
Creative Director: Luis Camano | Primary Credit: Luis Camano

147 ASCII-GMATIC | Ad Agency: Studio Eduard Cehovin | Art Director: Eduard Cehovin
Client: EuroJAZZ Foundation | Primary Credit: Eduard Cehovin

147 COTTON CAN | Ad Agency: Mythic | Art Director: Audelino Moreno
Client: Cotton Incorporated | Senior Designer: Alex-Marie Ablan
Associate Creative Directors: Alexandra Frazier, Audelino Moreno
Executive Creative Director:: David Olsen | Project Manager: Madison Racel
Production Artists: Jeff Buchbinder, Michael Baker | Account Director: Wendy Parker
Account Supervisor: James Stevens | Account Executive: Jordan Gayle
Strategy: Caleb Petty, Caroline Coffin | Primary Credit: Mythic

147 ONYX CAMPAIGN | Ad Agency: SJI Associates | Art Director: Matt Birdoff
Clients: Katie Secret, Outbrain | Designer: Matt Birdoff | Copywriter: Matt Birdoff
President: Suzy Jurist | Primary Credit: SJI Associates

148 TOP OF KYUSHU | Ad Agency: Gaaboo Inc. | Art Director: Masataka Tsuji
Client: Kitakyushu City | Editors: Arukikata. Co., Ltd., Kunihiro Arai, Takashi Miyata,
Rie Hinokuma, Marina Usami | Account Managers: Yuika Yoshida, Yukiko Tsuru
Directors: Miki Inoue, Tomoko Yoshida, Tomoko Takemoto, Mie Mitani
Designer: Giltae Lee | Primary Credit: Gaaboo Inc.

148 ACE YOUR SLEEP | Ad Agency: Eight Sleep | Art Director: Jisoo Sim
Client: Self-initiated | Lead Designer: Maria Salgado | Designer: Rafael Goraieb
Junior Designer: Minjeong Kang | Brand Strategy: Sabina Blankenberg
Brand Creative: Maria Salgado | Photographer: Mario Sierra | Contributor: Rafael Oliveira
Other: Rafael Goraieb, 3D Artist | Primary Credit: Maria Salgado

148 RED CROSS SAN DIEGO - TIJUANA BINATIONAL CAMPAIGN POSTER SERIES
Ad Agency: Freaner Creative & Design | Art Director: Ariel Freaner
Clients: Red Cross of Tijuana, Jorge Astiazaran | Creative Director: Ariel Freaner
Digital Artist: Ariel Freaner | Primary Credit: Ariel Freaner

148 SPAGHETTI MOP | Ad Agency: OUT TO LUNCH
Art Director: Tasos Georgiou | Client: BOROUME
Creative Directors: Anna Stilianaki, Tasos Georgiou | Copywriter: Anna Stilianaki
Artist: Debbie Lawson | Photographer: Debbie Lawson
Account Director: Irini Sohoriti | Primary Credit: Anna Stilianaki

149 SAVE THE BEES. SPREAD WILDFLOWERS. | Ad Agency: Sukle Advertising
Art Director: Katie Dondale | Client: Great Outdoors Colorado
Chief Creative Officer: Mike Sukle | Designer: Greg Jesse
Digital Artist: Matt Carpenter | Producer: Michon Schmidt
Account Director: Leigh Ann Bauer | Director of Client Services: Amy Taylor
Primary Credit: Sukle Advertising

149 MONSTER MELANOMA POOL DECALS
Ad Agency: Boundless Life Sciences Group | Art Director: Craig Mikes
Client: National Council on Skin Cancer Prevention | Photographer: Paul Swen
Primary Credit: Boundless Life Sciences Group

150 TIJUANA RED CROSS CORPORATE POSTERS
Ad Agency: Freaner Creative & Design | Art Director: Ariel Freaner
Clients: Red Cross of Tijuana, Jorge Astiazaran | Creative Director: Ariel Freaner
Digital Artist: Ariel Freaner | Illustrator: Ariel Freaner | Primary Credit: Ariel Freaner

150 RED CROSS 80 ANNIVERSARY POSTER SERIES CELEBRATING 80 YEARS OF...
Ad Agency: Freaner Creative & Design | Art Director: Ariel Freaner
Clients: Red Cross of Tijuana, Jorge Astiazaran | Primary Credit: Ariel Freaner

150 INSTITUTE FOR NONPROFIT NEWS (INN) AWARENESS CAMPAIGN
Ad Agency: NIEDERMEIER DESIGN | Art Director: Kurt Niedermeier
Client: Institute for Nonprofit News (INN) | Primary Credit: Kurt Niedermeier

151 ETHOS BY ANTHEM | Ad Agency: Toolbox Design
Art Director: Niko Potton | Client: Anthem Properties Group
Photographer: Gabriel Cabrera | Copywriter: Sandra O'Connell
Designer: Rachel Sanvido | Primary Credit: Toolbox Design

151 CITIZEN BY ANTHEM | Ad Agency: Toolbox Design | Art Director: Niko Potton
Client: Anthem Properties Group | Copywriter: Liberty Craig | Designer: Alice Zeng
Photographer: Marley Hutchinson | Primary Credit: Toolbox Design

152 RAMEN TATSU-YA SUMMER OF CHILL CAMPAIGN
Ad Agency: Be Someone Design Co. | Art Director: Jorde Matthews
Client: Ramen Tatsu-ya | Project Director: Carla Gomez
Primary Credit: Be Someone Design Co.

152 WINGMAN IN-STORE ENGAGEMENT | Ad Agency: Disrupt Idea Co.
Art Director: Bill Kresse | Client: Wingman Gifts & Supplies | Designer: Kris Ender
Writer: Bill Kresse | Photographers: Nick Pipitone, Pierre Stephenson, J.A. Dietrich
Account Executive: Greg Brown | Primary Credit: Bill Kresse

152 QUAD SQUAD SUMMER PROMOS | Ad Agency: Extra Credit Projects
Art Director: Eric Lowe | Client: Sweetwaters Coffee & Tea | Copywriter: Patrick Duncan
Executive Creative Director: Rob Jackson | Creative Director: Chad Hutchison
Account Director: Jake Stidham | Primary Credit: Rob Jackson

152 GO BIG ON GOOD | Ad Agency: Brunner | Art Director: James Hoenicke
Client: Goodwill of North Georgia | Group Creative Director: Jeff Shill
Animator: Alesis Heaps | Executive Creative Director: Dan Magdich
Copywriter: Ray Tolbert | Producers: Emily DeShantz, Krystle Grandy, Michele Huber
Account Director: Kimberly Strong | Photographer: Kathryn McCrary
Primary Credit: Brunner

153 YEAR OF THE DRAGON 2024 CAMPAIGN | Ad Agency: Extra Credit Projects
Art Directors: Jackie Foss, Evan Hatch, Summer Michmerhuizen
Client: Sweetwaters Coffee & Tea | Account Director: Jake Stidham
Executive Creative Director: Rob Jackson | Creative Director: Chad Hutchison
Primary Credit: Rob Jackson

153 I SEE AD PEOPLE | Ad Agency: Craig Bromley Photography
Art Director: Craig Bromley | Client: Self-initiated
Model: Hilary Huff | Primary Credit: Craig Bromley Photography

153 THE BRAVE LITTLE AGENCY | Ad Agency: Angry Dog
Art Director: Rafael Fernandes | Client: Self-initiated | Copywriter: Rafael Fernandes
Creative Director: Rafael Fernandes | Primary Credit: Rafael Fernandes

154 'CAUSE WE CAN | Ad Agency: Greenhaus | Art Director: Dave Roberts
Clients: Visit Dallas, Jennifer Walker | Chief Creative Officer: Rob Petrie
Creative Director: Chris Brown | Executive Producer: Nina Millane
Writers: Chris Brown, Dave Roberts, Delaney Clark | Account Director: Jay Evans

182 CREDITS & COMMENTARY

Account Executives: Amy Russell, Kachet Jackson-Bell | Photographer: Ty Milford
Wardrobe: Janelle Arreola | Hair: Hannah Handshy | Makeup: Hannah Handshy
Chief Strategy Officer: Paul Whitbeck | Primary Credit: Greenhaus

154 60TH ANNIVERSARY CANDLES OOH | Ad Agency: Extra Credit Projects
Art Director: Courtney French | Client: Gerald R. Ford International Airport
Executive Creative Director: Rob Jackson | Creative Director: Chad Hutchison
Account Director: Jake Stidham | Primary Credit: Rob Jackson

FILM/VIDEO PLATINUM WINNING WORKS:
156, 157 #SAVEDFLAGS | Ad Agency: Ogilvy Brazil
Art Directors: Pedro Minari, Caio Almeida, Ariel Saraiva, Danilo Eizo Kykuta, João Fialho
Clients: Indigenous Peoples Movement, Indigenous Ancestry, TYBYRA Collective,
Indigenous Media, ANIN (Agency of Indigenous News and Original Peoples),
Amondawa Peoples, Amanda Smith, Luana Barth, Danilo Tupinikim, Vherá Xunú,
Talys Mota Gonçalves, Wauto Oro Waram | Executive Creative Director: Samir Mesquita
Associate Creative Director: Alexander Davidson | Artist: Raquel Kuebo
Creative Group Head: Rubens Casanova | Chief Creative Officer: Sergio Mugnaini
Photographers: Giuliana Mendes, Rafael Rodrigues, Wauto Oro Waram, Vherá Xunú
Copywriters: João Soares, Gustavo Nassar, Tali Sztokbant | Primary Credit: Ogilvy Brazil
Assignment: The Indigenous people of the Amazon suffer land abuse and culture loss.
Our goal was to make them more visible and help their cause gain more support.
Approach: We hacked Instagram's save icon and turn it into a symbol painted on the
natives' bodies. The process was photographed by professionals from their community.
Results: The movement not only went viral - it went tribal, gaining support from an
Indigenous Emmy winner and influencers on Instagram.

FILM/VIDEO GOLD WINNING WORKS:
158 NIGHT VISION HAS EVOLVED | Ad Agency: Bailey Lauerman
Art Director: David Thornhill | Client: Bosch | Copywriter: Joey Googe
Account Director: Liz Urbaniak | Senior Account Executive: Cara Oldenhuis
Production Company: MSG Sphere Studio | Editor: Casey Stokes
Other: Megan Storm, Head of Media | Primary Credit: Bailey Lauerman
Assignment: Bosch Night Vision Wiper Blades reduce blur and glare, making driving
clearer on stormy nights.
Approach: Executions showed human eyes evolving into the eyes of nocturnal creatures.
But none as our "Night Vision Has Evolved" video shown on the Sphere in Las Vegas.
Results: Word of the Sphere video spread through social media, catching the attention
of the world, including Bosch corporate executives in Europe and Asia.

158 CRYSTAL GEYSER ASMR VIDEO | Ad Agency: Kabookaboo
Art Director: Kabookaboo | Client: Crystal Geyser | Primary Credit: Kabookaboo
Assignment: The assignment focused on revitalizing the brand's presence on social
media. We create an ASMR video to showcase the product's unique qualities.
Approach: Our approach centered on immersing viewers in an auditory and visual
experience that highlighted Crystal Geyser's refreshing attributes.
Results: The content garnered the highest number of shares and saves on social media.

159 AVIRA FREE SECURITY | Ad Agency: ID8 (In-house for Gen Digital)
Art Director: Brad Berg | Client: Avira | Primary Credits: Brad Berg (Executive Creative
Director), Sunny Yang (Senior Creative Director), Derek Taylor (Creative Director),
Chris Kontakis (Visual Design Manager), Danielle Karstetter (Producer)
Assignment: Avira is the #1 online security brand in Germany. This new video would
serve as a key component of a new upper funnel strategy with a targeted media plan.
Approach: We took advantage of two brand assets: the iconic red umbrella and the tagline
"Wir haben das auf dem Schirm" or "We have that on the screen." In German, "Schirm"
can also mean "umbrella." We opted for a cinematic treatment that turned each threat into
raindrops. Just before they hits a would-be victim, an umbrella pops up to protect them.

159 THIS IS SCAD | Ad Agency: Savannah College of Art & Design
Art Director: Nat Emmett | Client: Self-initiated | President: Paula Wallace
Primary Credit: Paula Wallace
Assignment: This video was designed to capture the essence of SCAD and highlight the
institution's degree programs, facilities, faculty, and success of its students and alumni.
Approach: We researched SCAD's programs, facilities, and alumni achievements and had
scripting and planning sessions. Production took place across SCAD's campuses while
integrating interviews with faculty and alumni.
Results: The video received high praise and was used as a marketing and branding tool.

160 METAL | Ad Agency: DeVito/Verdi | Art Directors: Matthew Thompson, Scott Steidl
Client: Lincoln Tech | Primary Credit: Eric Schutte
Assignment: Lincoln Tech provides diversified career-oriented post-secondary educa-
tion to recent high school graduates and working adults.
Approach: Currently 22 campuses in 13 states, programs in skilled trades, automotive
technology, healthcare services, hospitality services, and information technology.

160 ESCAPE RESTAURANT | Ad Agency: DeVito/Verdi
Art Directors: Scott Steidl, Matthew Thompson | Client: Lincoln Tech
Primary Credit: Eric Schutte
Assignment: Lincoln Tech provides diversified career-oriented post-secondary educa-
tion to recent high school graduates and working adults.
Approach: Currently 22 campuses in 13 states, programs in skilled trades, automotive
technology, healthcare services, hospitality services, and information technology.

161 ESCAPE HIGH SCHOOL | Ad Agency: DeVito/Verdi
Art Directors: Scott Steidl, Matthew Thompson | Client: Lincoln Tech
Primary Credit: Eric Schutte
Assignment: Lincoln Tech provides diversified career-oriented post-secondary educa-
tion to recent high school graduates and working adults.
Approach: Currently 22 campuses in 13 states, programs in skilled trades, automotive
technology, healthcare services, hospitality services, and information technology.

161 AMAZING GRACE | Ad Agency: DeVito/Verdi
Art Directors: Scott Steidl, Matthew Thompson | Client: Lincoln Tech
Primary Credit: Eric Schutte
Assignment: Lincoln Tech provides diversified career-oriented post-secondary educa-
tion to recent high school graduates and working adults.

Approach: Currently 22 campuses in 13 states, programs in skilled trades, automotive
technology, healthcare services, hospitality services, and information technology.

162 ANYTHING REALLY CAN HAPPEN | Ad Agency: The Republik
Art Directors: Dallas West, Rob McKinney | Client: Fayetteville State University
Chief Creative Officer: Robert Shaw West | Creative Director: Brad Magner
Designer: Brad Magner | Copywriters: Dwayne Fry, Scott Stripling
Account Director: Kirk deViere | Account Executive: Vanessa Nguyen
Executive Producer: Josh Eggleston | Editor: Josh Eggleston
Production Company: 11 Dollar Bill | Primary Credit: The Republik
Assignment: Fayetteville State University (FSU) is a historic HBCU, but the University
was often viewed as a North Carolina system school serving a regional population.
Approach: In reality, FSU was a bright shining light covered by a basket - with vitality
and relevance for the next generation of doers. Are You In?
Results: The campaign set enrollment records for the University.

162 WE COULD USE YOUR HELP | Ad Agency: The Republik
Art Directors: Dallas West, Rob McKinney | Client: Fayetteville State University
Executive Producer: Josh Eggleston | Editor: Josh Eggleston
Production Company: 11 Dollar Bill | Account Director: Kirk deViere
Account Executive: Vanessa Nguyen | Chief Creative Officer: Robert Shaw West
Creative Director: Brad Magner | Copywriters: Dwayne Fry, Scott Stripling
Designer: Matt Shapiro | Primary Credit: The Republik
Assignment: Fayetteville State University (FSU) is a historic HBCU, but the University
was often viewed as a North Carolina system school serving a regional population.
Approach: In reality, FSU was a bright shining light covered by a basket - with vitality
and relevance for the next generation of doers. Are You In?
Results: The campaign set enrollment records for the University.

163 HOLIEST OF NIGHTS AT CARLOW UNIVERSITY
Ad Agency: The Storyhaus Agency | Art Director: John Swisher
Client: Carlow University | Primary Credits: The Storyhaus Agency, Carlow University
Assignment: Communicate happy holiday wishes, emphasize the university's religious
heritage, and frame Dr. Humphrey as an icon and advocate for the university.
Approach: We considered 3 main points: Carlow's mission, heritage, and the season.
The song was the perfect choice as it communicates devotion and seasonal themes.
When choosing filming locations, we chose the University Commons, Campus Green,
and St. Joe's Gym. For the edit, we chose a black-and-white color treatment.
Results: The video had a 3.76% click-through rate for total impressions.

163 STRESS TEST CAMPAIGN | Ad Agency: The Gate
Art Director: Scott Barbey | Client: Federated Hermes, Inc. | Director: Scott Zacaroli
Writer: David Bernstein | Editor: Troy Mercury | Music & Sound: Robert Miller
Chief Creative Officer: David Bernstein | Primary Credit: David Bernstein
Assignment: We needed to reposition FHI and demonstrate how its DNA makes it well-
poised to deliver on clients' needs in a volatile investment landscape.
Approach: We created a campaign that leaned into FHI's ruthless vetting process by
equating the rigorous "stress tests" their investments go through to the ones that con-
sumer products go through.
Results: The campaign ended up truly resonating with professional investors.

164 FREEKICK | Ad Agency: DeVito/Verdi
Art Directors: Matthew Thompson, Peter Cortez
Client: Austin Capital Bank | Primary Credit: Eric Schutte
Assignment: Austin Capital Bank launched a parent-sponsored credit-building account
for minors and young adults and needs to create awareness of the new product.
Approach: We developed a new brand from the ground up to represent the FreeKick
product and all its benefits and created organic social media posts.
Results: Freekick was well received. Social media accounts saw a surge in followers.

164 WATCH DOG | Ad Agency: &Barr | Art Director: Jennifer Neuman
Client: Space Coast Credit Union | Creative Director: Christian Wojciechowski
Associate Creative Director: Jacqui Garcia | Account Executive: Kimberly Blaylock
Account Director: Adam Liszewski | Account Manager: Kimberly Saffran
Producers: Lynn Whitney Smith, Fleur O'Hara | Director: Kevin O'Brian
Copywriter: Jacqui Garcia | Production Company: Diamond View | Primary Credit: &Barr
Assignment: For the first time, Space Coast Credit Union wanted to bring their philos-
ophy, "Your Life, Your Financial Watchdog" to life.
Approach: With Watchdog ready for his first introduction to the world, our Public Rela-
tions team paved the road to success. The team developed a communications cascade
to launch the campaign efficiently and effectively, which identified each segmented
audience, and then determined the right order, timing, and delivery method for the
comprehensive plan's messaging. From developing all internal communications neces-
sary for our client to prepare the SCCU team, including leadership talking points and
emails, to creating all external communications including member newsletters, website
copy, and press releases.
Results: Brand Recognition, Credit Card, Debit Card, Auto, and Mortgage Loan Appli-
cations all up triple digits.

165 DEFECT - OFFICIAL REVEAL TRAILER
Ad Agency: PETROL Advertising | Art Directors: EmptyVessel, PETROL Advertising
Client: EmptyVessel | Primary Credits: EmptyVessel, PETROL Advertising
Assignment: Create an Trailer for Defect.
Approach: The Trailer was built within the Game Engine (UE5) and also the Game
Build to give Gamers an authentic look and show key game elements and mechanics.
Results: The Trailer garnered over 3 million views across various channels.

165 SQUID GAME: UNLEASHED - OFFICIAL ANNOUNCEMENT TRAILER
Ad Agency: PETROL Advertising | Art Director: PETROL Advertising
Clients: Netflix, Boss Fight Entertainment
Primary Credits: Netflix, Boss Fight Entertainment, PETROL Advertising
Assignment: Create an exciting Announce Trailer that balances the whimsical and fun
nature of the game with the serious and dark tone/mood of the award winning show.
Approach: The Trailer was built leveraging access to the development team's Unity
game build to not only integrate cinematic gameplay footage but also to develop CG
moments of iconic items/characters like the Piggy Bank and Pink Suited Guards.
Results: The Trailer garnered excitement for fans across various channels.

183 CREDITS & COMMENTARY

166 HUMAN PROGRESS HAS NO FINISH LINE | Ad Agency: DeVito/Verdi
Art Director: Matthew Thompson | Client: University of Florida Health
Primary Credit: Eric Schutte
Assignment: In 2023, UF Health joined the U.S. Olympic & Paralympic Medical Network providing care to US athletes. With this collaboration, UF Health had the opportunity to tap into a huge audience of people who are fans of the Olympics.
Approach: D/V concepted a campaign and tagline, Human Progress Has No Finish Line, and was able to develop six video creative executions.
Results: Over the first quarter of the campaign being in market through custom questions we fielded in NRC Health and our ongoing questions related to image, awareness, and preference we have seen gains of between three to nine percentage points.

166 HURDLES OF LIFE | Ad Agency: DeVito/Verdi | Art Director: Rob Slosberg
Client: University of Florida Health | Primary Credit: Rob Slosberg
Assignment: In 2023, UF Health joined the U.S. Olympic & Paralympic Medical Network providing care to US athletes. With this collaboration, UF Health had the opportunity to tap into a huge audience of people who are fans of the Olympics.
Approach: D/V concepted a campaign and tagline, Human Progress Has No Finish Line, and was able to develop six video creative executions.
Results: Over the first quarter of the campaign being in market, we have seen gains of between three to nine percentage points.

167 VILLAGE DENTAL TELEVISION :30 POOL | Ad Agency: The Republik
Art Directors: Matt Shapiro, Rob McKinney | Client: Village Dental
Director: Mark Scoggins | Copywriters: Scott Stripling, Dwayne Fry
Strategy Director: Dwayne Fry | Primary Credit: The Republik
Assignment: Going to the dentist can be stressful. Our goal was to use humor to make the process less scary and let patients know they are not alone in their worries.
Approach: We were able to reach many current and potential patients to let them know that Village Dental understands their concerns and are here to help them Smile It Away.
Results: Village Dental was able to position themselves as the sympathetic, understanding option when it comes to oral health and bring in more patients.

167 VILLAGE DENTAL TELEVISION :30 GROCERY | Ad Agency: The Republik
Art Directors: Matt Shapiro, Rob McKinney | Client: Village Dental
Director: Mark Scoggins | Copywriters: Scott Stripling, Dwayne Fry
Chief Creative Officer: Robert Shaw West | Strategy Director: Dwayne Fry
Primary Credit: The Republik
Assignment: Going to the dentist can be stressful. Our goal was to use humor to make the process less scary and let patients know they are not alone in their worries.
Approach: We were able to reach many current and potential patients to let them know that Village Dental understands their concerns and are here to help them Smile It Away.
Results: Village Dental was able to position themselves as the sympathetic, understanding option when it comes to oral health and bring in more patients.

168 OUT OF CONTROL CAMPAIGN - CAR RENTAL :30
Ad Agency: ID8 (In-house for Gen Digital) | Art Director: Brad Berg
Client: LifeLock | Editors: Doug Walker, 1606 Studio
Music & Sound: Yessian Music, Inc., M2 Productions
Primary Credits: Brad Berg (Executive Creative Director), Sunny Yang (Senior Creative Director), Derek Taylor (Creative Director), Dave Folley (Associate Creative Director), Kathryn Redekop (Producer)
Assignment: LifeLock doesn't just protect you from evil identity thieves. LifeLock protects your identity from everyday incompetence. This idea gave us permission to be in places and talk about things that normally a cybersecurity brand simply can't.
Approach: We focused on consumers that have families, with three relatable scenarios plus matching personal info. In the final moments, we show a grid of places that can give away personal info before reassuring viewers that LifeLock monitors those places.
Results: The TV spot performed exceptionally well amongst its target audience.

168 OUT OF CONTROL CAMPAIGN - DENTIST :30
Ad Agency: ID8 (In-house for Gen Digital) | Art Director: Brad Berg
Client: LifeLock | Editors: Doug Walker, 1606 Studio
Music & Sound: Yessian Music, Inc., M2 Productions
Primary Credits: Brad Berg (Executive Creative Director), Sunny Yang (Senior Creative Director), Derek Taylor (Creative Director), Dave Folley (Associate Creative Director), Kathryn Redekop (Producer)
Assignment: LifeLock doesn't just protect you from evil identity thieves. LifeLock protects your identity from everyday incompetence. This idea gave us permission to be in places and talk about things that normally a cybersecurity brand simply can't.
Approach: We focused on unmarried consumers with three relatable scenarios plus matching personal info. In the final moments, we show a grid of places that can give away personal info. Then we reassure viewers that LifeLock monitors those places.
Results: The TV spot outperformed all other US National Representative tested ads.

169 KENTUCKY BOURBON TRAIL — BRAND LAUNCH VIDEO
Ad Agency: Lewis Communications | Art Director: Roy Burns III
Client: Kentucky Distillers' Association | Design Director: Roy Burns III
Creative Directors: Stephen Curry, Robert Froedge | Copywriter: Stephen Curry
Vice Presidents Brand Creative: Tom Johnson, Ryan Gernenz
Vice President: Katie Peninger | Account Director: Nick Michel
Editor: Andy Stewart | Producer: Jacob Garner | Partner: Robert Froedge
Music & Sound: Adam Wesley | Primary Credit: Roy Burns III
Assignment: The Kentucky Bourbon Trail® celebrated its 25th anniversary with the unveiling of a new identity and rebrand.
Approach: Born of hundreds of hours of extensive research, site visits, and interviews, the advertising elements reinforce the new brand positioning while serving as an invitation to discover the birthplace of America's Native Spirit.
Results: The rebrand has been enthusiastically received.

169 KENTUCKY BOURBON TRAIL — :30 VIDEO | Ad Agency: Lewis Communications
Art Director: Roy Burns III | Client: Kentucky Distillers' Association
Design Director: Roy Burns III | Creative Directors: Stephen Curry, Robert Froedge
Copywriter: Stephen Curry | Vice President: Katie Peninger
Vice Presidents Brand Creative: Tom Johnson, Ryan Gernenz | Editor: Andy Stewart
Account Director: Nick Michel | Producer: Jacob Garner | Music & Sound: Adam Wesley
Partner: Robert Froedge | Primary Credit: Roy Burns III

Assignment: The Kentucky Bourbon Trail® celebrated its 25th anniversary with the unveiling of a new identity and rebrand.
Approach: Born of hundreds of hours of extensive research, site visits, and interviews, the advertising elements reinforce the new brand positioning while serving as an invitation to discover the birthplace of America's Native Spirit.
Results: The rebrand has been enthusiastically received.

FILM/VIDEO SILVER WINNING WORKS:
170 THIS IS PRECISION AI: LAUNCH CAMPAIGN | Ad Agency: Weights&Pulleys
Art Director: James Selman | Client: Palo Alto Networks
Production Company: Minted Content | Copywriter: Greg Clampffer
Director: David Leitch | Account Executive: Lance O'Connor
Chief Creative Officer: James Selmon | Editor: Cartel | Visual Designer: UPP
Director of Photography: Jonathan Sela | Producer: Chris Lam
Executive Creative Directors: Allison Khoury, JL Watkins
Account Executives: Edina Sallay, Amy Berriocha | Strategy Director: Karin Knutson
Account Management: Cindy Lewellen | Chief Marketing Officer: KP Unnikrishnan
Vice President: Aarti Mittal | Production Designer: David Scheunemann
Animator: Buck | Account Director: Anne Halvorson
Others: Daniel Pemberton, We Are Walker, Composers
Primary Credits: Weights&Pulleys, Palo Alto Networks

170 PROMISES IN LIGHTS | Ad Agency: Bailey Lauerman
Art Director: Jim Ma | Clients: Phillips 66, Hunter Oil | Production Company: Lucky Dog
Creative Directors: Sean Faden, Joey Googe, Casey Stokes
Motion Designer: Casey Stokes | Copywriter: Sophia Messineo
Account Director: Liz Urbaniak | Managing Director: Jessica Jarosh
Other: Megan Storm | Primary Credit: Bailey Lauerman

170 ANTI-AI | Ad Agency: DeVito/Verdi
Art Directors: Scott Steidl, Matthew Thompson | Client: Lincoln Tech
Primary Credit: Eric Schutte

171 MISSING PERSONS | Ad Agency: DeVito/Verdi
Art Directors: Scott Steidl, Matthew Thompson | Client: Lincoln Tech
Primary Credit: Eric Schutte

171 THE SEASON OF OUTSIDE | Ad Agency: Brunner | Art Director: Katie Greco
Client: Church's Texas Chicken | Executive Creative Director: Dan Magdich
Creative Director: Jonathan Banks | Copywriter: Vanessa Suarez
Senior Art Director: Katie Greco | Producer: Bryan Jameson | Director: Amr Singh
Production Company: Lord Danger | Production Partner: Modern Logic
Music & Sound: Jonathan Banks, Kevin Taylor Jr., KTGotBeats, LLC
Group Creative Directors: Leo Gomez, Black//Brown | Primary Credit: Brunner

171 FEAR NO LIGHT | Ad Agency: The BAM Connection
Art Directors: Renata Baiocco, Julia Granger | Client: Rohto Eye Drops
Account Executive: Maria Keddis | Chief Creative Officer: Rob Baiocco
Director of Photography: Will Nellis | Copywriter: Manas Paradkar
Associate Creative Director: Manas Paradkar | Editor: Renata Baiocco
Managing Director: Anthony DelleCave | Social Media Manager: Katrina Culp
Creative Director: Gary Ennis | Others: Mike Crocker, Social Media Director,
Maureen Maldari, Chief Executive Officer | Primary Credit: Manas Paradkar

172 THE CRANKY CANKER SORE | Ad Agency: Brunner | Art Director: Kristen Scialo
Client: Blistex | Creative Directors: Jackie Murray, Kristen Scialo
Copywriter: Jackie Murray | Producers: Emily DeShantz, Bryan Jameson
Account Director: Kellyn Wilhide | Executive Creative Director: Dan Magdich
Production Company: Make | Primary Credit: Brunner

172 MINIATURE MOMENTS | Ad Agency: &Barr | Art Director: Rachel Clements
Client: Massey Services | Creative Director: Christian Wojciechowski
Associate Creative Director: Jacqui Garcia | Account Executive: Kimberly Blaylock
Account Director: Adam Liszewski | Account Manager: Kimberly Saffran
Producers: Lynn Whitney Smith, Caitlin McManus | Director: Kevin O'Brian
Production Company: Diamond View | Copywriter: Megan Rosenoff
Primary Credit: &Barr

172 UNFORTUNATE ENDINGS: GOLDILOCKS | Ad Agency: Sukle Advertising
Art Director: Katie Dondale | Client: Wyoming Department of Health
Chief Creative Officer: Mike Sukle | Writers: Heather French, Jim Glynn
Director of Production: Michon Schmidt | Account Director: Natalie Ross
Production Company: Flesh and Bones | Director: Aaron Ray
Designer: Aaron Ray | Executive Producers: Rob Traill, Tony Benna
Animators: Amy Charlick, Camille Vincent | Music & Sound: Jennifer Pague
Other: Deco Daviola, Storyboard | Primary Credit: Sukle Advertising

173 UNFORTUNATE ENDINGS: SNOW WHITE | Ad Agency: Sukle Advertising
Art Director: Katie Dondale | Client: Wyoming Department of Health
Chief Creative Officer: Mike Sukle | Writers: Heather French, Jim Glynn
Director of Production: Michon Schmidt | Account Director: Natalie Ross
Production Company: Flesh and Bones | Director: Aaron Ray
Designer: Aaron Ray | Executive Producers: Rob Traill, Tony Benna
Animators: Amy Charlick, Camille Vincent | Music & Sound: Jennifer Pague
Other: Deco Daviola, Storyboard | Primary Credit: Sukle Advertising

173 CITIZEN BY ANTHEM | Ad Agency: Toolbox Design
Art Director: Niko Potton Client: Anthem Properties Group
Videographer: Justin Pelleier | Designer: Alice Zeng
Primary Credit: Toolbox Design

173 RED CROSS TIJUANA - SAN DIEGO BINATIONAL CAMPAIGN
Ad Agency: Freaner Creative & Design | Art Director: Ariel Freaner
Clients: Red Cross of Tijuana, Jorge Astiazaran | Creative Director: Ariel Freaner
Digital Artist: Ariel Freaner | Editor: Fernanda Freaner
Creative Team: Ariel Freaner, Ariel Mitchell Freaner, Jr.
Primary Credit: Ariel Freaner

184 INDEX

ADVERTISING AGENCIES

&Barr 137, 164, 172
AG Creative Group 132, 133
AMV BBDO 141
Angry Dog 153
Arcana Academy 82, 83
ARSONAL 30, 69, 72, 73,
............. 78, 79, 139, 140
Bailey Lauerman 100,
............. 145, 158, 170
Bald&Beautiful 146
Barlow.Agency 31, 139, 140
Be Someone Design Co. 152
Boundless Life Sciences Group
............. 92, 149
Brunner 152, 171, 172
Cactus 138
Canyon 32-37, 74, 75, 143
Célie Cadieux 71, 140
Chang Liu 46, 47

Chen Yu Min Design 106
Collective Turn 101
Craig Bromley Photography 153
Darkhorse Design 52-55
DeVito/Verdi 64, 65, 96, 97,
135, 137, 146, 160, 161, 164, 166, 170, 171
Disrupt Idea Co. 84, 152
Dunn&Co. 144
Eight Sleep 42-45, 148
Extra Credit Projects 110, 111,
............. 139, 142, 152-154
forceMAJEURE Design ... 62, 63, 135
Freaner Creative & Design 85,
............. 137, 141, 148, 150, 173
Gaaboo Inc. 148
Gastdesign 68
Greenhaus 154
ID8 (In-house for Gen Digital) ... 159, 168
Innerspin Marketing 144

Kabookaboo 158
Lewis Communications 56, 57,
............. 126-131, 169
Media.Work 142
Mythic 147
NIEDERMEIER DESIGN 150
Nikkeisha, Inc. 136
Not William 104, 105, 124, 125
Ogilvy Brazil 156, 157
OUT TO LUNCH 80, 81, 113, 148
Partners + Napier 141, 146
PETROL Advertising 38-41,
............. 86-91, 145, 165
PPK 48, 49, 102, 103,
............. 107-109, 112, 114-121
Qianzi Chao 60, 61
Rhubarb 77
Ron Taft Brand Innovation & Media Arts
............. 70

Savannah College of Art & Design ..
............. 159
Shanghai Cary Branding Design Co., Ltd.
............. 137, 138
SJI Associates 66, 67,
............. 136, 139, 147
Studio Eduard Cehovin 147
STUDIO INTERNATIONAL 146
Sukle Advertising 149, 172, 173
The BAM Connection 93, 171
The Gate 163
The Republik 94, 95, 98, 99,
............. 122, 123, 162, 167
The Storyhaus Agency 163
Todd Watts & Nick Fox 76
Toolbox Design 151, 173
Traction Factory 59
Vanderbyl Design 50, 51
Weights&Pulleys 170

CLIENTS

ABC Branding & Design 74, 75
Activision 88-91
Alonzo, Isabella 136
AMC 79
AMC+ 79
American Advertising Federation of
Greater Rochester 141
Amondawa Peoples 156, 157
Animal Welfare Institute (AWI) .. 112,
............. 114, 115
ANIN (Agency of Indigenous News and
Original Peoples) 156, 157
Anthem Properties Group.... 151, 173
Anything Floral 124, 125
Arteriors 50, 51
Astiazaran, Jorge 148, 150, 173
Austin Capital Bank 164
Available For Download 76
Avira 159
Balloon Brigade 82, 83
Barreiro, Mariano 66, 67, 136
Barth, Luana 156, 157
Big Cat Rescue 48, 49, 107-109
Blistex........................ 172
BOROUME 113, 148
Bosch 100, 158
Boss Fight Entertainment .. 145, 165
Brandeis University 137
Campari 62, 63
Cargill 145
Carlow University 163
Chamlee, Derrick 139
Church's Texas Chicken.......... 171
City of Radicondoli, Italy 85
Cîroc Vodka 135
COPI (Central Office of Public Interest)
............. 141
Cotton Incorporated 147
County of San Diego Agriculture, Weights
and Measures 141
Creative Projects Group 70
Crystal Geyser 158

CYM Design Gallery 106
Danielle Baynes Films 139
Diageo 135
Dunnington, Mary 136
EarthDay.org 110, 111
East China Normal University ... 138
EmptyVessel 38-41, 165
Eu Natural 93
EuroJAZZ Foundation 147
Everett, Brian 66, 67, 136
Fayetteville State University 162
Federated Hermes, Inc. 163
Foundation for Individual Rights in
Education 64, 65
Foundation for Suicide Prevention .
............. 92
FOX Entertainment 77
Frederik Meijer Gardens & Sculpture
Park 142
FX 143
FX Network 30, 69
Gandy Installations 132, 133
Gerald R. Ford International Airport
............. 154
Glory Days Grill 102, 103, 118-121
Gonçalves, Talys Mota 156, 157
Goodwill of North Georgia 152
Grasso, Pete 146
Great Outdoors Colorado 149
Grow Financial Federal Credit Union
............. 144
HALF TEA LLC 46, 47
HBO 72, 73
HBO Max 78
High And Mighty Photo.Com .. 52-55
Hrvatski Prirodoslovni Muzej (Croatian
Natural History Museum) 146
Hunter Oil 170
Indigenous Ancestry 156, 157
Indigenous Media 156, 157
Indigenous Peoples Movement
............. 156, 157

Institute for Nonprofit News (INN) ..
............. 150
Kee, Lee Kum 144
Kentucky Distillers' Association
............. 56, 57, 126-131, 169
Kitakyushu City................ 148
Ladi, Prasino 80, 81
Last One Standing Productions ... 31
Libbrecht, Stacey 139
LifeLock 168
Lincoln Tech 160, 161, 170, 171
Lionsgate+ 143
Mancillas, Porfirio 141
Massey Services 172
Michigan State University 139
Milles, Humphrey 141
Minutes + Hours 84
Moet Hennessy 135
My.Games 86, 87
National Council on Skin Cancer
Prevention 149
National Geographic 36, 37,
............. 66, 67, 136
Netflix 32-35, 139, 140, 145, 165
Nike 142
NST Lawyers 68
Out of Home Advertising Association
of America 110, 111
Outbrain 147
Palo Alto Networks 170
PBS Creative Services 139
Phillips 66 170
Quin, Claire 139
Ramen Tatsu-ya 152
Red Cross of Tijuana .. 148, 150, 173
Regency Centers 122, 123
Rohto Eye Drops.............. 171
Rose Dynasty Foundation .. 116, 117
Rosen Hotels & Resorts 137
Rubenstein, Ira 139
RUSH University Medical Center ...
............. 96, 97

School of Communication at East China
Normal University 137
Secret, Katie 147
Sledgehammer 88, 89
Smith, Amanda 156, 157
Snap-on Diagnostics 59
Soundsations Records 146
Space Coast Credit Union 164
Spencer, Chris 66, 67, 136
Stefan Hunt Films 140
Stories of Space 104, 105
Strong National Museum of Play
............. 146
Sweetwaters Coffee & Tea .. 152, 153
Tesla Design Studio 60, 61
The Match Factory 140
Thunderlips Films 140
TODA CORPORATION 136
Traver, Jared 139
Treyarch 90, 91
Tupinikim, Danilo 156, 157
TYBYRA Collective 156, 157
University of Florida Health 135,
............. 146, 166
University of Miami Herbert Business
School 138
Utopia 140
Vice Studios 71
Village Dental 94, 95, 167
Visit Dallas 154
Voltari 98, 99
Walker, Jennifer 154
Waram, Wauto Oro 156, 157
Wellbeam Consumer Health 93
Wilson, Lee 146
Wingman Gifts & Supplies......... 152
Wojda, Leah 66, 67
Wyoming Department of Health
............. 172, 173
Xunú, Vherá 156, 157
Yakult Honsha Co., Ltd. 136
ZETA Weekly 137

ART DIRECTORS/SENIOR ART DIRECTORS

Almeida, Caio 156, 157
ARSONAL 30, 69, 72, 73,
............. 78, 79, 139, 140
Baiocco, Renata 93, 171
Baitinger, Scott 84
Barbey, Scott 163
Barlow.Agency 31, 139, 140
Basse, Mike 59
Berg, Brad 159, 168
Birdoff, Matt 147

Bissiau, Lea 135
Brdicko, Jared 145
Bromley, Craig 153
Burns III, Roy 56, 57,
............. 126-131, 169
Cadieux, Célie 71, 140
Camano, Luis 146
Canyon 36, 37, 74, 75, 143
Cehovin, Eduard 147
Chao, Qianzi 60, 61

Chen, Yu Min 106
Clements, Rachel 172
Cortez, Peter 164
Cotilla, Gabby 118
Delebois, Pierre 62, 63, 135
Dondale, Katie 149, 172, 173
Ducilon, Pierre 107-109
Emmett, Nat 159
EmptyVessel 38-41, 165
Fernandes, Rafael 153

Fialho, João 156, 157
Foss, Jackie 110, 111, 142, 153
Fox, Nick 76
Freaner, Ariel 85, 137,
............. 141, 148, 150, 173
French, Courtney 139, 154
Gast, Wolfgang 68
Georgiou, Tasos 80, 81, 113, 148
Goodrich, Mitchell 144
Granger, Julia 93, 171

185 INDEX

Greco, Katie — 171
Hatch, Evan — 139, 153
Hoenicke, James — 152
Jung, Stewart — 132, 133
Kabookaboo — 158
Kerkstra, Mario — 141
Kim, Jinyoung — 101
Kresse, Bill — 152
Kykuta, Danilo Eizo — 156, 157
Lambright, Julia — 32-35
Liu, Chang — 46, 47
Ljubicic, Boris — 146
Lowe, Eric — 152
Ma, Jim — 170
Magner, Brad — 94, 95
Malhotra, Akriti — 62, 63
Masataka, Tsuji — 148
Masterson, Carmen — 116, 117
Matthews, Jorde — 152
McKinney, Rob — 98, 99, 162, 167
Michmerhuizen, Summer — 139, 153
Mikes, Craig — 92, 149
Minari, Pedro — 156, 157
Moreno, Audelino — 147
Mosquera, Melanie — 119
Nakamura, Hiroyuki — 136
Neuman, Jennifer — 164
Niedermeier, Kurt — 150
O'Hanlon, David — 66, 67, 136, 139
O'Sullivan, Sammie — 138
PETROL Advertising — 38-41, 86-91, 145, 165
Ponomarev, Dmitry — 142
Potton, Niko — 151, 173
Purcell, Molly — 32-35
Quintana, Javier — 48, 49, 102, 103, 120, 121
Rhubarb — 77
Roberts, Dave — 154
Rodriguez, Sergio — 112
Saraiva, Ariel — 156, 157
Schneller, Alan — 114-117
Schur, Colin — 144
Scialo, Kristen — 172
Selman, James — 170
Shapiro, Matt — 98, 99, 122, 123, 167
Sim, Jisoo — 42-45, 148
Slosberg, Rob — 166
Smith, Danielle — 146
Steidl, Scott — 96, 97, 135, 137, 146, 160, 161, 170, 171
Stevenson, Kristin — 141
Stewart, Jordan — 137
Stokes, Casey — 100
Strahl, Jeff — 138
Sugiyama, Hidetaka — 136
Sullivan, Aaron — 139, 142
Swisher, John — 163
Taft, Ron — 70
Talarczyk, Robert — 52-55
Thompson, Matthew — 64, 65, 96, 97, 137, 160, 161, 164, 166, 170, 171
Thornhill, David — 153
Vanderbyl, Michael — 50, 51
Victor, Davina Roshansky — 144
Wallace, Rich — 104, 105, 124, 125
Walters, Lee — 82, 83
Watts, Todd — 75
West, Dallas — 162
Xie, Mengyi — 137, 138

CREATIVE DIRECTORS/CHIEF, EXECUTIVE, GROUP, ASSO. CREATIVE DIRS./CREATIVE TEAMS, GROUP HEADS/CHIEF CREATIVE OFFS.

Baiocco, Rob — 93, 171
Banks, Jonathan — 171
Bernstein, David — 163
Black//Brown — 171
Bowen, Steve — 116, 117
Brown, Chris — 154
Brown, David — 59
Camano, Luis — 146
Casanova, Rubens — 156, 157
Chevallier, Hugo — 135
Curry, Stephen — 56, 57, 126-131, 169
Davidson, Alexander — 156, 157
Delebois, Pierre — 135
Dempster, Max — 144
DeVito, John — 137
Dunn, Troy — 144
Ennis, Gary — 93, 171
Faden, Sean — 170
Fernandes, Rafael — 153
Frazier, Alexandra — 147
Freaner, Ariel — 85, 137, 141, 148, 150, 173
Freaner Jr., Ariel Mitchell — 173
Froedge, Robert — 56, 57, 126-131, 169
Garcia, Jacqui — 137, 164, 172
Georgiou, Tasos — 80, 81, 113, 148
Gomez, Leo — 171
Googe, Joey — 100, 170
Hackforth-Jones, George — 141
Hartzman, Marc — 104, 105
Hutchison, Chad — 110, 111, 139, 142, 152-154
Irving, Andrew — 77
Jackson, Rob — 110, 111, 139, 142, 152-154
Kasher, Debbie — 124, 125
Khoury, Allison — 170
Kottkamp, Rob — 141, 146
Kresse, Bill — 84
Magdich, Dan — 152, 171, 172
Magner, Brad — 94, 95, 162
Mesquita, Samir — 156, 157
Moreno, Audelino — 147
Morrison, Stephanie — 144
Mugnaini, Sergio — 156, 157
Murray, Jackie — 172
O'Donnell, Dan — 141, 146
Olsen, David — 147
Paradkar, Manas — 93, 171
Petrie, Rob — 154
Prato, Paul — 48, 49, 102, 103, 107-109, 112, 114, 115, 118-121
Quintana, Javier — 48, 49, 102, 103, 107-109, 119-121
Rodriguez, Sergio — 112
Schillig, Michael — 48, 49, 102, 103, 107-109, 112, 114, 115, 118-121
Schur, Colin — 144
Scialo, Kristen — 172
Selmon, James — 170
Shearer, Norm — 138
Shill, Jeff — 152
Smedley, Jack — 141
Sordokhonov, Igor — 142
Stilianaki, Anna — 80, 81, 113, 148
Stokes, Casey — 100, 170
Sugiyama, Hidetaka — 136
Sukle, Mike — 149, 172, 173
Taft, Ron — 70
Thornhill, David — 100
Tulley, Vinney — 137
Wallace, Rich — 104, 105, 124, 125
Warchol, Rob — 141
Watkins, JL — 170
Watson, Brian — 138
Weitz, Carter — 145
West, Robert Shaw — 94, 95, 98, 99, 122, 123, 162, 167
Wojciechowski, Christian — 137, 164, 172

DESIGNERS/GRAPHIC, JUNIOR, LEAD, SENIOR DESIGNERS/DESIGN DIRECTORS

Ablan, Alex-Marie — 147
Birdoff, Matt — 66, 147
Burns III, Roy — 56, 57, 126-131, 169
Davis, Cody — 144
De La Torre, Bertha — 62, 63
Eltsov, Roman — 142
Ender, Kris — 84, 152
Freaner, Ariel — 85
Gadzhiev, Artur — 142
Goraieb, Rafael — 148
Hornberger, Chad — 66
Jesse, Greg — 149
Jung, Stewart — 132, 133
Kang, Minjeong — 148
Koch, Tori — 50, 51
Komarov, Aleksei — 142
Lee, Giltae — 148
Ma, Jim — 100
Maesaka, Hikari — 136
Magner, Brad — 94, 95, 162
Makhin, Daniil — 142
Makhin, Kirill — 142
Mosquera, Melanie — 102, 103, 118
Nakamura, Hiroyuki — 136
O'Hanlon, David — 67
Ray, Aaron — 172, 173
Salgado, Maria — 42-45, 148
Sanvido, Rachel — 151
Selbst, Adam — 136, 139
Semenov, Denis — 142
Shapiro, Matt — 162
Shurupov, Sergey — 142
Trespando, Cris — 144
Vorobeva, Alexandra — 142
West, Dylan — 122, 123
Zeng, Alice — 151, 173
Zinchuk, Vasily — 142

COPYWRITERS/WRITERS/EDITORS

1606 Studio — 168
Allen, Scott — 141, 146
Arai, Kunihiro — 148
Arukikata. Co., Ltd. — 148
Baiocco, Renata — 171
Barlament, S.J. — 59
Bernstein, David — 163
Birdoff, Matt — 147
Bromberg, David — 137
Brown, Chris — 154
Cartel — 170
Chamlee, Meg — 116, 117
Clampffer, Greg — 170
Clark, Delaney — 154
Cliffe, Alicia — 141
Couch, Kevin — 92
Craig, Liberty — 151
Curry, Stephen — 56, 57, 126-131, 169
DeVito, John — 137
Duncan, Patrick — 152
Eggleston, Josh — 162
Fernandes, Rafael — 153
Freaner, Fernanda — 173
French, Heather — 172, 173
Fry, Dwayne — 94, 95, 122, 123, 162, 167
Garcia, Jacqui — 164
Gerber, Dylan — 70
Glynn, Jim — 172, 173
Googe, Joey — 100, 158
Grainger, Laurens — 141
Hartzman, Marc — 104, 105
Hawes, Dan — 138
Hinokuma, Rie — 148
Jackson, Michala — 144
Jung, Stewart — 132, 133
Kasher, Debbie — 124, 125
Kresse, Bill — 84, 152
Links, Zach — 144
Magner, Brad — 94, 95
Mayer, Carole — 139
Mercury, Troy — 163
Messineo, Sophia — 170
Mikes, Craig — 92
Miyata, Takashi — 148
Morihira, Shu — 136
Murray, Jackie — 172
Nassar, Gustavo — 156, 157
O'Connell, Sandra — 151
Paradkar, Manas — 171
Polly, Jack — 137
Roberts, Dave — 154
Rosenoff, Megan — 172
Roth, Jay — 138
Schillig, Michael — 48, 49, 102, 103, 107-109, 112, 114, 115, 118-121
Selbst, Adam — 66
Soares, João — 156, 157
Stewart, Andy — 169
Stilianaki, Anna — 148
Stokes, Casey — 158
Stripling, Scott — 98, 99, 162, 167
Suarez, Vanessa — 171
Sztokbant, Tali — 156, 157
Teringo, Mark — 137
Tolbert, Ray — 152
Tulley, Vinny — 137
Usami, Marina — 148
Wakabayashi, Takeshi — 136
Walker, Doug — 168
Winfield, Wayne — 137

FONT, PRODUCTION, WEB, VISUAL DESIGNERS/TYPOGRAPHERS

Freeman, Sean — 141
Kardos, Jeff — 144
Scheunemann, David — 170
Steben, Eve — 141
UPP — 170
Vigden, Lenny — 140
Wallace, Rich — 104, 105

186 INDEX

ARTISTS/DIGITAL ARTISTS/ILLUSTRATORS/MUSIC & SOUND/ANIMATORS/MOTION DESIGNERS

Ampoo Studio ... 80, 81	Freeman, Sean ... 141	M2 Productions ... 168	Protogeridis, Konstantinos ... 80, 81
Banks, Jonathan ... 171	Heaps, Alesis ... 152	Magwire Art ... 84	Rohlfs, Scott ... 84
Buck ... 170	Koelsch, Michael ... 79	Markaryan, Artem ... 142	Stokes, Casey ... 170
Carpenter, Matt ... 149	KTGotBeats, LLC ... 171	McDermott, Joe ... 145	Taylor Jr., Kevin ... 171
Charlick, Amy ... 172, 173	Kuebo, Raquel ... 156, 157	Miller, Robert ... 163	Vincent, Camille ... 172, 173
Freaner, Ariel ... 137, 141,	Lawson, Debbie ... 148	Montesinos, Roman ... 113	Wesley, Adam ... 169
... 148, 150, 173	Leroy's Place ... 84	Pague, Jennifer ... 172, 173	Yessian Music, Inc. ... 168

PHOTOGRAPHERS/PHOTO RETOUCHING/PHOTO STUDIOS/DIRECTORS OF PHOTOGRAPHY/VIDEOGRAPHERS/CAMERAS

Ascroft, Robert ... 77	Hac Job ... 59	Nellis, Will ... 171	Talarczyk, Robert ... 52-55
Cabrera, Gabriel ... 151	Harunah, Leo ... 140	NIKON ... 52-55	Teez Agency ... 144
Cargile, Andy ... 56, 57, 126-131	Hutchinson, Marley ... 151	Pelleier, Justin ... 173	Wallace, Rich ... 104, 105,
DeLong, Mark ... 137	Iv-skaya, Elena ... 42-45	Pipitone, Nick ... 152	... 124, 125
Dietrich, J.A. ... 152	Johnson, John P. ... 140	Rodrigues, Rafael ... 156, 157	Waram, Wauto Oro ... 156, 157
Escobar, Lou ... 62, 63, 135	Kern, Geof ... 50, 51	Sela, Jonathan ... 170	Winters, Dan ... 78
Freeman, Sean ... 141	Lawson, Debbie ... 148	Sierra, Mario ... 148	Xunú, Vherá ... 156, 157
Gorbachenko, Yulia ... 135	McCrary, Kathryn ... 152	Simmonds, Steven ... 76	
Guyer, Patrick ... 102, 103,	Mendes, Giuliana ... 156, 157	Stephenson, Pierre ... 152	
... 116, 117, 120, 121	Milford, Ty ... 154	Swen, Paul ... 149	

PRODUCTION/PRODUCTION ARTISTS, COMPANIES, MANAGERS, PARTNERS/DIRECTORS OF PRODUCTION

11 Dollar Bill ... 162	Cole, Lauren ... 146	Lord Danger ... 171	MSG Sphere Studio ... 158
Adams, Gayle ... 145	Diamond View ... 164, 172	Lucky Dog ... 170	Schmidt, Michon ... 172, 173
Baker, Michael ... 147	DiSalvo, Wendy ... 141	Make ... 172	Smith, JP ... 141
Buchbinder, Jeff ... 147	Flesh and Bones ... 172, 173	Minted Content ... 170	Stampone, Michael ... 66, 67,
Canada ... 62, 63, 135	Hausrath, Stephen ... 138	Modern Logic ... 171	... 136, 139

PRESIDENTS/VICE PRESIDENTS/SENIOR VICE PRESIDENTS/PARTNERS

Choi, Elcid ... 144	Garcia, Garrett ... 48, 49,	MacRitchie, Ian ... 77	Wallace, Paula ... 159
Froedge, Robert ... 56, 57,	... 102, 103, 107-109, 112, 114-121	Mittal, Aarti ... 170	
... 126-131, 169	Jurist, Suzy ... 66, 67, 136, 139, 147	Peninger, Katie ... 56, 57, 126-131, 169	

DIRECTORS/MANAGING DIRECTORS

DelleCave, Anthony ... 93, 171	Leitch, David ... 170	Ray, Aaron ... 172, 173	Takemoto, Tomoko ... 148
Inoue, Miki ... 148	Mitani, Mie ... 148	Scoggins, Mark ... 167	Yoshida, Tomoko ... 148
Jarosh, Jessica ... 170	O'Brian, Kevin ... 164, 172	Singh, Amr ... 171	Zacaroli, Scott ... 163

MARKETING/MARKETING ASS., MANS./DIRS. OF BRAND MARKETING/CREATIVE MARKETING/CHIEF MARKETING OFFS.

Alvarez, Itzel ... 144	Graham, Jeff ... 138	Pezim, Max ... 32-35	Unnikrishnan, KP ... 170
Crespo, Javier ... 139, 140	Groffie, Ryan ... 42-45	Rawnsley, Missy ... 139, 140	
Goucher, Kayla ... 116, 117	Netflix Marketing ... 32-35	Shapiro, Joelle ... 32-35	

PRODUCERS/PRINT, EXECUTIVE, AGENCY, ART PRODUCERS

Benna, Tony ... 172, 173	Gordon, Steve ... 137	McManus, Caitlin ... 137, 172	Scriven, Maggie ... 141
Checkush, Raven ... 138	Grandy, Krystle ... 152	Millane, Nina ... 154	Smith, Lynn Whitney ... 137, 164, 172
DeShantz, Emily ... 152, 172	Huber, Michele ... 152	O'Hara, Fleur ... 164	Steben, Eve ... 141
Dolding, Ella ... 141	Jameson, Bryan ... 171, 172	Pringle, Rodney ... 137	Sukhoruchkin, Andrey ... 142
Eggleston, Josh ... 162	Kotova, Alexandra ... 142	Schmidt, Michon ... 149	Tavizon, Veronica ... 62, 63
Garner, Jacob ... 169	Lam, Chris ... 170	Scoggins, Mark ... 122, 123	Traill, Rob ... 172, 173

STRATEGY/STRATEGY DIRECTORS, OFFICERS/BRAND CREATIVES, STRATEGY/VICE PRESIDENTS BRAND CREATIVE

Arnautou, Frances ... 42-45	Gernenz, Ryan ... 56, 57,	Knutson, Karin ... 170	Salgado, Maria ... 148
Blankenberg, Sabina ... 42-45, 148	... 126-131, 169	Linekin, Julia ... 62, 63	Weedge, Meilyn ... 62, 63
Coffin, Caroline ... 147	Johnson, Tom ... 56, 57,	McWilliam, Miles ... 144	Whitbeck, Paul ... 154
Fry, Dwayne ... 122, 123, 167	... 126-131, 169	Petty, Caleb ... 147	

ACCOUNT DIRECTORS, EXES., MANAGERS, SUPERVISORS, MANAGEMENT/GROUP ACCOUNT DIRECTORS/SR. ACCOUNT EXES.

Ancrum, Dave ... 132, 133	Gallagher, Emma ... 145	Liszewski, Adam ... 164, 172	Saffran, Kimberly ... 164, 172
Babic, Courtney ... 102, 103, 118-121	Gayle, Jordan ... 147	Mahieu, Raphaelle ... 62, 63, 135	Sallay, Edina ... 170
Bauer, Leigh Ann ... 149	Haley, Logan ... 102, 103, 118, 119	Michel, Nick ... 56, 57,	Sawada, Kunihiro ... 136
Berriocha, Amy ... 170	Halvorson, Anne ... 170	... 126-131, 169	Scott, Christine ... 146
Blaylock, Kimberly ... 137, 164, 172	Harvey, Claire ... 141, 146	Nguyen, Vanessa ... 162	Sohoriti, Irini ... 80, 81, 113, 148
Brown, Greg ... 152	Heller, Griffin ... 135	O'Connor, Lance ... 170	Stevens, James ... 147
Butler, Anna ... 144	Ivey, Gwen ... 100	Oldenhuis, Cara ... 100, 158	Stidham, Jake ... 139, 142, 152-154
deViere, Kirk ... 162	Jackson-Bell, Kachet ... 154	Parker, Mikela ... 138	Strong, Kimberly ... 152
Egan, Shannon ... 59	Jensen, Rachel ... 144	Parker, Wendy ... 147	Tanaka, Rikako ... 136
Elizundia, Carla Sofia ... 62, 63	Junne, Geysel ... 77	Robinson, Cecil ... 116, 117	Tsuru, Yukiko ... 148
Essick, Rebekah ... 137	Keddis, Maria ... 171	Rockwell, Rachel ... 141	Urbaniak, Liz ... 158, 170
Evans, Jay ... 154	Kowsakowski, Elyse ... 141	Ross, Natalie ... 172, 173	Wilhide, Kellyn ... 172
Fortune, Ainslie ... 138	Lewellen, Cindy ... 170	Russell, Amy ... 154	Yoshida, Yuika ... 148

187 WINNERS DIRECTORY

PLATINUM

ARSONAL
www.arsonal.com
3524 Hayden Ave.
Culver City, CA 90232
United States
Tel +1 310 815 8824
info@arsonal.com

Barlow.Agency
www.barlow.agency
1-5 Woodburn St., Stu. A3a
Redfern, NSW 2016
Australia
timothy@barlow.agency

Canyon
www.canyondesigngroup.com
4929 Wilshire Blvd., Ste. 500
Los Angeles, CA 90010
United States
Tel +1 323 933 2203
awards@canyondesigngroup.
com

Chang Liu
www.linkedin.com/in/chang-
liu-0622851ba
27340 El Macero Court
El Macero, CA 95618
United States
Tel +1 646 403 7360
cliu43@sva.edu

Darkhorse Design
www.darkhorsedesign-usa.
com
8 Whitefield Lane
Lancaster, PA 17602
United States
Tel +1 717 844 2888
roberttalarczyk@mac.com

Eight Sleep
www.jisoosim.com
89B W. Edsall Blvd.
Palisades Park, NJ 07650
United States
Tel +1 917 584 8632
jisoosim27@gmail.com

Lewis Communications
www.lewiscommunications.
com
2030 1st Ave. N
Birmingham, AL 35203
United States
Tel +1 205 980 0774
ryan@lewiscommunications.
com

Ogilvy Brazil
www.joaowrites.com
Avenida Campeche 2930,
Apt. 105
Florianopolis, Santa Catarina
88063-300
Brazil
Tel +55 21 98174 0269
johnny.ferrao.soares@gmail.
com

PETROL Advertising
www.petrolad.com
443 N. Varney St.
Burbank, CA 91502
United States
Tel +1 323 644 3720
bnessan@petrolad.com

PPK
www.uniteppk.com
1102 N. Florida Ave.
Tampa, FL 33602
United States
Tel +1 813 496 7000
kgoucher@uniteppk.com

Vanderbyl Design
www.vanderbyl.com
511 Tokay Lane
St. Helena, CA 94574
United States
Tel +1 415 543 8447
michael@vanderbyl.com

GOLD

&Barr
www.andbarr.co
600 E. Washington St.
Orlando, FL 32801
United States
Tel +1 407 849 0100
christian.wojo@andbarr.co

AG Creative Group
www.agcreative.ca
100 - 2250 Boundary Road
Burnaby, BC V5M 3Z3
Canada
Tel +1 604 559 1411
stew@agcreative.ca

Arcana Academy
www.arcanaacademy.com
13323 W. Washington Blvd.,
Ste. 301
Los Angeles, CA 90066
United States
Tel +1 310 279 5024
jessica.darke@arcanaacade
my.com

ARSONAL
www.arsonal.com
3524 Hayden Ave.
Culver City, CA 90232
United States
Tel +1 310 815 8824
info@arsonal.com

Bailey Lauerman
www.baileylauerman.com
1299 Farnam St., 9th Fl.
Omaha, NE 68102
United States
Tel +1 402 514 9400
rsack@baileylauerman.com

**Boundless Life
Sciences Group**
www.boundlesslife.com
5747 N. Highway 77
Lincoln, TX 78948
United States
Tel +1 512 320 8511
craig@whiskeytexas.com

Canyon
www.canyondesigngroup.com
4929 Wilshire Blvd., Ste. 500
Los Angeles, CA 90010
United States
Tel +1 323 933 2203
awards@canyondesigngroup.
com

Célie Cadieux
www.celiecadieux.com
124 Rue de Tolbiac
Paris 75013
France
hello@celiecadieux.com

CHEN YU MIN DESIGN
www.behance.net/chenyu
mindesign
No. 20, Fenyang Road,
Sanmin Dist.
Kaohsiung City 807
Taiwan
Tel +09 2660 0147
axlchen7@gmail.com

Collective Turn
www.instagram.com/jinyoun
gkim.official
4F, 2, Ttukseom-ro 30-gil,
Gwangjin-gu
Seoul 05085
South Korea
Tel +82 108 061 0828
coltv.turn.j@gmail.com

DeVito/Verdi
www.devitoverdi.com
330 Hudson St.
New York, NY 10013
United States
Tel + 1 212 431 4694
nryan@devitoverdi.com

Disrupt Idea Co.
www.disruptidea.com
219 N. Milwaukee St., Ste. 640
Milwaukee, WI 53202
United States
Tel +1 414 522 7914
kris.ender@disruptidea.com

Extra Credit Projects
www.extracreditprojects.com
1250 Taylor Ave. NE
Grand Rapids, MI 49505
United States
Tel +1 616 454 2955
rob@extracreditprojects.com

forceMAJEURE Design
www.forcemajeure.design
219 36th St.
Brooklyn, NY 11232
United States
Tel +1 212 625 0708
rmahieu@forcemajeure.design

Freaner Creative & Design
www.freaner.com
113 W. G St., No. 650
San Diego, CA 92101
United States
Tel +1 619 870 4699
arielfreaner@freaner.com

Gastdesign
www.gastdesign.de
Peter-Loer-Str. 20
Neuss, NRW 41462
Germany
Tel +49 157 7287 1899
info@gastdesign.de

ID8 (In-house for Gen Digital)
www.gendigital.com
60 E. Rio Salado Parkway,
Ste. #1000
Tempe, AZ 85281
United States
shannon.curwick@gendigital.
com

Kabookaboo
www.kabookaboo.com
1155 Walnut Ave.
Vallejo, CA 94592
United States
Tel +1 707 217 1249
ella@affinitycreative.com

Lewis Communications
www.lewiscommunications.
com
2030 1st Ave. N
Birmingham, AL 35203
United States
Tel +1 205 980 0774
ryan@lewiscommunications.
com

Not William
www.richwallace.myportfolio.
com
New Jersey
United States
Tel +1 718 207 3285
wallacerich1@gmail.com

OUT TO LUNCH
www.outtolunch.gr
P. Kyriakoy 21
Athens, Attiki 11521
Greece
Tel +306 972 209 174
anna.stilianaki@gmail.com

PETROL Advertising
www.petrolad.com
443 N. Varney St.
Burbank, CA 91502
United States
Tel +1 323 644 3720
bnessan@petrolad.com

PPK
www.uniteppk.com
1102 N. Florida Ave.
Tampa, FL 33602
United States
Tel +1 813 496 7000
kgoucher@uniteppk.com

Qianzi Chao
www.qz.cargo.site
1201 Unit Jia Building 7
Xincheng Jinjun Chashan S.
Changzhou, Jiangsu, 213000
China
Tel +86 189 2106 0276
1458446111@qq.com

Rhubarb
www.rhubarbagency.com
1325 Palmetto St., Unit 120
Los Angeles, CA 90013
United States
Tel +1 818 720 0503
andrew@rhubarbagency.com

**Ron Taft Erand Innovation
& Media Arts**
www.rontaft.com
2934 Beverly Glen Circle, #372
Los Angeles, CA 90077
United States
Tel +1 310 339 2442
ron@rontaft.com

**Savannah College
of Art & Design**
www.scad.edu
P.O. Box 3146
Savannah, GA 31402
United States
Tel +1 912 525 6830
awards@scad.edu

SJI Associates
www.sjiassociates.com
127 W. 24th St., 2nd Fl.
New York, NY 10011
United States
Tel +1 212 391 4140
david@sjiassociates.com

The BAM Connection
www.thebam.com
20 Jay St., Ste. 1007
Brooklyn, NY 11201
United States
Tel +1 857 400 4522
manas@thebam.com

188 WINNERS DIRECTORY

The Gate
www.us.thegateworldwide.com
71 5th Ave., 8th Fl.
New York, NY 10003
United States
Tel +1 401 489 1741
chris.vartanian@thegateworldwide.com

The Republik
www.therepublik.com
1700 Glenwood Ave.
Raleigh, NC 27608
United States
Tel +1 919 656 0038
rswest@therepublik.net

The Storyhaus Agency
www.thestoryhausagency.com
240 Devonshire St.
Boston, MA 02110
United States
Tel +1 412 427 0644
jswisher@stryhaus.com

Todd Watts & Nick Fox
www.toddwatts.com.au
45/75 Drummond Street,
Carlton
Melbourne, VIC 3053
Australia
Tel +61 041 313 6249
hello@toddwatts.com.au

Traction Factory
www.tractionfactory.com
247 S. Water St.
Milwaukee, WI 53204
United States
Tel +1 414 944 0900
tf_awards@tractionfactory.com

SILVER

&Barr
www.andbarr.co
600 E. Washington St.
Orlando, FL 32801
United States
Tel +1 407 849 0100
christian.wojo@andbarr.co

AMV BBDO
www.amvbbdo.com
Bankside 3, 90 Southwark St.
London, SE1 0SW
United Kingdom
Tel +44 20 3787 0100
hello@amvbbdo.com

Angry Dog
www.angrydog.com.br
Rua Teodoro Sampaio, 352
Conjunto 171,
São Paulo 05406-900
Brazil
Tel +55 119 8340 8517
contato@angrydog.com.br

ARSONAL
www.arsonal.com
3524 Hayden Ave.
Culver City, CA 90232
United States
Tel +1 310 815 8824
info@arsonal.com

Bailey Lauerman
www.baileylauerman.com
1299 Farnam St., 9th Fl.
Omaha, NE 68102
United States
Tel +1 402 514 9400
rsack@baileylauerman.com

Bald&Beautiful
Los Angeles, CA
United States
luiscamano1@gmail.com

Barlow.Agency
www.barlow.agency
1-5 Woodburn St., Stu. A3a
Redfern, NSW 2016
Australia
timothy@barlow.agency

Be Someone Design Co.
www.besomeonedesign.com
2469 Cimarron Drive
Grand Junction, CO 81505
United States
Tel +1 970 200 4938
jorde@besomeonedesign.com

**Boundless Life
Sciences Group**
www.boundlesslife.com
5747 N. Highway 77
Lincoln, TX 78948
United States
Tel +1 512 320 8511
craig@whiskeytexas.com

Brunner
www.brunnerworks.com
11 Stanwix St., 5th Fl.
Pittsburgh, PA 15222
United States
Tel +1 412 995 9500
lsuchy@brunnerworks.com

Cactus Inc.
www.cactusinc.com
2128 15th St.
Denver, CO 80202
United States
Tel +1 303 455 7545
katiewilson@cactusinc.com

Canyon
www.canyondesigngroup.com
4929 Wilshire Blvd., Ste. 500
Los Angeles, CA 90010
United States
Tel +1 323 933 2203
awards@canyondesigngroup.com

Célie Cadieux
www.celiecadieux.com
124 Rue de Tolbiac
Paris 75013
France
hello@celiecadieux.com

Craig Bromley Photography
www.craigbromley.com
1136 Briarcliff Road NE, Stu. 2
Atlanta, GA 30306
United States
Tel +1 404 229 7279
craig@craigbromley.com

DeVito/Verdi
www.devitoverdi.com
330 Hudson St.
New York, NY 10013
United States
Tel +1 212 431 4694
nryan@devitoverdi.com

Disrupt Idea Co.
www.disruptidea.com
219 N. Milwaukee St., Ste. 640
Milwaukee, WI 53202
United States
Tel +1 414 522 7914
kris.ender@disruptidea.com

Dunn&Co.
www.dunn-co.com
202 S. 22nd St.
Tampa, FL 33605
United States
Tel +1 813 350 7990
dunn@dunn-co.com

Eight Sleep
www.jisoosim.com
89B W. Edsall Blvd.
Palisades Park, NJ 07650
United States
Tel +1 917 584 8632
jisoosim27@gmail.com

Extra Credit Projects
www.extracreditprojects.com
1250 Taylor Ave. NE
Grand Rapids, MI 49505
United States
Tel +1 616 454 2955
rob@extracreditprojects.com

forceMAJEURE Design
www.forcemajeure.design
219 36th St.
Brooklyn, NY 11232
United States
Tel +1 212 625 0708
rmahieu@forcemajeure.design

Freaner Creative & Design
www.freaner.com
113 W. G St., No. 650
San Diego, CA 92101
United States
Tel +1 619 870 4699
arielfreaner@freaner.com

Gaaboo Inc.
www.gaaboo.jp
Tokyo Tatemono Higashi
Shibuya Bld. 9F, 1-26-20
Higashi, Shibuya Ku 1500011
Japan
Tel +09 083 019 582
info@fleedesign.jp

Greenhaus
www.greenhaus.agency
337 S. Cedros Ave., Ste. G
Solana Beach, CA 92075
United States
Tel +1 619 992 3875
droberts@greenhaus.com

Innerspin Marketing
www.innerspinmarketing.com
360 N. Pacific Coast Highway,
Ste. 2000
El Segundo, CA 90245
United States
Tel +1 213 529 0805
gloria@innerspinmarketing.com

Media.Work
www.media.work
453 S. Spring St., Ste. 400,
PMB 102
Los Angeles, CA 90013
United States
Tel +1 813 502 7416
alexandra@media.work

Mythic
www.mythic.us
3700 S. Blvd., Ste. 325
Charlotte, NC 28217
United States
Tel +1 704 315 8884
dshuford@mythic.us

NIEDERMEIER DESIGN
www.kngraphicdesign.com
719 S. Mason Ave.
Tacoma, WA 98405
United States
Tel +1 206 351 3927
kurt@kngraphicdesign.com

Nikkeisha, Inc.
www.nks.co.jp
1-2-7 Motoakasaka
Minato-ku
Tokyo 1070051
Japan
Tel +81 90 1121 5422
nakamu02@gmail.com

OUT TO LUNCH
www.outtolunch.gr
P. Kyriakoy 21
Athens, Attiki 11521
Greece
Tel +306 972 209 174
anna.stilianaki@gmail.com

Partners + Napier
www.partnersandnapier.com
1 S. Clinton Ave., Ste. 400
Rochester, NY 14604
United States
Tel +1 617 828 8228
dan.odonnell@partnersandnapier.com

PETROL Advertising
www.petrolad.com
443 N. Varney St.
Burbank, CA 91502
United States
Tel +1 323 644 3720
bnessan@petrolad.com

**Shanghai Cary Branding
Design Co., Ltd.**
www.behance.net/Studio_XL
Rm. 601, #12
289 An Ning Road,
Min Hang Dist.
Shanghai 200240
China
Tel +86 138 1649 8792
87339976@qq.com

SJI Associates
www.sjiassociates.com
127 W. 24th St., 2nd Fl.
New York, NY 10011
United States
Tel +1 212 391 4140
david@sjiassociates.com

Studio Eduard Cehovin
www.facebook.com/eduard.cehovin
Ul. Milana Majcna 35
Ljubljana SI-1000
Slovenia
Tel +386 40 458 657
eduard.cehovin@siol.net

STUDIO INTERNATIONAL
www.studio-international.com
Buconjiceva 43 Buconjiceva
43/III
Zagreb HR-10 000
Croatia
Tel +385 1 37 60 171
boris@studio-international.com

Sukle Advertising
www.sukle.com
2430 W. 32nd Ave.
Denver, CO 80211
United States
Tel +1 303 964 9100
info@sukle.com

The BAM Connection
www.thebam.com
20 Jay St., Ste. 1007
Brooklyn, NY 11201
United States
Tel +1 857 400 4522
manas@thebam.com

Toolbox Design
www.toolboxdesign.com
304-1228 Hamilton St.
Vancouver, BC V6B 6L2
Canada
Tel +1 778 322 7474
victoria@toolboxdesign.com

Weights&Pulleys
www.weightsandpulleys.com
2824 NW Thurman St.
Portland, OR 97210
United States
Tel +1 503 546 1520
awards@weightsandpulleys.com

189 WINNERS BY COUNTRY

Visit Graphis.com to view the work within each country, state, or province.

BEST IN THE AMERICAS

BRAZIL
Angry Dog 153
Ogilvy Brazil 156, 157

CANADA
AG Creative Group 132, 133
Toolbox Design 151, 173

UNITED STATES
&Barr 137, 164, 172
Arcana Academy 82, 83
ARSONAL 30, 69, 72, 73, 78, 79, 139, 140
Bailey Lauerman 100, 145, 158, 170
Bald&Beautiful 146
Be Someone Design Co. 152
Boundless Life Sciences Group 92, 149
Brunner 152, 171, 172
Cactus 138
Canyon 32-37, 74, 75, 143
Chang Liu 46, 47
Craig Bromley Photography 153
Darkhorse Design 52-55
DeVito/Verdi 64, 65, 96, 97, 135, 137, 146, 160, 161, 164, 166, 170, 171
Disrupt Idea Co. 84, 152
Dunn&Co. 144
Eight Sleep 42-45, 148
Extra Credit Projects 110, 111, 139, 142, 152-154
forceMAJEURE Design 62, 63, 135
Freaner Creative & Design 85, 137, 141, 148, 150, 173
Greenhaus 154
ID8 (In-house for Gen Digital) 159, 168
Innerspin Marketing 144
Kabookaboo 158
Lewis Communications 56, 57, 126-131, 169
Media.Work 142
Mythic 147
NIEDERMEIER DESIGN 150
Not William 104, 105, 124, 125
Partners + Napier 141, 146
PETROL Advertising 38-41, 86-91, 145, 165
PPK 48, 49, 102, 103, 107-109, 112, 114-121
Rhubarb 77
Ron Taft Brand Innovation & Media Arts 70
Savannah College of Art & Design 159
SJI Associates 66, 67, 136, 139, 147
Sukle Advertising 149, 172, 173
The BAM Connection 93, 171
The Gate 163
The Republik 94, 95, 98, 99, 122, 123, 162, 167
The Storyhaus Agency 163
Traction Factory 59
Vanderbyl Design 50, 51
Weights&Pulleys 170

BEST IN EUROPE/AFRICA

CROATIA
STUDIO INTERNATIONAL 146

FRANCE
Célie Cadieux 71, 140

GERMANY
Gastdesign 68

GREECE
OUT TO LUNCH 80, 81, 113, 148

SLOVENIA
Studio Eduard Cehovin 147

UNITED KINGDOM
AMV BBDO 141

BEST IN ASIA/OCEANIA

AUSTRALIA
Barlow.Agency 31, 139, 140
Todd Watts & Nick Fox 76

CHINA
Qianzi Chao 60, 61
Shanghai Cary Branding Design Co., Ltd. 137, 138

JAPAN
Gaaboo Inc. 148
Nikkeisha, Inc. 136

SOUTH KOREA
Collective Turn 101

TAIWAN
Chen Yu Min Design 106

I applaud the teams responsible for the work I saw this year. I found the strategic thinking that was the foundation of the best work to be impressive.
Scott Bucher, *President, Traction Factory*

There were inspiring examples of smart creative, insightful design, and slick visual storytelling.
Steve Chavez, *Executive Vice President, Managing Partner, & Chief Creative Officer, The Buntin Group*

What an amazing privilege it was to review some of the most innovative and thought-provoking work in the industry.
Mike Kriefski, *President & Chief Creative Officer, Shine United*

Graphis Titles

Design Annual 2025

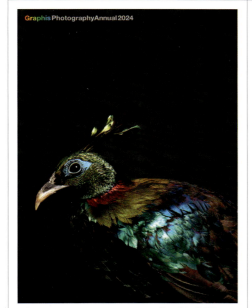

2024
Hardcover: 272 pages
200-plus color illustrations
Trim: 8.5 x 11.75"
ISBN: 978-1-954632-34-9
US $75

Awards: Graphis presents 12 Platinum, 163 Gold, and 401 Silver awards, along with 118 Honorable Mentions.
Platinum Winners: 33 and Branding (China), Dankook University (South Korea), EJ Communication Studio (South Korea), Media. Work (USA), National Kaohsiung University of Science and Technology (NKUST) (Taiwan), Sol Benito (India), Stranger & Stranger (USA/UK), Studio DelRey (Brazil), Studio Hinrichs (USA), The Balbusso Twins (Italy)
Content: This annual volume spans more than 550 award-winning works of global design excellence from over 30 countries. This meticulously curated volume celebrates the most innovative and visually compelling works worldwide, offering a treasure trove of inspiration for designers and creative enthusiasts alike.

Poster Annual 2025

2024
Hardcover: 256 pages
200-plus color illustrations
Trim: 8.5 x 11.75"
ISBN: 978-1-954632-33-2
US $75

Awards: Graphis presents 12 Platinum, 100 Gold, 418 Silver awards, and 90 Honorable Mentions.
Platinum-winning Instructors: Atelier Bundi AG, CollierGraphica, Dankook University, dGwaltneyArt, Freaner Creative, Gallery BI, João Machado Design, Katarzyna Zapart, Melchior Imboden, Skolos-Wedell, The Union Design Company, and THERE IS STUDIO.
Content: Explore the stories behind the designs with insightful commentary from Platinum and Gold-winning talents, who share their creative processes and the inspiration behind their award-winning work. This beautiful hardcover book is a visual feast, showcasing full-page, full-color images of Platinum-winning designs alongside Gold and Silver winners. With Honorable Mentions listed, every piece of exceptional work is celebrated.

New Talent Annual 2024

2024
Hardcover: 256 pages
200-plus color illustrations
Trim: 8.5 x 11.75"
ISBN: 978-1-954632-29-5
US $75

Awards: Graphis presents 13 Platinum, 132 Gold, 587 Silver, and 858 Honorable Mentions.
Platinum-winning Instructors: Rob Clayton, Simon Johnston, Stephen Serrato, Ming Tai, David Tillinghast, HyoJun Shim, Peter Bergman, Nathan Savage, Billy Magbua, Justin Colt, Natasha Jen, Richard Mehl, William Meek
Content: The New Talent 2024 Annual presents award-winning work submitted by teachers and students of prominent schools, who are dedicated to shaping the next generation of graphic designers. Platinum winners share their creative process, providing valuable insights and inspiration for aspiring creatives. A special section that revisits the Platinum-winning works from the past decade, offering a unique lens on the evolution of creative excellence.

Photography Annual 2024

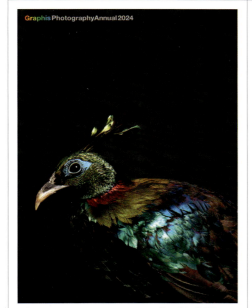

2024
Hardcover: 256 pages
200-plus color illustrations
Trim: 8.5 x 11.75"
ISBN: 978-1-954632-28-8
US $75

Awards: Graphis presents 12 Platinum, 102 Gold, and 216 Silver awards, along with 54 Honorable Mentions.
Platinum Winners: Craig Cutler, Lindsey Drennan, Jonathan Knowles, James Minchin, Artem Nazarov, Peter Samuels, Howard Schatz, John Surace, and Paco Macias Velasco.
Content: This book is full of exceptional work by our masterful judges, our Platinum, Gold, and Silver award winners, and our Honorable Mentions. It also includes a retrospective on our Platinum 2014 Photography winners, a list of international photography museums and galleries, and an In Memoriam list of photographers who have passed away this past year. The digital copy has an extra 52 pages of additional content for you to peruse.

Packaging 10

2022
Hardcover: 240 pages
200-plus color illustrations
Trim: 8.5 x 11.75"
ISBN: 978-1-954632-12-7
US $75

Awards: Graphis presents 12 Platinum, 100 Gold, 204 Silver, and 249 Honorable Mentions for innovative work in product packaging.
Platinum Winners: Michele Gomes Bush (Next), Chad Roberts (Chad Roberts Design Ltd.), XiongBo Deng (Shenzhen Lingyun Creative Packaging Design Co., Ltd.) and Lu Chen (Xiaomi), Vishal Vora (Sol Benito), Mattia Conconi (Gottschalk+Ash Int'l), and Frank Anselmo (New York Mets), Ivan Bell (Stranger & Stranger), Brian Steele (SLATE), and the team at PepsiCo Design & Innovation.
Content: This book contains award-winning packaging from the judges, as well as international Platinum, Gold, and Silver-winning packaging designs from designers and design firms from around the world. Honorable Mentions are presented, and a feature of award-winning work from our Packaging 9 Annual is also included.

Narrative Design: Kit Hinrichs

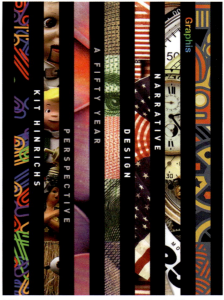

2023
Hardcover: 248 pages
200-plus color illustrations
Trim: 9 x 12"
ISBN: 978-1-954632-03-5
US $65

Narrative Design: A Fifty-Year Perspective is a collection of over 50 years of work from the obsessive graphic designer Kit Hinrichs. To the legendary AIGA medalist, author, teacher, and collector, design is the business of telling a story. It's not just about communicating a product or a corporate ethos—it's about contributing to the collective culture of storytelling. Presented in the book are not individual case studies but rather categories of work and graphic approaches to assignments that have wowed clients and dazzled viewers. The work is arranged to communicate Hinrichs' creative thinking, which always leads to a unique and effective solution to any design conundrum.

Books are available at graphis.com/publications

www.Graphis.com